My Last Supper

MY LAST SUPPER

50 Great Chefs and Their Final Meals

Portraits, Interviews, and Recipes

MELANIE DUNEA

INTRODUCTION BY ANTHONY BOURDAIN

BOOK DESIGN BY GIOVANNI CARRIERI RUSSO / NO11, INC.

BLOOMSBURY

FOR NIGEL

CHE

TON
SAYS

Y Chefs have been playing the "My Last Supper" game, in one version or another, since humans first gathered round the flames to cook. Whether late at night, after their kitchens had closed, sitting at a wobbly table on the periphery of Les Halles in nineteenth-century Paris and drinking vin ordinaire, or while nibbling bits of chicken from skewers in after-hours izakayas in Tokyo, or perched at the darkened bar of a closed New York City restaurant, enjoying pilfered vintages they couldn't otherwise afford, someone always piped up: "If you were to die tomorrow, what single dish, what one mouthful of food from anywhere in the world or anytime in your life, would you choose as your last? What would be your choice for your last meal on earth?"

I've played the game myself, hundreds of times, with my crew in Manhattan, line cooks in San Francisco and Portland, chefs from Sydney to Kuala Lumpur to São Paulo — and with many of the subjects in this book. It's remarkable how simple, rustic, and unpretentious most of their selections are. These are people who, more often than not, have dined widely and well. They know what a fresh white truffle tastes like. The finest beluga, for them, holds no

mysteries. Three-hundred-dollar-a-pound otoro tuna and the most unctuous cuts of Kobe beef are, to them, nothing new. A lot of the people in this book know each other. In this respect, being a chef is a lot like being in the Mafia. Everyone knows everyone else. We're all just two degrees separated, part of the same subculture — frequently just a phone call away from sitting down at the "chef's table" in a kitchen on the other side of the world. I'm not bragging. It's simply a bald statement of fact that no matter who you are — and how much money you have — you have not eaten nearly as well as most chefs. Flip a page in this book and you're probably looking at someone who has dined at Arzak, El Bulli, the French Laundry, Ducasse, Tetsuya's, Masa, Le Bernardin, and many, many others — most often in the kitchen, and as frequently with the chef — all within recent memory. With chefs traveling so much these days — tending to far-flung outposts, being honored at Food & Wine festivals, or consulting on hotel and casino restaurant operations — many have enjoyed as well the delights of Singaporean street food, elaborate kaiseiki meals in Japan, the ancient culinary traditions of mainland China, and every variety of edible

exotica. Reeking, yet delicious, Sardinian cheeses, boutique wines, and rare, illegal game birds have been known to make their way to some of their tables. Which is to say, chefs know the good stuff. And they get a lot of it.

And yet, when we ask ourselves and each other the question, what — if strapped to a chair, facing a fatal surge of electricity — would we want as that last taste of life, we seem to crave reminders of simpler, harder times. A crust of bread and butter. A duck confited in a broken home. Poor-people food. The food of the impoverished but (only in the abstract) the relatively carefree. When we think of what we would eat last, we revert from the loud, type A, obsessive, dominating control freaks we've become back to the children we once were. Not that all of us were happy children, but we were children just the same. If cooking professionally is about control — about manipulating the people, the ingredients, and the strange, physical forces of the kitchen universe to do one's bidding; always anticipating, always preparing, always dominating one's environment — then eating well is about submission. About letting go.

Melanie Dunea managed to convince a goodly number of the world's best, and best-known, chefs to let it all go. To behave for a few moments like children, and then to allow those moments to be photographed. To be playful, or to play at being the adults they aspired to be. Certainly Daniel Boulud's dream of a noble death at Versailles is a little boy's fantasy (though now not so unthinkable a scenario). For a guy whose name has been inexorably associated with El Bulli (the bulldog), it's surprising that Ferran Adrià had never actually been photographed with one before. The result captures, I think, the playfulness at the core of both the great chef and his craft. Mario Batali's plumage surely expresses both a desire to dress up and his outsize aspirations for greatness. Suzanne Goin is caught in freeze-frame at the beach, like a young Antoine Doinel at the water's edge. Laurent Tourondel grabs for a Krispy Kreme (though he'd prefer to enjoy it with a grown-up beer). Giorgio Locatelli looks petulant, yet unlikely to give up his mackerel. And I guess it's only right that Jamie Oliver is photographed in front of the Union Jack. He's earned it. Eric Ripert and José Andrés play with their food. Lidia Bastianich wears it.

Two of my favorite photographs from this collection are of adults and children. The amazing father-daughter chef team of Juan Mari and Elena Arzak stand awkwardly apart and at attention, as if to distinguish the daughter's considerable achievements and abilities from those of her father. They appear expressionless, but the love and respect between the two fills the empty space. It is the father who beams like a proud schoolboy—a few feet away from his greatest accomplishment. And of course, Gabrielle Hamilton gets right to the core of what chefs do in typically blunt fashion: We feed others.

I'm of two minds about my photograph. I do always joke that (as some comedian once suggested) "I want to leave this world as I entered it: naked, screaming, and covered with blood," but I think perhaps Melanie might have taken me too literally. I'm sure we can all agree that it's probably not wise to make career decisions after four shots of tequila.

Maybe she just thought it was cheaper than flying me to Versailles...

—ANTHONY BOURDAIN

The setting for the lunch — it would have to be lunch — is a Saturday in summer at home at the kitchen table, with the window wide open so you can hear the busy street below. I would prepare the lunch for family and friends. To start we would have many platters of sea urchins washed down with muscadet, then a pre-cheese cigarette, excellent red burgundy, and goat cheese, followed by one scoop each of dark butter chocolate ice cream.

We'd finish with strong coffee, much Vieille Prune, and more cigarettes. Then there can be music and drunken dancing to Wilson Pickett. That should help soften the blow.

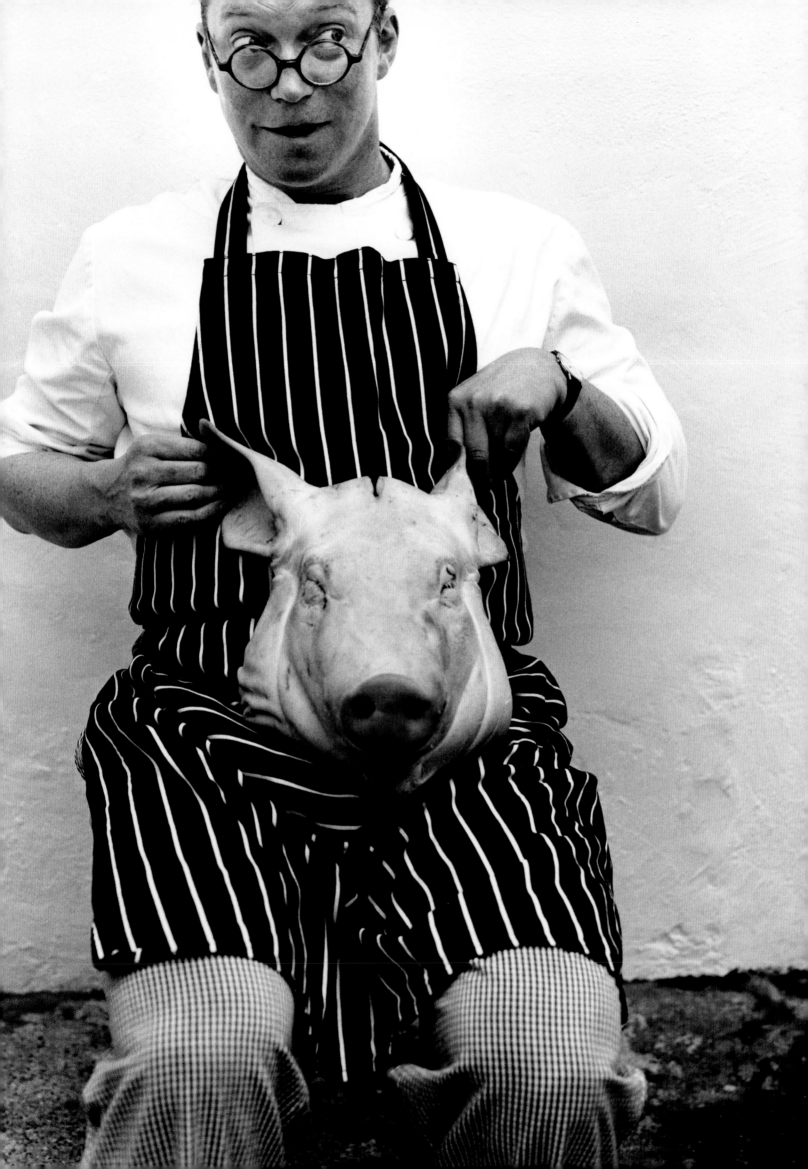

WOULD THERE BE MUSIC?

❧

Just the telly, playin

n the background.

What would be your last meal on earth?

> *I would have a big pot of spaghetti all'arrabiata made with three types of chilies. It is soft, sweet, and silky — my perfect comfort food. If I were going to have dessert, it would be homemade rice pudding with roasted peaches. The rice pudding would be served very cold and topped with the hot caramelized peaches.*

What would be the setting for the meal?

> *I would be in my house in Essex, cuddled up on the sofa with my missus. There would be some crap on the television, and a fire going. The window would be open just a crack, with the fresh air cooling the back of my neck after all of those hot chilies in the pasta sauce.*

What would you drink with your meal?

> *I would love a bottle of Hoegaarden beer.*

Who would be your dining companions?

> *My wife, Jools, would be sitting beside me.*

Who would prepare the meal?

> *I would prepare it myself.*

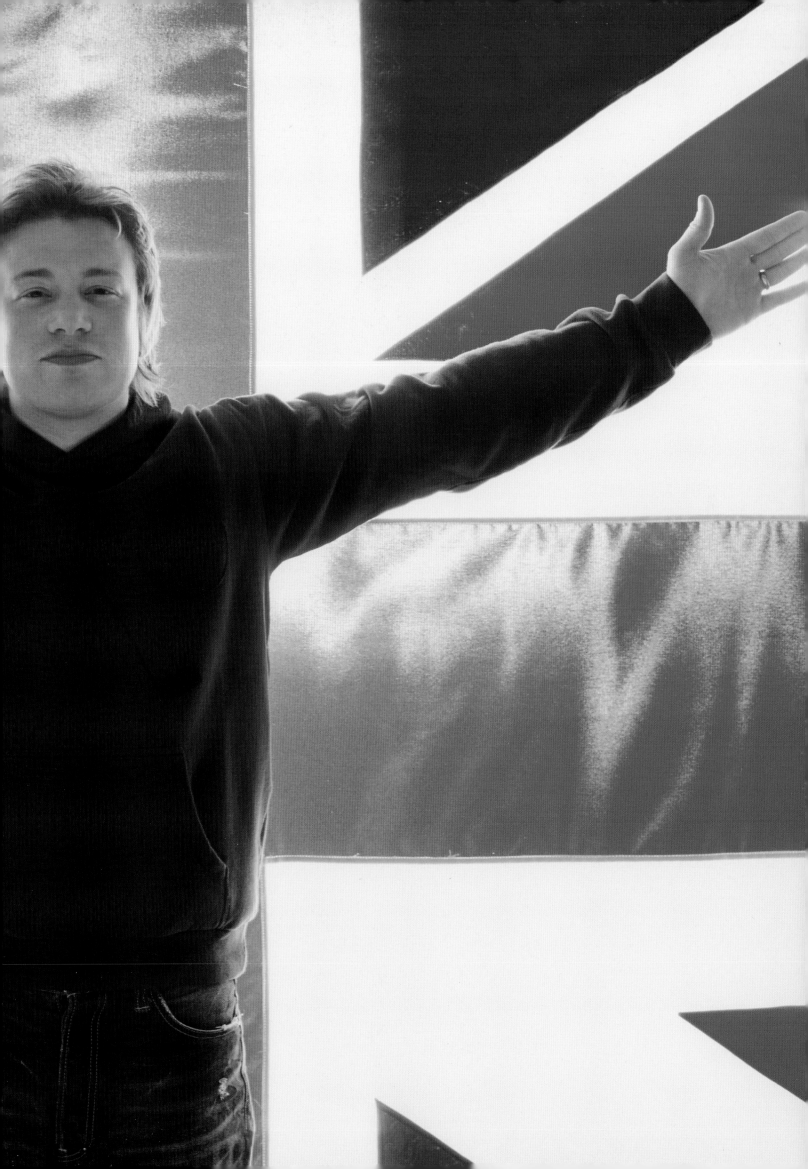

What would be your last meal on earth?

Roast bone marrow with parsley and caper salad, with a few toasted slices of baguette and some good sea salt.

What would be the setting for the meal?

The dining room of St. John in London — after-hours.

What would you drink with your meal?

They pour a perfect Guinness at St. John.

Would there be music?

The Brian Jonestown Massacre and Curtis Mayfield would play live — at a comfortable remove.

Who would be your dining companions?

Given that I'm ostensibly facing imminent death, I'd probably prefer being alone. But assuming heroic sangfroid, an eclectic bunch of dinner companions from times present and past might keep the conversation interesting: Graham Greene, Kim Philby, Ava Gardner, Louise Brooks, Orson Welles, Iggy Pop, Martin Scorsese, Gabrielle Hamilton, Nick Tosches, Muhammad Ali, and Carole Lombard.

Who would prepare the meal?

Naturally, I'd prefer that it be prepared and served by the creator of my favorite version: Fergus Henderson, chef and partner at St. John. And in a perfect world, my pals Eric Ripert, Mario Batali, and Gordon Ramsay would be around to assist. We could all go out and talk shit afterward — when the civilians are gone.

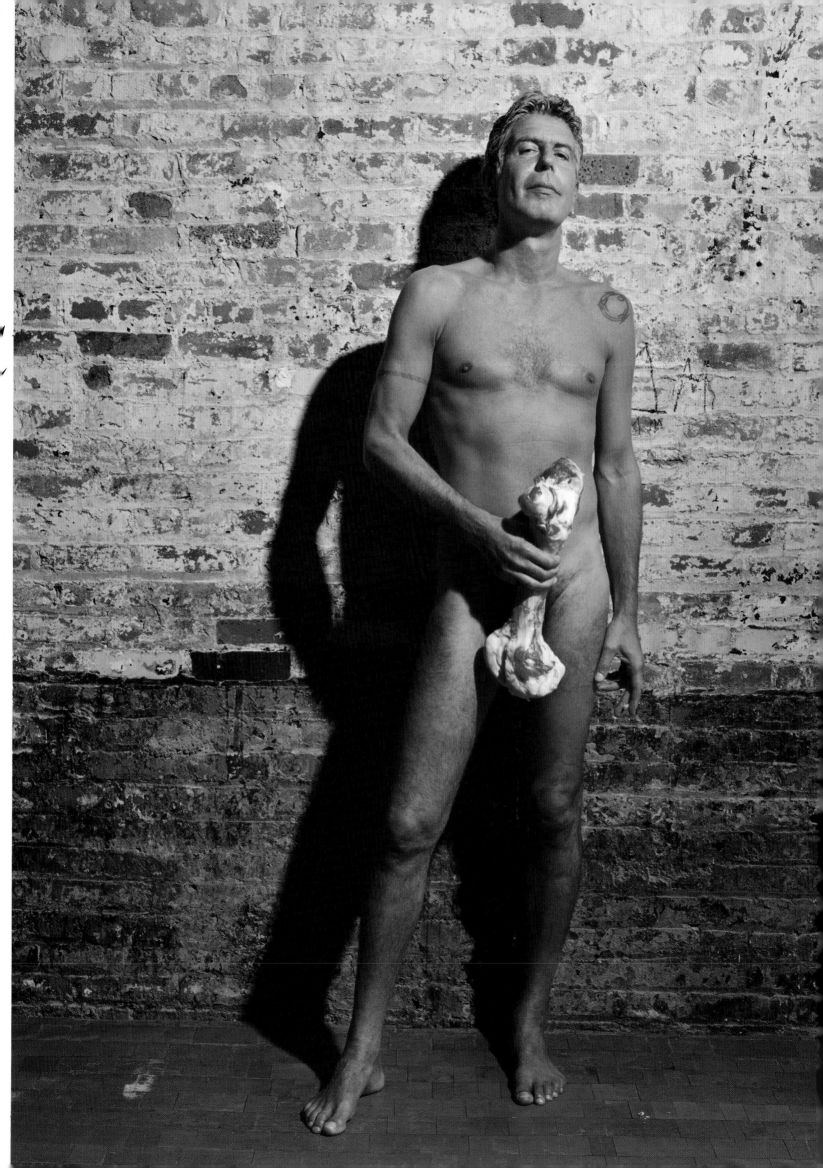

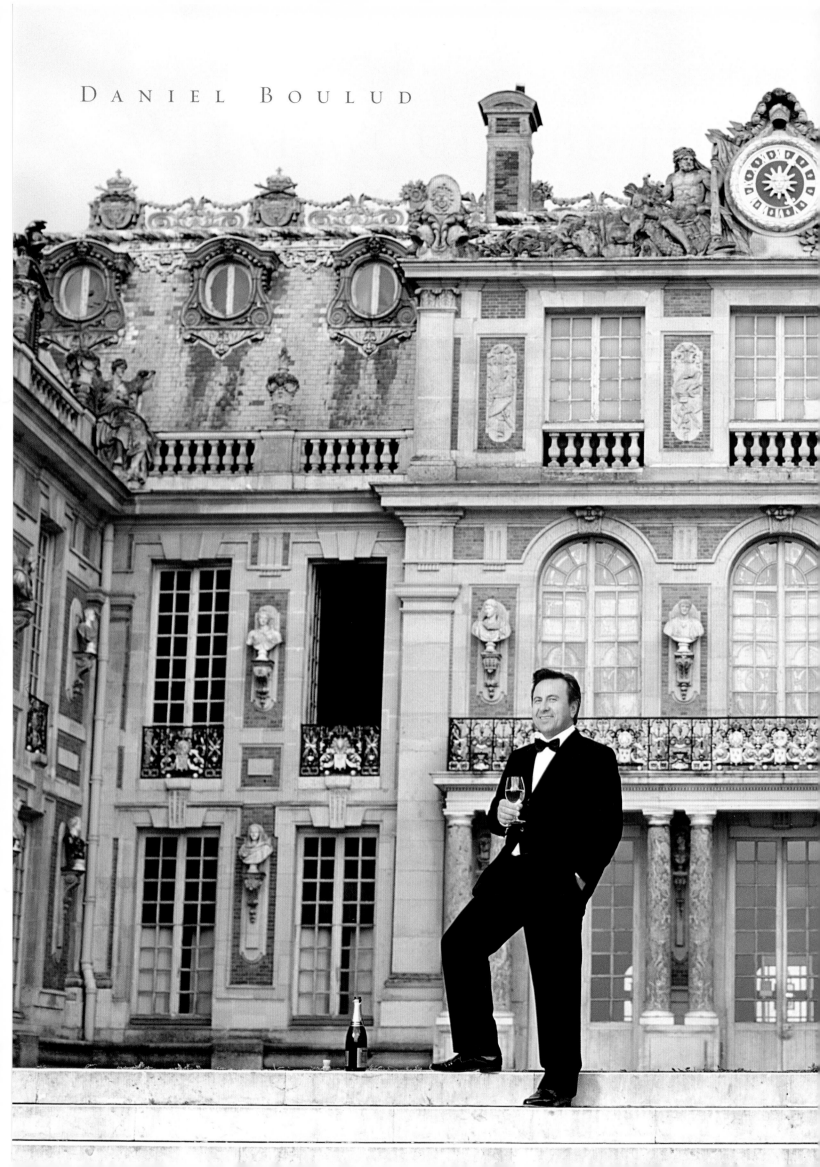

DANIEL BOULUD

t Versailles.

What would be your last meal on earth?

> *It would depend upon the season, and upon whatever Alain Ducasse would like to cook for me. A multicourse menu might include a soup; a foie gras terrine; seafood such as lobster or langoustine; a fish course; perhaps some game bird such as squab, pheasant, or partridge; a beef or lamb dish; a cheese course; and to finish, at least two dessert courses, followed by chocolates and petits fours.*

What would you drink with your meal?

> *Incredible white burgundies such as Montrachet Domaine des Comtes Lafon 1986, Montrachet Ramonet 1982, and Musigny Comte de Vogüé 1962; red burgundies such as Domaine de la Romanée-Conti La Tâche 1959, l'Eglise-Clinet, Pomerol 1947, and La Mission Haut-Brion 1955; and from Bordeaux, a 1921 Château d'Yquem.*

Would there be music?

> *Mozart and Bono would play live.*

Who would be your dining companions?

> *I would dine alongside Apicius, Bacchus, Marie-Antoine Carême, Escoffier, and Paul Bocuse.*

Who would prepare the meal?

> *Alain Ducasse, bien sûr.*

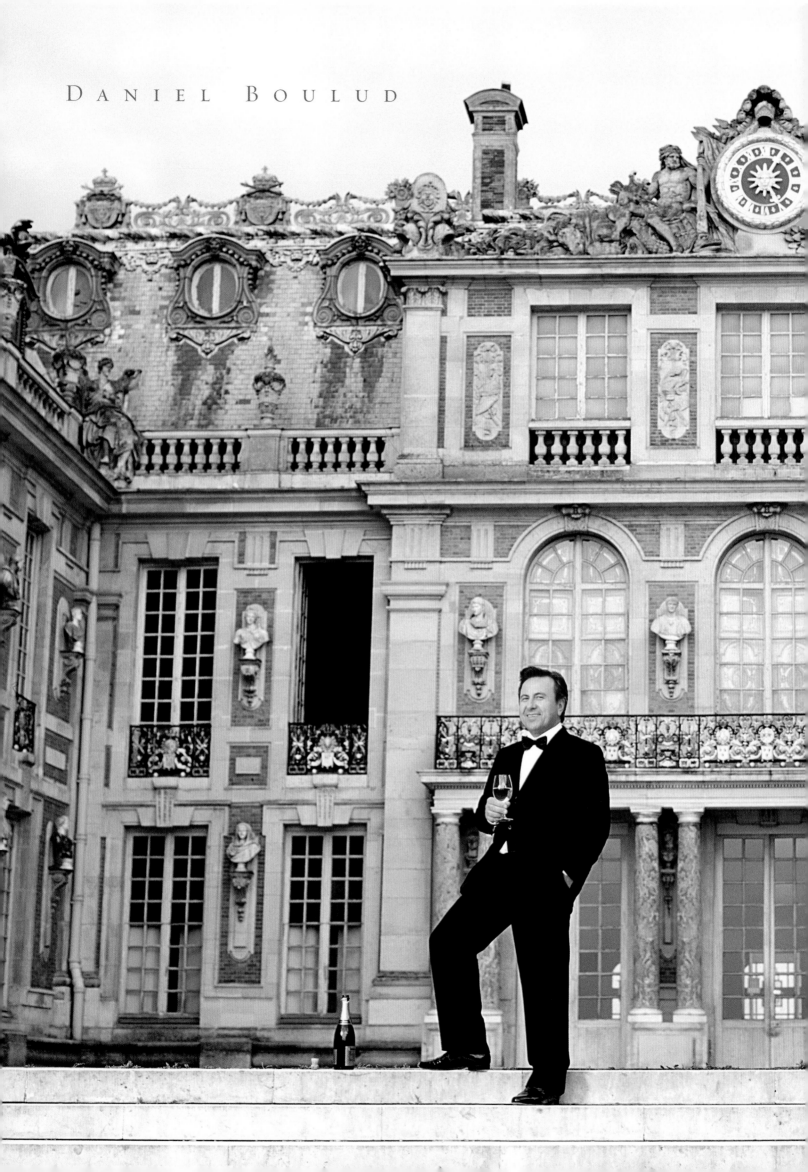

DANIEL BOULUD

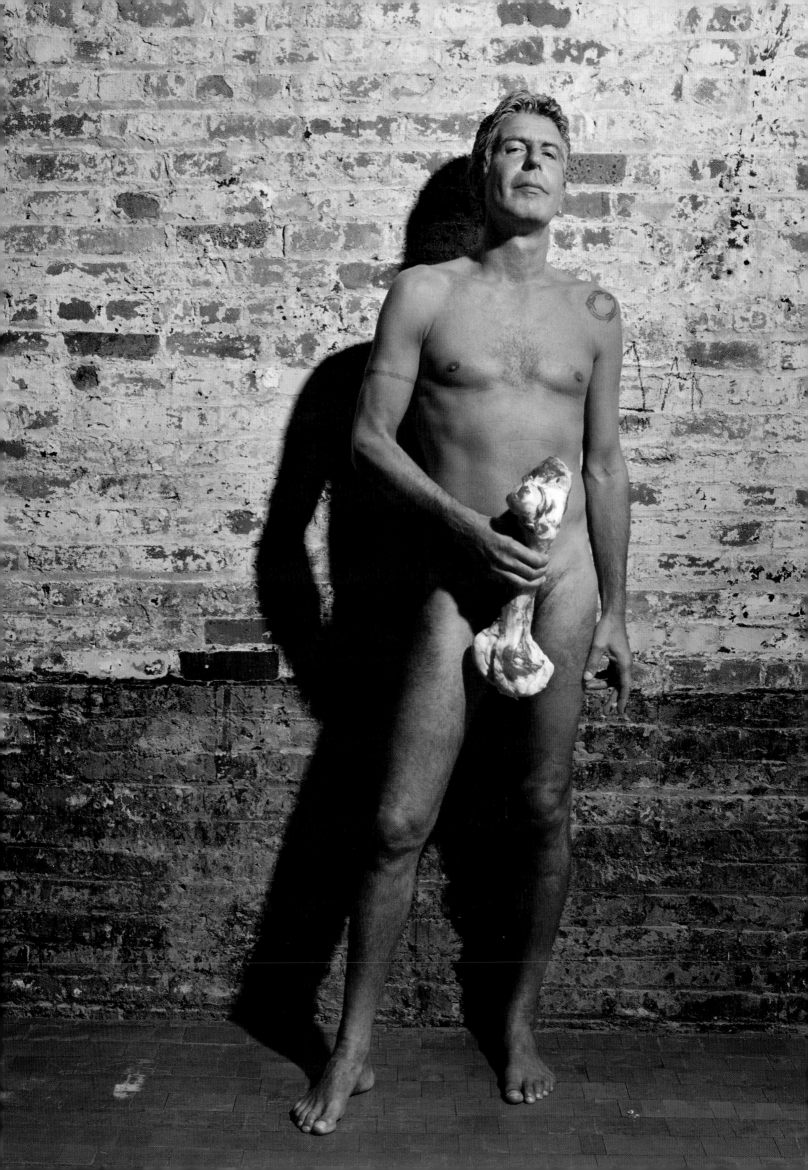

— D A N I E L B O U L U D —

WHAT WOULD BE THE
SETTING FOR THE MEAL?

❧

The Hall of Mirror

❧

WHAT WOULD YOU DRINK WITH YOUR MEAL?

*I would drink cham
champagne is magic
exceptional champa
happiness. When I'
champagne, my sou*

gne, because
he bubbles of an
e are like stars of
ink a great
happy.

What would be your last meal on earth?

I love seafood, so my last meal would be a tasting menu that featured a variety of seafood, prepared in many different ways, and inspired by the cuisine at Kiccho Restaurant in Kyoto, Japan. Some of the dishes I would like to eat would be bamboo with assorted sashimi; prawns with tuzu; clams, sesame, and nori seaweed soup; roasted fugu; scallops with miso and a clam tart; daikon turnip with abalone and sansho lettuce; kuzu tagliatelle with freshly grated ginger; and mountain potato stuffed with sweet beans and yuzu. I would finish the meal with fruit from the Amazon that I had never tasted before.

What would be the setting for the meal?

I wouldn't like to have my last meal on earth, but if there were no alternative, I would have it at Kiccho. I have enjoyed many meals during my life, some of them so marvelous that without a doubt they could be considered as artistic an experience as any museum visit or dance performance, but I had this feeling the most during my visit to Kiccho.

It was on my first trip to Japan. Our hosts told my group that we were going to a unique restaurant in Kyoto, but after going to so many restaurants, we thought it would be difficult to surprise us with the concept of how a restaurant should be. What was so special about it? How is it different from so many others? Let me try to explain. First, we took the bullet train from Tokyo to Kyoto and, after arriving, strolled through the city. We arrived at the restaurant at 7.30 P.M. — Juli Soler, Albert Adrià, Oriol Castro, our Japanese friends, and myself. We sensed magic as soon as we entered; it was a strange sensation. I feel magic is always impossible to explain.

The restaurant is a Japanese house with a beautiful Zen garden. We crossed the garden, approached the front door, and once inside we saw that it bore no relation to a classic restaurant. There were approximately five or six different rooms, each about sixty square meters. The room in which we ate seated eight people and four or five waitresses dressed in kimonos were there to serve us. This had a strong impact. We had all been in the best restaurants in the world, but none were like this one. It had incredible atmosphere: the dining room was very Zen, decorated with floral designs and little else. All of this created a magical ambience. We hadn't even eaten anything yet, but it was already worthwhile just to be there for these sensations.

They first offered us sake from inside an eighteenth-century bottle; the bottle was a glass jewel, the most beautiful that I have ever seen. I had never tasted sake like this either. All of this told me that the meal would be as magical as the setting. The food was traditional Japanese. Each dish was presented on a beautiful tray inside handmade porcelain crockery, some of it more than a hundred years old. Everything was wonderful. It was a gastronomic fiesta!

Would there be music?

I would like to listen to fusion music, and the same Berber music that they have at Yacout restaurant in Marrakech, Morocco. To see Berber musicians performing transports you to ancestral times and places, while at the same time it sounds so progressive and modern.

Who would be your dining companions?

My companions would be my wife, my family, and my friends.

Who would prepare the meal?

Daydreaming, I would like to see Auguste Escoffier return to the land of the living after many years away. Then I could taste his cooking in person. For me, when we talk about gastronomy, Escoffier is the icon. I would love to listen to him and to learn, above all, his philosophy.

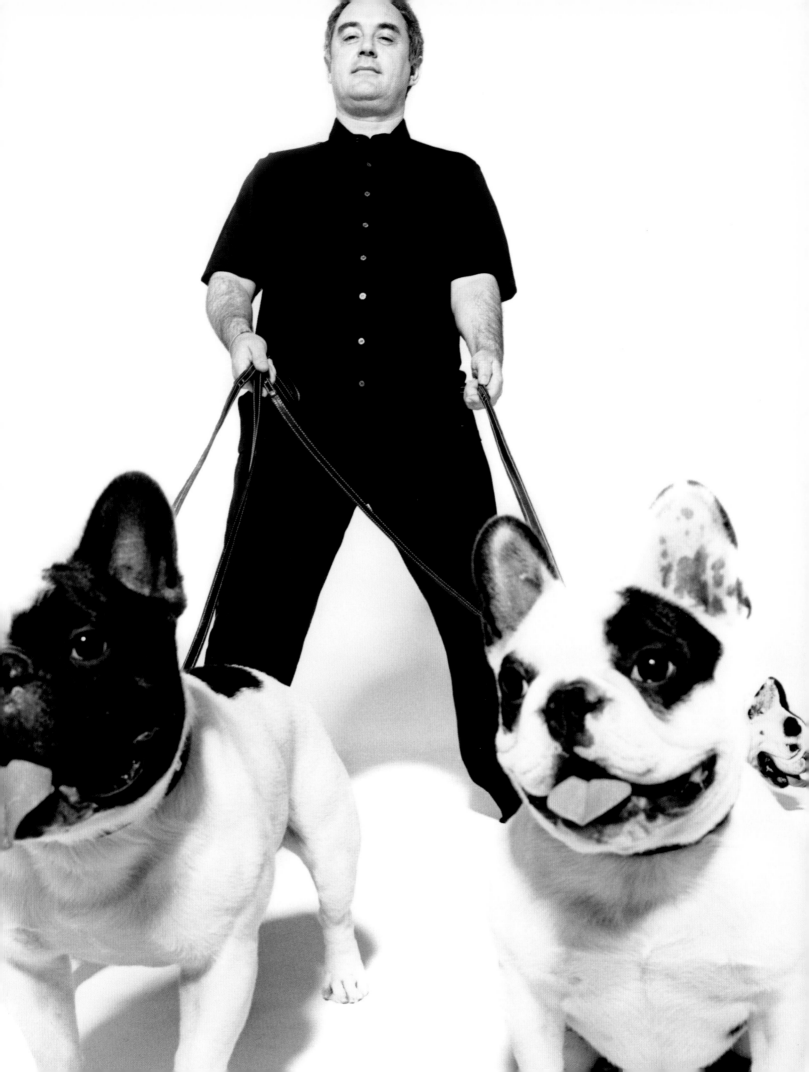

WHO WOULD BE YOUR DINING COMPANIONS?

*I'd like my best frien
family to be there, a
on this evening, mir
would like certain p
whom I have lost to
earth for the length*

and my immediate
ut thirty people. If,
es were possible, I
le close to me
able to return to
the dinner.

What would be your last meal on earth?

For me, the ideal menu would be a confit of foie gras, with the foie gras selected by Robert Dupérier, prepared simply, and served with country bread that has been toasted over a wood fire; osetra caviar from Iran served with a good Pullman loaf and raw double cream; a soft-boiled farm egg with coarsely grated black Périgord truffle, with the egg collected by my little nephews from their henhouse that morning, and the truffle from the Saint-Alvaire market in

Périgord; a roast chicken with french fries — the chicken would be from Landes, very big and fat, roasted simply in duck fat with garlic and bay leaf and basted during the cooking so that its skin was very crunchy, and the sauce would just be the juice, deglazed from the pan and with the fat barely skimmed off; the fries would be fairly thick, cooked in the duck fat until good and crunchy; a Saint-Nectaire farmer's cheese; a chocolate éclair; a Victoria cake from Pierre Hermé; and wild strawberries with whipped cream made with muscovado sugar and served with shortbread cookies (my father would have gathered the strawberries from the gardens I planted as a child).

What would be the setting for the meal?

I would like this meal to be a dinner and for it to take place on the terrace of the house I rent in Biarritz, which overlooks the sea and offers a magnificent 180-degree view of the Basque coast. I'd like for the sky to be clear enough for us to watch the sunset, which is unique to that place. I would have one table for everyone, and I would pay particular attention to the art of the table that night, using a tablecloth embroidered by my aunt, my grandmother's silver, Bernardaud napkins inherited from my grandfather, and bouquets of lilacs and sweet peas.

What would you drink with your meal?

I'd like to drink a Château d'Yquem with the foie gras, a 1973 Dom Pérignon with the caviar, and have Pétrus with the rest of the dinner. Afterward, a 1967 Bas-Armagnac Francis Darroze Domaine de Saint Aubin. Lastly, fresh water from the mill spring at my parents' house.

Would there be music?

The Bach cello suites, if there were any music at all. They aren't very cheerful, but to me they are the most beautiful music in the world. I wouldn't want music for very long, however; I think that the mood itself would be enough.

Who would prepare the meal?

I would like the foie gras to be cooked by Thierry, my sous-chef, according to my recipe; the caviar to be selected by Mr. Petrossian; and the egg to be cooked by my grandmother Charlotte, if miracles were possible and she could return to earth. I'd like my grandmother Louise to cook the chicken and french fries, again, only if miracles are possible on this night; if not, the chicken would be prepared by my mother, and the fries by my friend Suzy (who makes the best ones in the world after those my grandmother made for me when I was a child). The cream and the cheese would be selected by Marie Quatrehomme, the bread prepared by Jean-Luc Poujauran, the desserts by Pierre Hermé, and the whipped cream and shortbread by Kirk, my pastry chef.

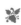

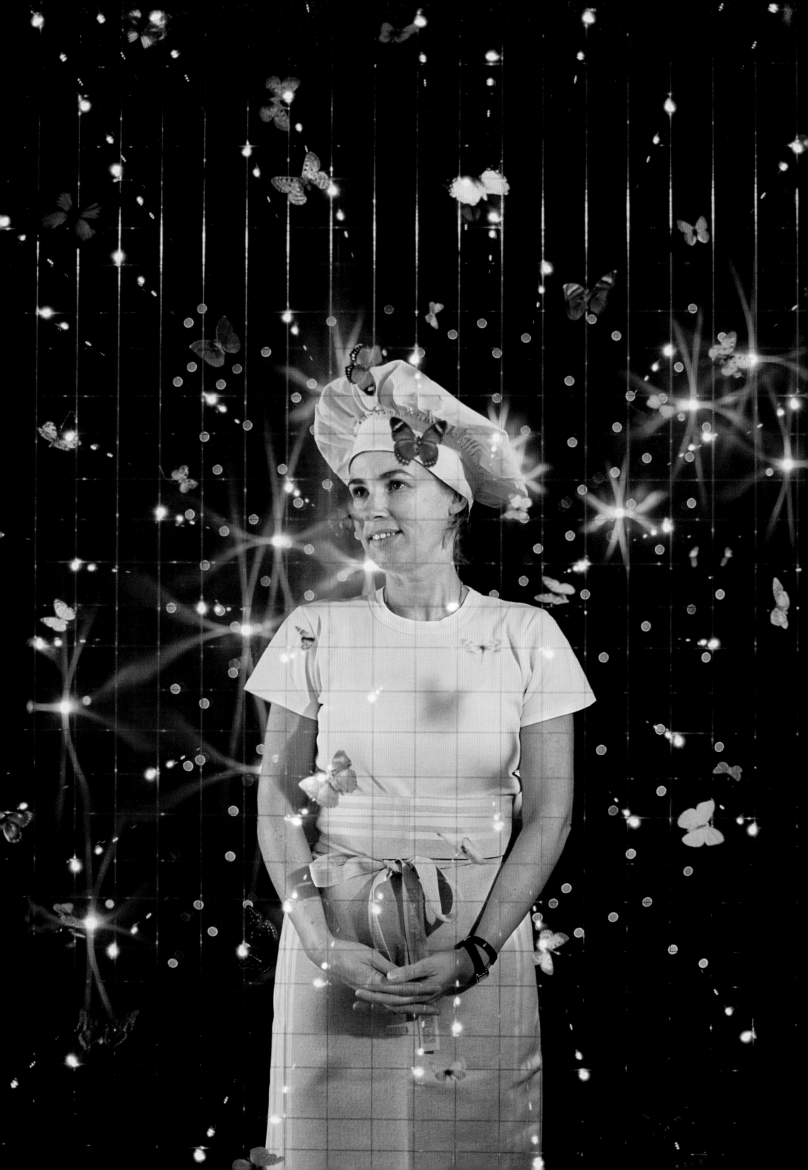

What would be your last meal on earth? *It would be a simple dish, a slice of toasted country bread, some olive oil, shaved black truffle, rock salt, and black pepper.* What would be the setting for the meal? *It would be under a very big oak tree or banyan tree.* What would you drink with your meal? *Tequila! I'm just kidding. I'd have a great bottle of red bordeaux.* Would there be music? *The sounds of nature would be enough, the wind moving through the branches and maybe the sound of the birds.* Who would be your dining companions? *I would like to be surrounded by the people I love.* Who would prepare the meal? *It is a very simple and amazing meal. I would like to prepare it myself, for the pleasure of doing so one last time.*

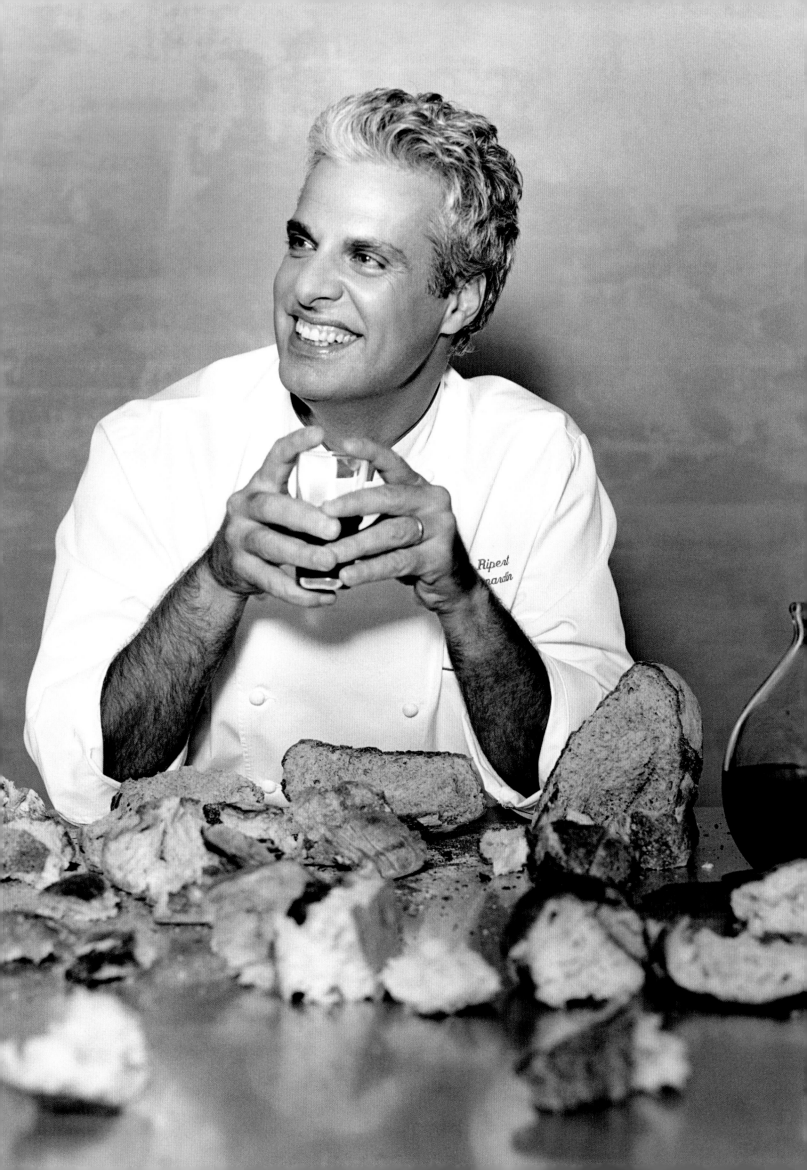

— Giorgio Locatelli —

What would be your last meal on earth?
My last meal on earth would be something simple and fresh — grilled mackerel and broccoli with chili and garlic.

What would be the setting for the meal?
A beach in Sicily, at sunset, with a bonfire.

What would you drink with your meal?
I'd have a bottle of Planeta Cometa 1994.

Would there be music?
My wife, Plaxy, and her friend Antonia would sing for the night, as long as they made sure to include "Silly Games" by Janet Kay.

Who would be your dining companions?
Lots of friends and family. I'd have a big party on the beach under the stars. What could be a better send-off?

Who would prepare the meal?
Vittorio from Vittorio's in Porto Palo would hold court over the barbecue, and he'd cook as he always does, in his underwear.

WHO WOULD BE YOUR DINING COMPANIONS?

*My dining compani
who keep kosher, as
see people with diet
enjoying food they w
allowed to eat.*

s would be people
is my final wish to
restrictions
uldn't normally be

What would be your last meal on earth?

Wild blowfish sashimi with liver; grilled live matsuba crab; fried blowfish cheeks; grilled shirako risotto with white truffle; clear blowfish soup with temomi somen noodle; and blowfish-testicle pudding with thousand-year-old balsamic vinegar.

What would be the setting for the meal?

I would like to eat on a boat.

What would you drink with your meal?

Bowmore single-malt poured over a ball of glacier ice.

Would there be music?

Live Mozart, possibly with Mozart himself coming back to perform.

Who would prepare the meal?

I would prepare the meal myself, or a rabbi could prepare the meal.

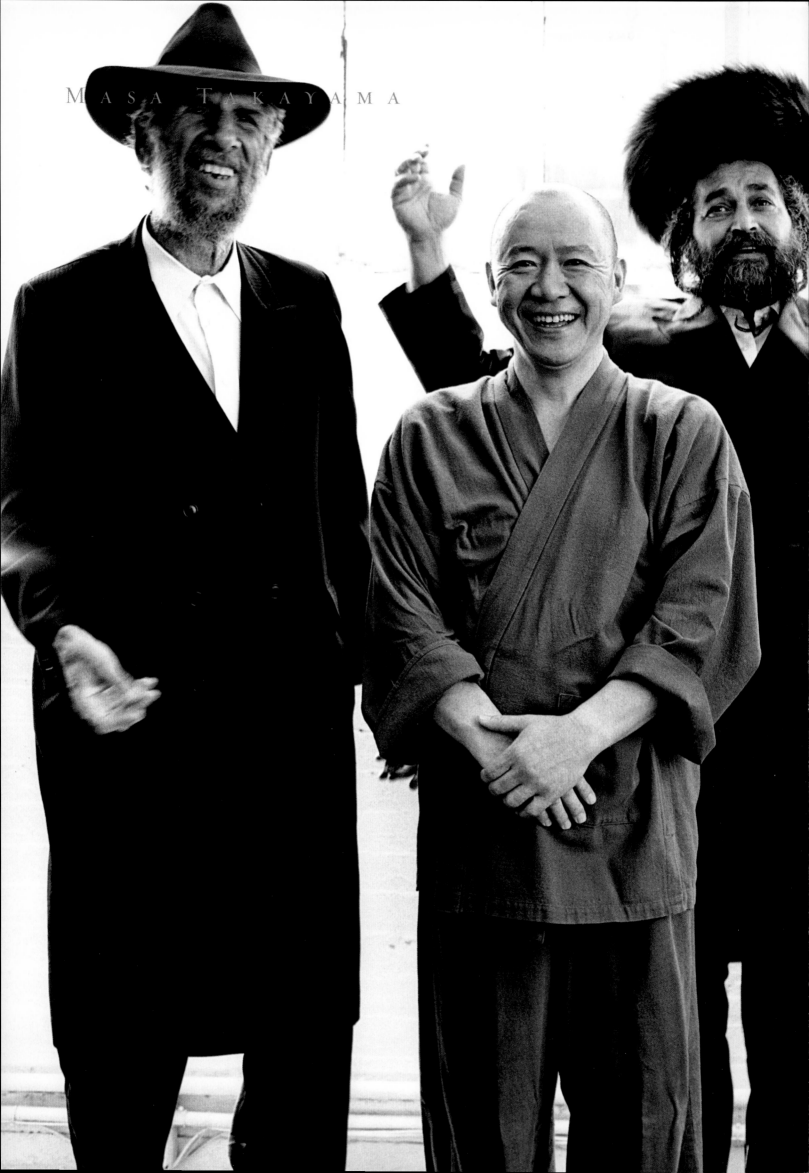

MASA TAKAYAMA

— ELENA ARZAK AND
JUAN MARI ARZAK —

❧

What would be your last meal on earth?

ELENA: My main course would be a whole merluza (hake) fish, caught locally just moments before and then lightly grilled. Grilled txipirones (summer squid) with poached onion marmalade would accompany it, and afterward I'd cook potatoes with some truffles, which would give off an incredible aroma. I would definitely finish with lots of good 70 percent cocoa chocolate.

JUAN MARI: I want to have as many tastes as possible before I go, so my last meal on earth would feature many different dishes. I would start with flor de huevo y tartufo en grasa de oca con txistorra de dátiles (a flower of egg and tartufo in goose fat with chorizo and dates). Then I would have a dish called lomo de merluza en salsa verde con almejas (hake with a green salsa and clams). A local San Sebastian fisherman would have just pulled the fish from the sea. I would also like to have one of the forbidden birds, either a becada or an ortolan. I would end with the fromage blanc that we make at Restaurant Arzak.

What would be the setting for the meal?

ELENA: We would sit down in the kitchen for dinner, my favorite meal, around nine o'clock.

JUAN MARI: The setting would be the kitchen at Restaurant Arzak.

What would you drink with your meal?

ELENA: A local Basque white wine called txakolí. We always drink it on special occasions; it reminds me of my life, good moments, and grand events.

JUAN MARI: Ten glasses would surround my place setting so that whenever I wished for a certain taste, it would be there. From left to right, the drinks would be sherry, amontillado, blanco, txakolí, Tinto Rioja Alavesa 2005, Tinto Rioja Alavesa 1940 to 1950, champagne, Pedro Ximénez, beer, and Coca-Cola. There wouldn't be any water. I don't like water.

Would there be music?

ELENA: I'd listen to "La Marcha de San Sebastián" by Raimundo Sarriegui.

JUAN MARI: During the meal, there wouldn't be any music as it distracts me. However, while I am dying I would like to hear the Orfeón Donostiarra chorus being conducted by Nicola Sani.

Who would be your dining companions?

ELENA: My family, but other people would stop by to say hello and possibly join us. I love an impromptu meal with people stopping by, especially when you have known them for years, like your local fisherman.

JUAN MARI: My daughter Elena and I would enjoy the meal together with the family.

Who would prepare the meal?

ELENA: I would prepare the meal, and only at the last moment. The taste is not the same otherwise.

JUAN MARI: My daughter Elena and I would prepare the meal together because we understand the way each other cooks.

❧

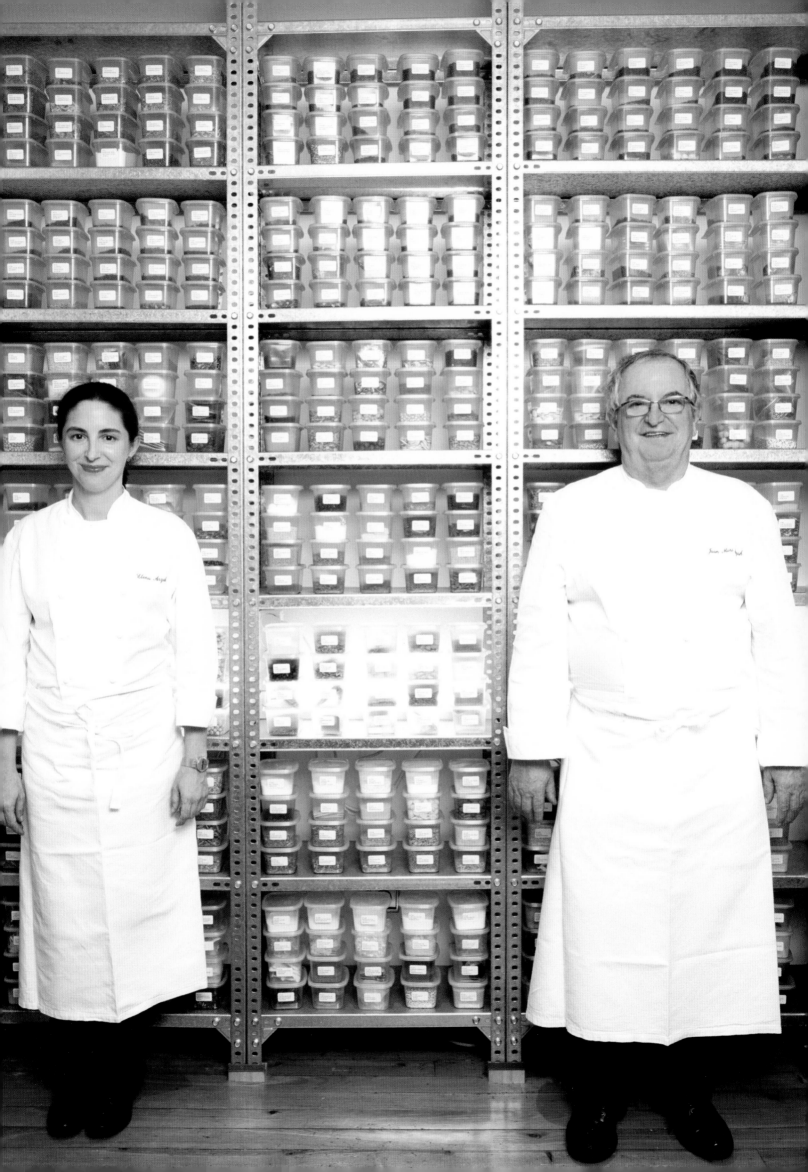

WHO WOULD PREPARE THE MEAL?

∞

*I would cook this m
the pleasure of cook
cook without thinki
cost, profitability, a
satisfaction.*

∞

myself, cherishing
for so few, and to
about timing, food
customer

What would be your last meal on earth?

The Last Supper idea is so intimidating and so personally ironic because I'm constantly telling my staff, "It's not the Last Supper, for Christ's sake!" when they become paralyzed by their perfectionism and anal-retentive ways. And now I find myself paralyzed by the question. I think the correct response to imagining one's last meal is to grab at one last chance to have all those super deluxe items that are only trotted out during life's most special occasions. Even so, I think my preference is one last visit with the foods that have accompanied me throughout my whole life: eggs, salt, bread, butter. I seriously think I would like a couple fat spoonfuls of fish eggs — it could even be salmon roe; it doesn't have to be the finest beluga — and a few crisp, cold, spicy radishes, followed by a plate of warm, soft-scrambled eggs with sea salt and cracked black pepper and chopped fresh parsley. Last, but not least, buttered, yeasty toast and a handful of good ripe cherries.

What would be your last meal on earth?

My last meal would consist of a plate of sliced San Daniele prosciutto with some ripe black figs; linguini with white clam sauce; a plate of Grana Padano; and perfectly ripe, juicy peaches.

What would be the setting for the meal?

The setting would be in my house overlooking the Adriatic, while the waves cracked against the rocky shore.

What would you drink with your meal?

I would have plenty of Bastianich wines. I would like to pair Bastianich Rosato with the prosciutto, Bastianich Vespa with the white clam sauce, and Morellino la Mozza with the Grana Padano.

Would there be music?

Sheherazade would be playing in surround sound.

Who would be your dining companions?

I would like my family and closest friends with me.

Who would prepare the meal?

I would cook with the assistance of my mother and children as we always do at home.

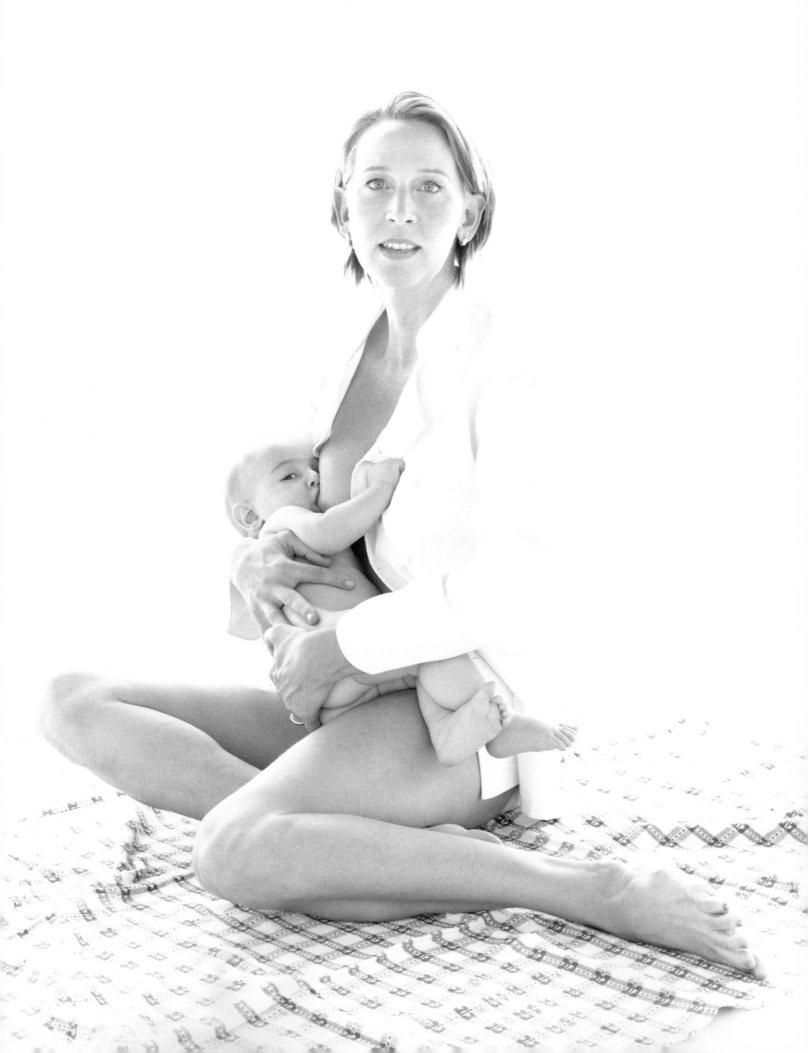

— L I D I A B A S T I A N I C H —

What would be your last meal on earth?
> My last meal would consist of a plate of sliced San Daniele prosciutto with some ripe black figs; linguini with white clam sauce; a plate of Grana Padano; and perfectly ripe, juicy peaches.

What would be the setting for the meal?
> The setting would be in my house overlooking the Adriatic, while the waves cracked against the rocky shore.

What would you drink with your meal?
> I would have plenty of Bastianich wines. I would like to pair Bastianich Rosato with the prosciutto, Bastianich Vespa with the white clam sauce, and Morellino la Mozza with the Grana Padano.

Would there be music?
> Sheherazade would be playing in surround sound.

Who would be your dining companions?
> I would like my family and closest friends with me.

Who would prepare the meal?
> I would cook with the assistance of my mother and children as we always do at home.

myself, cherishing
for so few, and to
about timing, food
customer

The Last Supper idea is so intimidating and so personally ironic because I'm constantly telling my staff, "It's not the Last Supper, for Christ's sake!" when they become paralyzed by their perfectionism and anal-retentive ways. And now I find myself paralyzed by the question. I think the correct response to imagining one's last meal is to grab at one last chance to have all those super deluxe items that are only trotted out during life's most special occasions. Even so, I think my preference is one last visit with the foods that have accompanied me throughout my whole life: eggs, salt, bread, butter. I seriously think I would like a couple fat spoonfuls of fish eggs — it could even be salmon roe; it doesn't have to be the finest beluga — and a few crisp, cold, spicy radishes, followed by a plate of warm, soft-scrambled eggs with sea salt and cracked black pepper and chopped fresh parsley. Last, but not least, buttered, yeasty toast and a handful of good ripe cherries.

— GABRIELLE HAMILTON —

∞

What would be the setting for the meal?

My most cherished meals have been seaside, on vacation, in that grayish-blue hour of dusk. It's very hard for me to eat during the heat of the day or the heat of service. Because I've spent my entire life deep in ruthlessly noisy and relentlessly hot restaurant kitchens during mealtime — when the rest of the world eats, I work — I love to be alone during my meals, silent, and outdoors in the fresh air. And I have a real thing with the ocean. There is something about being one-on-one with the ocean just after the sun has set — the vast expanse of bright dusky sky before you — that makes me feel like I am a good person with a pure heart. Plus, I have a fierce appetite at that hour. After a long day in the sun, and a cool shower, changed into a white cotton T-shirt and with a healthy little sunburn, I can ravage a bottle of champagne and some salty food with remarkable gusto. Actually, that would be the real requirement of my last supper: that I have a perfect appetite, a good healthy hunger, not the shaky, wired, "I've waited too long and now I'm starving" kind nor a wishy-washy peckishness.

What would you drink with your meal?

The splurge I would make is that I would drink endless Billecart-Salmon rosé champagne, probably two bottles all by myself, because I could drink that stuff from the minute I wake up in the morning until I died that night.

Would there be music?

I'd want the sound of the waves and nothing else.

Who would be your dining companions?

The dining-companion question is tricky, as I would love to have my last supper with my children, enjoying them, enjoying feeding them. I really love it when Marco (who's two) loves and eats what I cook, and I also love the perfect feeling when my boobs are brimming and Leone is very hungry and latches on with serious intention. When this works, it's blissful. But then I would really love for them to go away and fall deeply asleep so that I could eat quietly, contemplatively, and pretend that I was a single, younger person without intense, bone-crushing responsibilities. Somehow, part of my fantasy about this last meal includes me traveling back in time to those carefree days when I was sans employees, children, or saggy boobs!

∞

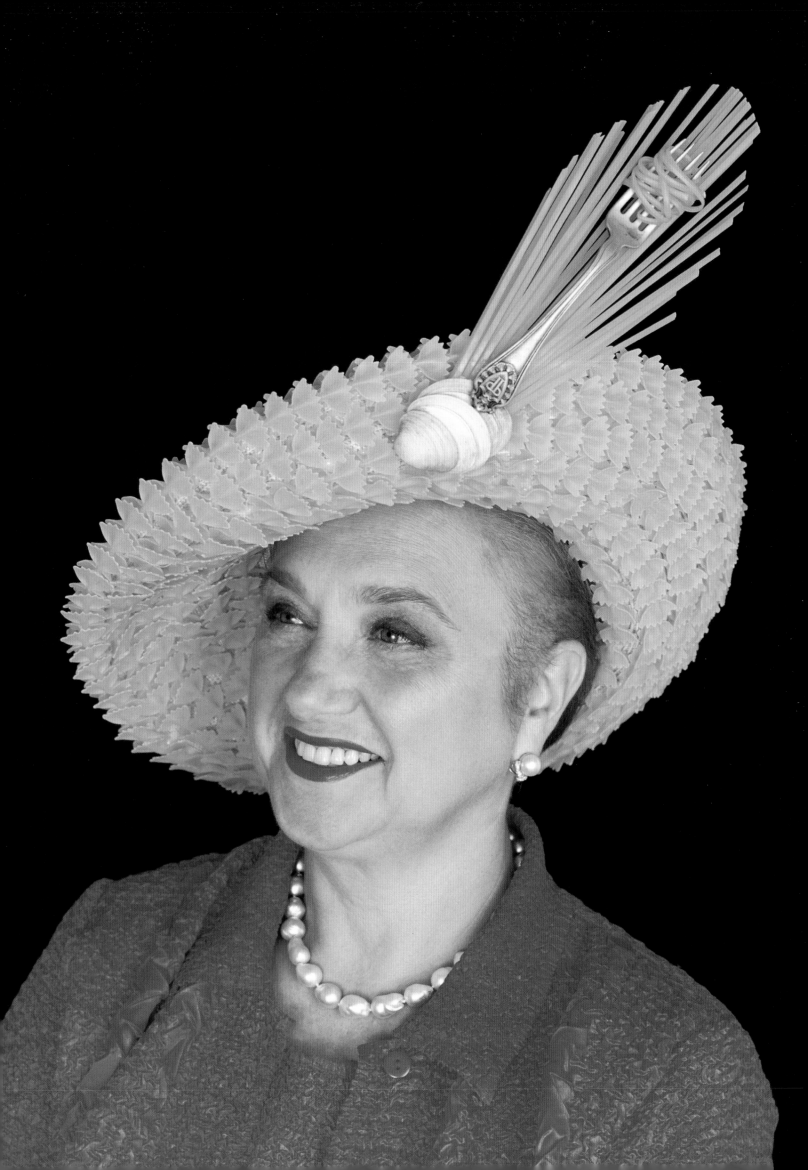

— DAN BARBER —

❧

What would be your last meal on earth?
Rack of Boris, with a salad of ears, wattle, cheeks, etc. If I'm going, so is Boris.

What would be the setting for the meal?
An American pastoral — a large, open field as the sun sets. I've always wanted to sit in one of these scenes alone, staring out at the fading light, but it always seemed too precious and corny. But for this, my last dance, I wouldn't much care what people think.

What would you drink with your meal?
I would have wine, for sure; probably a big amarone in order to go out with a bang.

Would there be music?
Gregorian chants, played very loud, as that's what my father blasted through the house every Sunday in the late afternoon. The combination of the end of the weekend, homework, and the chants was enough to make me wish for death. I imagine if I heard them again, alongside my last bites, I wouldn't feel so anxious about moving on...

Who would be your dining companions?
No companions. I'm too long-winded at good-byes.

Who would prepare the meal?
Me. I'd have one final chance to get it right.

❧

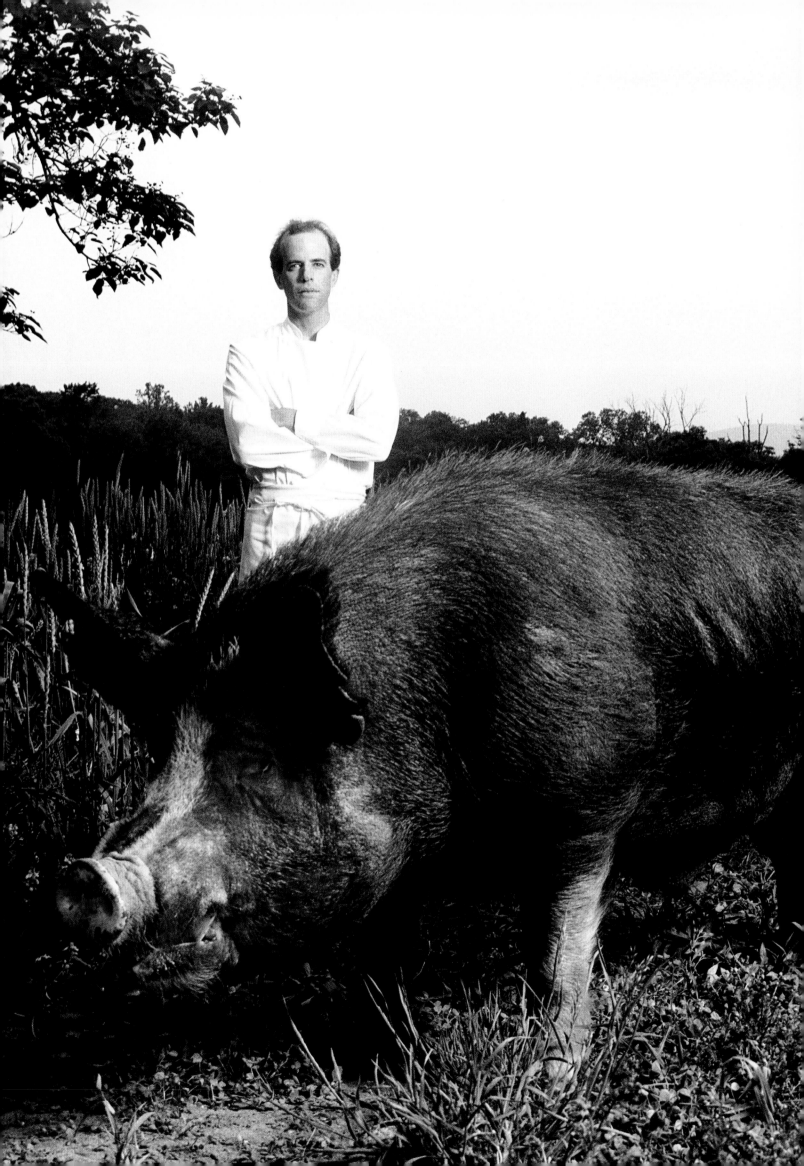

What would be your last meal on earth?

My dish would be an English roast lunch — a one-dish wonder, and pretty comforting for me. It would have to have some roast beef, with two kinds of potatoes; some roasted in hot duck fat, and some mashed ones too. Also, some lovely boiled carrots tossed in butter, or even better, cooked in butter with lots of sea salt. Caramelized brussels sprouts, again with massive amounts of butter, crispy roast parsnips with black pepper, and pan juices from the beef would be nice too. I'd have a slab of banoffee pie for dessert, which is a pie with bananas, dulce de leche cream, and grated chocolate. (Note: I don't eat this way all the time!)

What would be the setting for the meal?

I would like to be in a pub where there are a few oak trees — very English! Or maybe on a plane that has a kitchen (do these exist?), so I could fly over England with my family and my other half and look down at the countryside.

What would you drink with your meal?

I would maybe drink a 1998 Sassicaia. I remember this being awesome when drinking it in Rome; it was one of the first wines to blow me away. And maybe a few coldies to finish.

Would there be music?

Music — wow, that is hard. A little Nancy Griffith, Alison Krauss, Kate Bush, and some Fleetwood Mac, Eagles, and Ben Watt. It would be fun to just mix it up while drinking the coldies. This is kind of spooky; it feels like I'm writing my will.

Who would be your dining companions?

I'd like to be with my friends, my family, and my other half.

Who would prepare the meal?

I would love my friend Pete Begg to cook. He is the best!

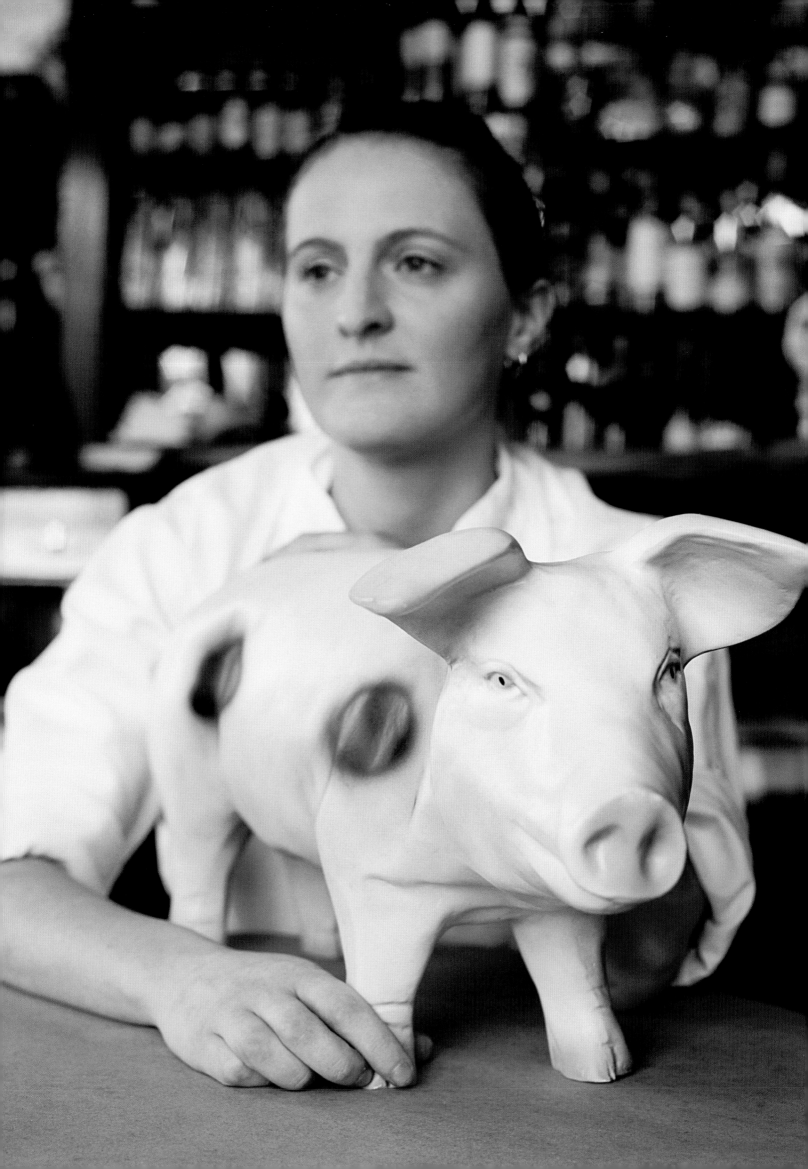

WHO WOULD PREPARE THE MEAL?

I would like all the Laundry and Bouch final meal.

fs from the French
to prepare my

What would be your last meal on earth?

I would begin with a half kilo of osetra caviar, followed by some otoro. I would then have a quesadilla, followed by a roast chicken, and finally, brie with truffles. For dessert I would choose to have either profiteroles or a lemon tart.

What would be the setting for the meal?

I would want to eat my last meal at home in Yountville, California, and in New York City.

What would you drink with your meal?

I would start out with a 1983 Salon champagne, followed by a Ridge Lytton Springs zinfandel. I would end with a twenty-five-year-old Macallan scotch.

Would there be music?

I would listen to the compilation of music that is played at Ad Hoc, our restaurant in Napa Valley.

Who would be your dining companions?

Laura Cunningham, my brothers, my sister, and my father.

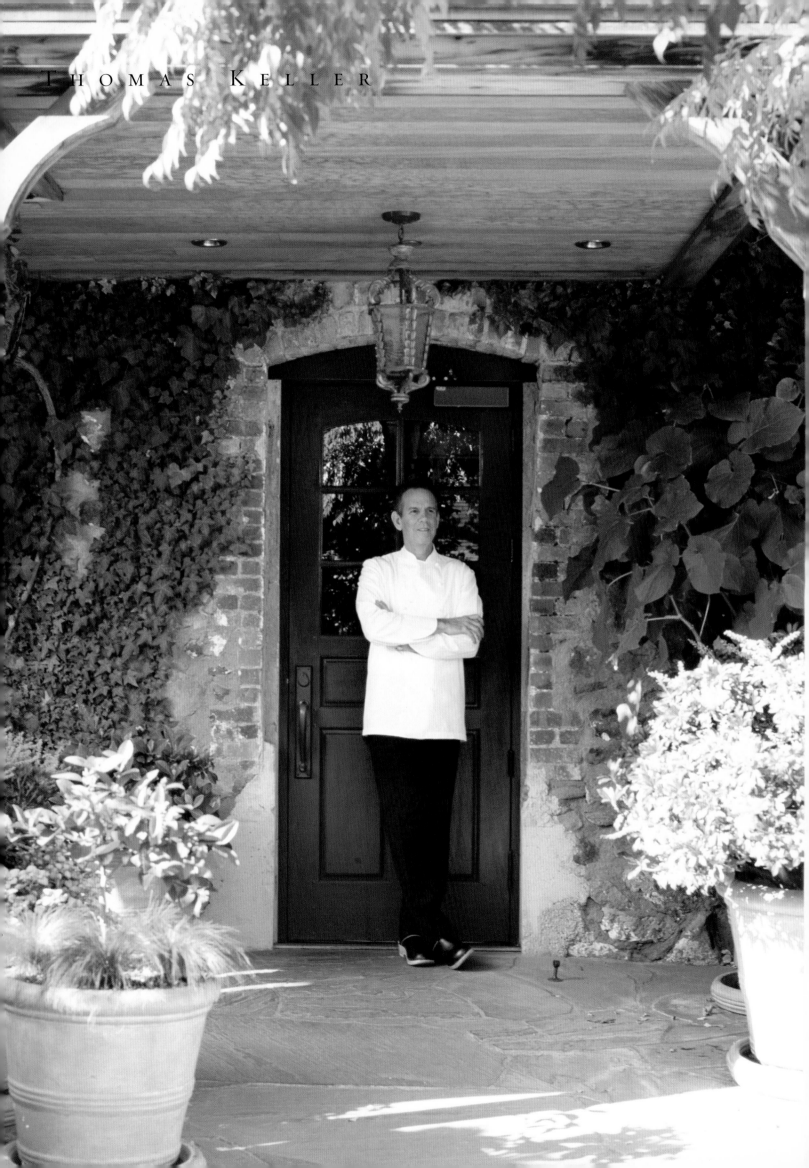

THOMAS KELLER

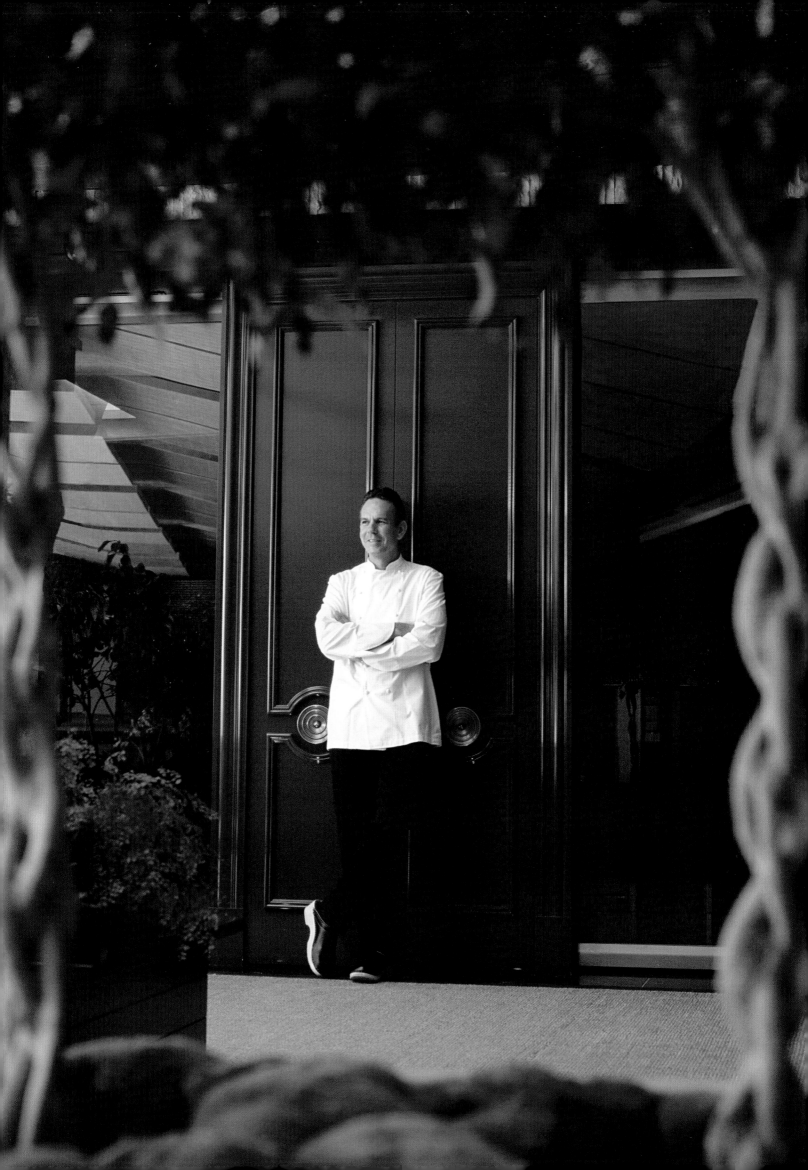

What would be your last meal on earth? *I would have a classic roast dinner — roast beef with Yorkshire pudding and red wine gravy.* What would be the setting for the meal? *Definitely my home in South London.* What would you drink with your meal? *Bâtard-Montrachet.* Would there be music? *I would listen to Keane's first album,* Hopes and Fears. Who would be your dining companions? *My family: my wife, Tana, our four children, and my mum, Helen.* Who would prepare the meal? *I would prepare it with Tana, and the children like to help out too.*

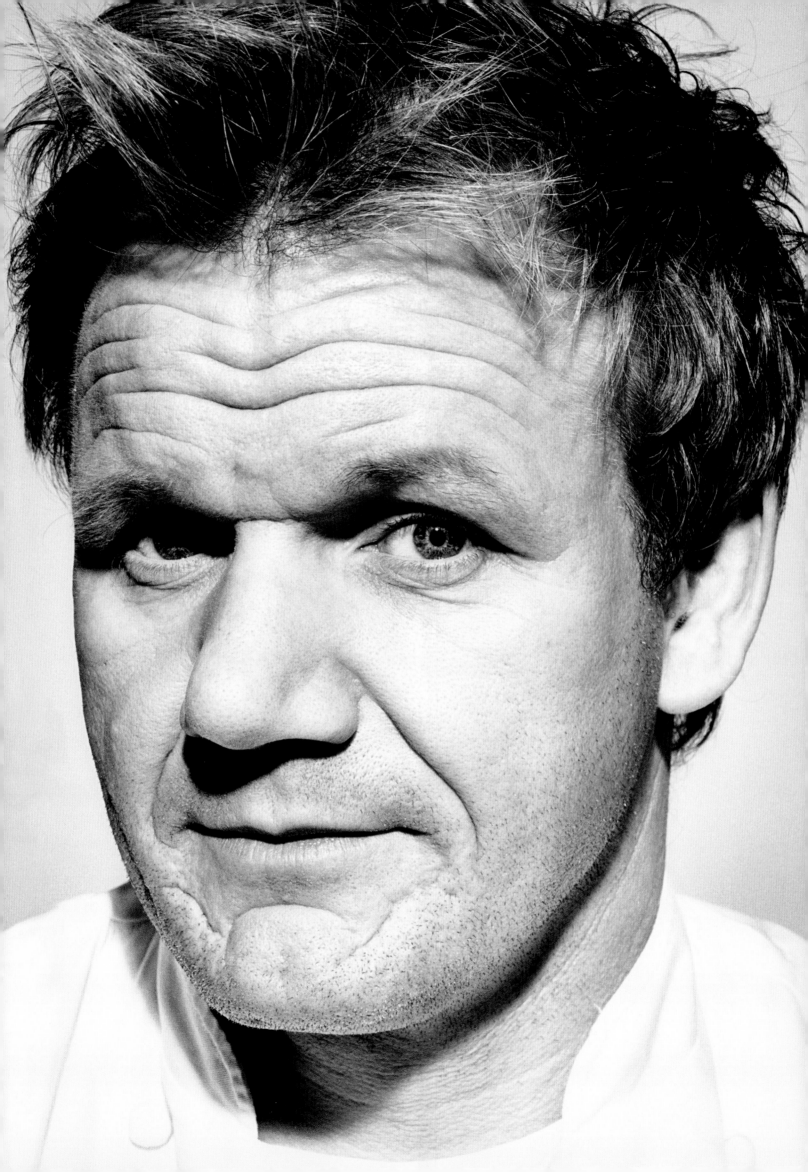

WHAT WOULD BE YOUR LAST MEAL ON EARTH?

❧

*My last meal on ear
long, drawn-out, an
multicourse feast.*

would have to be a electable

I would want the people who created the favorite dishes of my life to prepare miniature versions for me. Since this is the grand finale, I'd want to slow down and taste every morsel. I tend to get excited and eat too quickly (as chefs learn to do out of necessity), but for this meal, I'd want to savor every bite. I would have a dozen perfect, chilled oysters—six Island Creek and six Kumamoto, both with lemon—followed by a tin of golden osetra caviar atop crème fraîche and my mom's potato pancakes. I'd have asparagus served just how I ate it in a tapas restaurant in San Sebastián, Spain: fat and earthy, room-temperature, and topped with a frothy garlic and lemon aioli—absolutely perfect. And sorry animal activists, but this is my dream meal, so next would be braised foie gras from Alain Ducasse, like I ate at his restaurant in Monaco, topped with a ton of fresh shaved summer truffles and duck jus. Then Gary Danko's poached lobster. I don't know whether it was eating it alongside my husband and being in utter ecstasy, or just the lobster itself, but it was damn good! I would definitely have some of my momma's amazing lasagna, just a little tiny piece, which she layers with an awesome Bolognese filled with spicy sausage and creamy béchamel, and reggiano and pecorino cheese. It's been my birthday favorite ever since I can remember. And perhaps it's mundane, but it's my dream—a slice of steak from Peter Luger's! Sushi from Masa would cleanse my palate and make me feel so uplifted, and since this is my last supper, who cares about the money! Last, but not least, a virtual carousel of pastries—amazing Miami pastry chef Hedy Goldsmith's interpretation of a s'more; Mom's upside-down pear cake; macaroons from Fauchon; anything made by Pierre Hermé, but hopefully something with chocolate; some Joe's Stone Crab key lime pie; and, finally, some of my own banana cream pie.

— MICHELLE BERNSTEIN —

What would be the setting for the meal?

> *I think the best place would be at home, not at the dining room table or anything, but just lounging about as if we were in Morocco, on pillows, comfortable and relaxed.*

What would you drink with your meal?

> *It depends on the course, but I'd like to include champagne, beer, and a chewy red wine.*

Would there be music?

> *Definitely, but I'm afraid that I would jump up and down and spin around too much if it were live, so I think it would have to be recorded. I love Maná, U2, Sting, and anything by Cole Porter.*

Who would be your dining companions?

> *My husband, my close family, and my in-laws.*

Who would prepare the meal?

> *The chefs above — oh, and Mom! But Mom would have to make sure she was done cooking her part way before the meal began because I'd want her to sit and enjoy the whole dinner!*

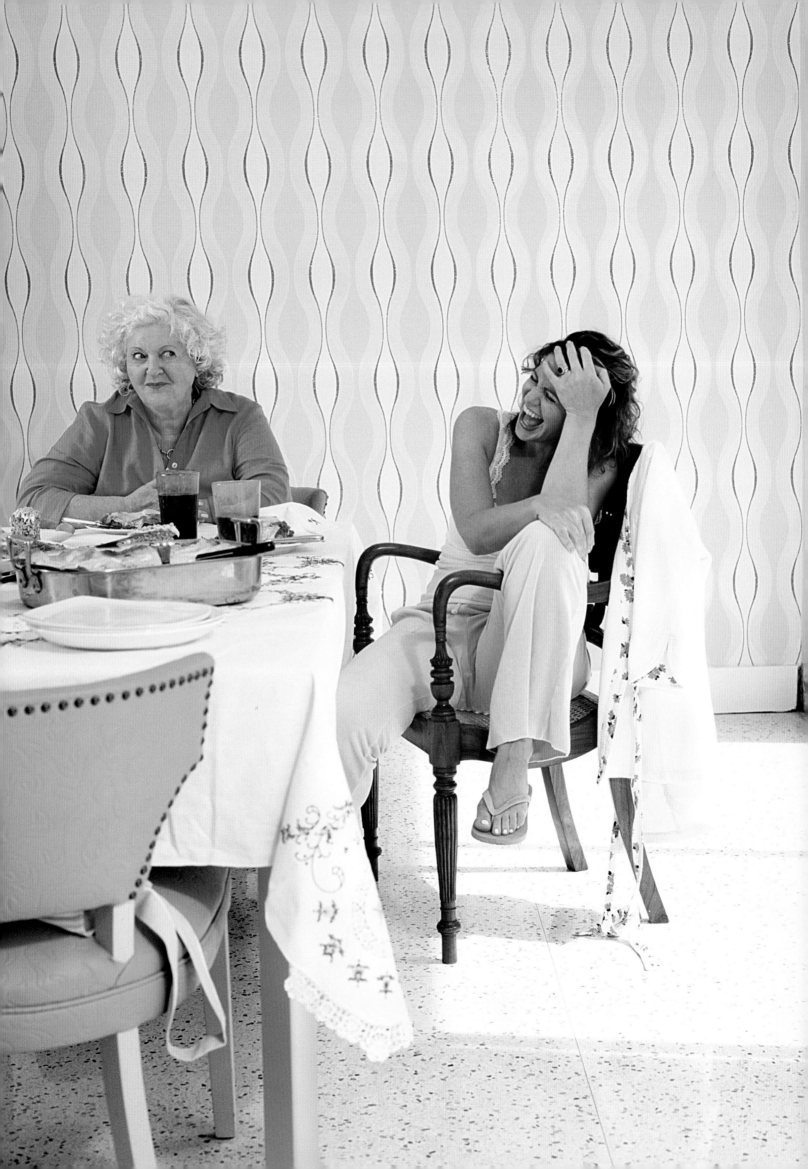

— MARCUS SAMUELSSON —

What would be your last meal on earth?

I would like to go out in a calm and chilled way, with good people and good conversation surrounding me. I want to embody the fact that I have lived a great life, full of rich experiences, and to grab at what's left while I can. The food is not that important. I would eat some gravlax with crisp bread accompanied by dill mustard sauce. Then I would have some sushi, nigiri-style, with soy sauce, ginger, and wasabi.

What would be the setting for the meal?

I would like to sit as close to the water as possible, and at a low table. It would all take place in the early evening.

What would you drink with your meal?

Red wine, but it doesn't have to be super fancy. I would end with some honey wine from Ethiopia.

Would there be music?

Miles Davis would perform live.

Who would be your dining companions?

I would choose to be with my family, and the people who have been important to me. I would also like to include Martin Luther King and Gandhi.

Who would prepare the meal?

I would.

What would be your last meal on earth? *My last meal on earth would definitely be sushi. I would get two pieces each of (in this order) whitefish sushi, tuna sushi, shad sushi, red clam sushi, sea urchin sushi, and sea eel sushi. Then I would finish with a cucumber roll.* What would be the setting for the meal? *In one of my restaurants, sitting at the sushi bar.* What would you drink with your meal? *Green tea.* Would there be music? *Kenny G on CD.* Who would be your dining companions? *My wife and family.* Who would prepare the meal? *One of my sushi chefs.*

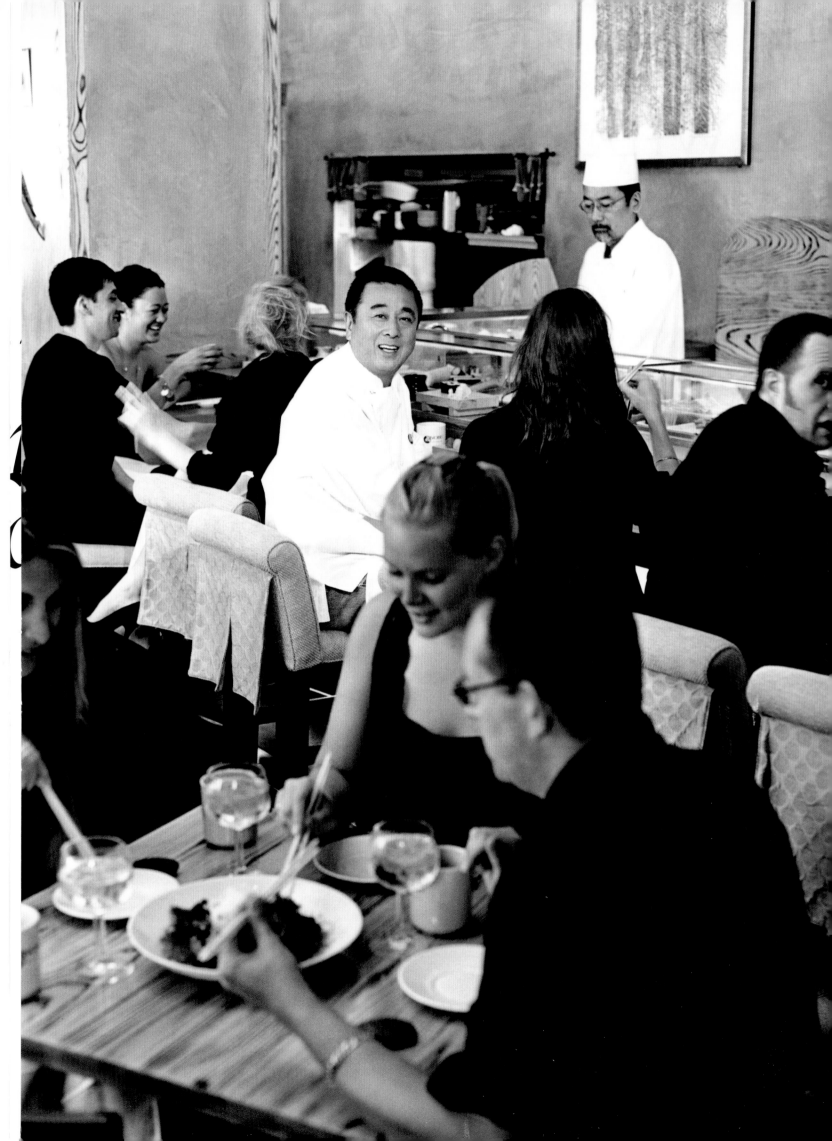

GARY DANKO

Would there be music?

Enchanting music would seduce the soul and make the mood very surreal. It would be a mixture influenced by Persian, Indian, Middle Eastern, and Turkish sounds, and also the softer sounds of meditation and healing, like Rasa Mello II by Donna D'Cruz, for example.

Who would be your dining companions?

Assuming this is all fantasy, the guests, living and deceased, would include: one hundred-plus of my outrageous friends, including my partner, Greg Lopez; Hunt Slonem, a New York artist; John Kennedy Jr. and Jacqueline Kennedy Onassis; Alfred Hitchcock; Madonna (but she would have to be eating meat that night); Princess Grace; Rock Hudson; Audrey Hepburn; Tom Ford; Cher; Maria Manetti Farrow; James Beard; Pablo Picasso; Andy Warhol; Jackson Pollock; Bill Clinton; Martha Stewart; Sharon Stone; Andrew Lloyd Webber; Elton John; Ben Harper; Carlos Santana; Sting; Van Morrison; and Gertrude Stein. Robert Parker and Thomas Jefferson would be invited, as well, because of their love of wine.

Who would prepare the meal?

Each course would be prepared by an expert in their field.

GARY DANKO

What would you drink with your meal?

A team of sommeliers would orchestrate the following wines: Champagne, Krug, Krug Collection 1947 Nebuchadnezzar; Riesling Auslese, Schloss Rheinhartshausen, Erbacher Bruhl, Rheingau, Germany, 1949 Rehoboam; Montrachet, Grand Cru, Ramonet, Burgundy, France, 1986 Salmanazar, and Domaine de la Romanée-Conti, Burgundy, France, 1989 Salmanazar; Romanée-Conti, Grand Cru, Domaine de la Romanée-Conti, Burgundy, France, 1978 and 1985 Salmanazars; Côte-Rôtie, Guigal, La Mouline and La Landonne, Northern Rhone Valley, France, 1978 Methuselahs; Barbaresco, Gaja, Piedmont, Italy, 1985 Salmanazar; Cabernet Sauvignon, Heitz, Martha's Vineyard, Napa Valley, California, 1974, Salmanazar, and Harlan Estate, Napa Valley, California, 1994 Methuselah; Pauillac, Château Latour, Bordeaux, France, 1928 Salmanazar; Saint-Émilion, Château Cheval Blanc, Bordeaux, France, 1947 Balthazar; Riesling Trockenbeerenauslese, J. J. Prüm, Wehlener Sonnenuhr, Mosel-Saar-Ruwer, Germany, 1971 Magnum; Vintage Port, Taylor, Duoro Valley, Portugal, 1935 Magnum.

[Rehoboam — 4.5 liters (6 bottles); Methuselah — 6 liters (8 bottles); Salmanazar — 9 liters (12 bottles); Balthazar — 12 liters (16 bottles); Nebuchadnezzar — 15 liters (20 bottles)]

would be a staged
ic banquet
od the world had

The best of everything would be gathered from the corners of the world and served from tableside carts to lounging guests. Circling around would be caviar atop buckwheat blinis, cooked to order from a caviar cart. A roasted Bleu Bresse, a homegrown version of France's mythical poulet de Bresse, would be wheeled into the dining room and displayed like a trophy before being carved. Spit-roasted suckling pigs, and black truffles wrapped in thin slices of salt pork, would circle the tables as well. Like Roman and Greek banquets, the food would be eaten by hand—scooped up with the finest breads from around the world. An orgy of food and consumption, this delicious and awesome festival would serve as a respite from human civility.

What would be the setting for the meal?

This Hollywood set of an ancient culture would be somewhere like a lakeside palace in Udaipur, in northwestern India. We'd sail across the lake on gondolas, approaching the palace in the fading light of sunset, disembark, and then set the gondolas adrift into the peaceful water. A sense of the surreal and the glorious would permeate everything. The palace's rooms—massive tents, really—are grand in scale and would be divided into twenty semicircular alcoves. Each alcove would have a platform bed sheeted in the finest linen and covered with plush pillows. The floors would be carpeted in bold, rich silk, and the walls gilded in gold, royal blue, and rich browns. Jewel-toned silk drapes would flow from the high ceilings to the floor around each alcove. A large pool in the center would serve as the stage for the performances during and between courses by Cirque du Soleil, dancers, and eunuchs. All the guests at the meal would be served in the ancient fashion, while lying down on the spectacular beds.

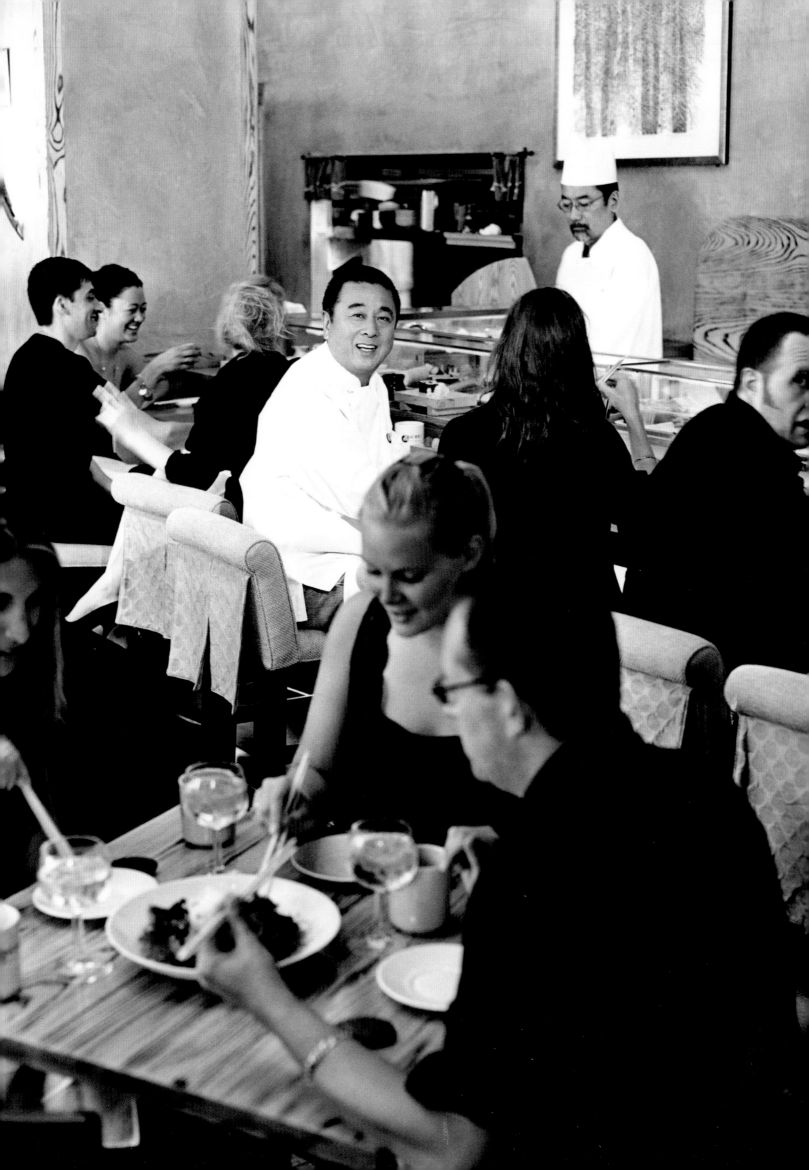

WHAT WOULD BE YOUR LAST MEAL ON EARTH?

*My last meal on ear[th]
feast, a sultry and e[xquisite?]
showcasing the fines[t]
to offer.*

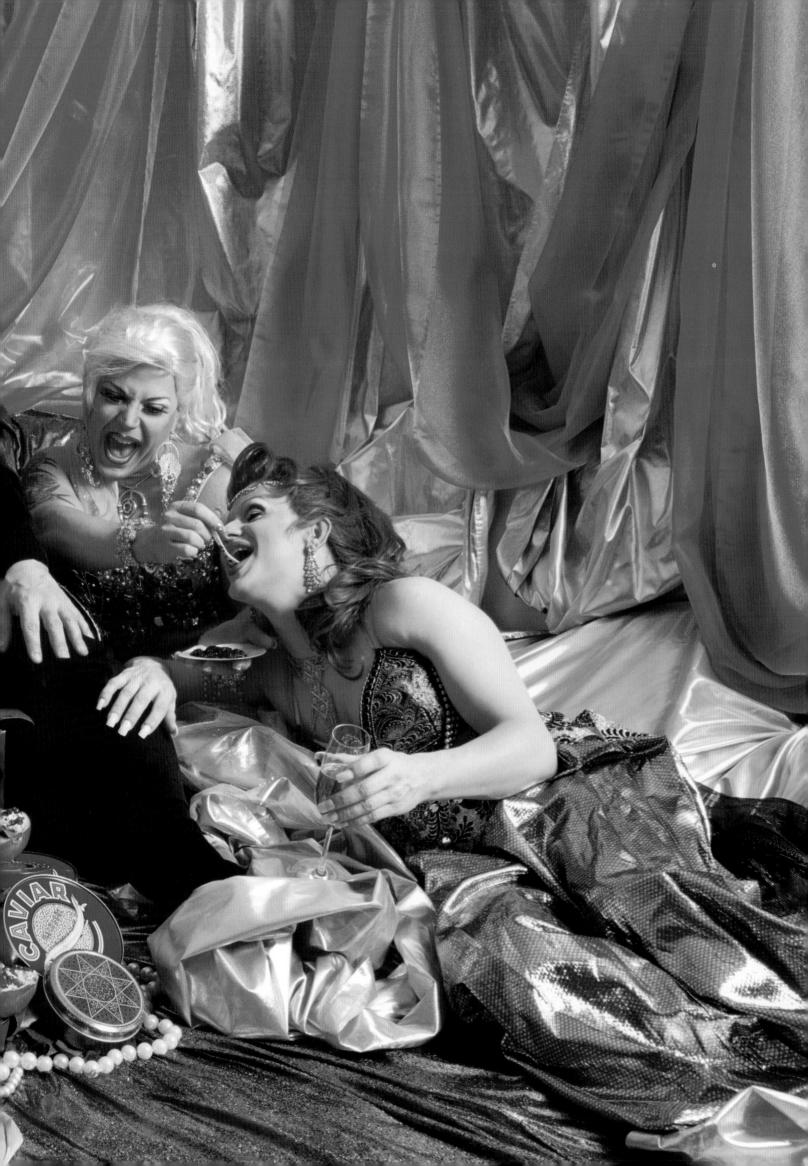

What would be your last meal on earth?

I would have eight or ten courses of magnificent seafood, pasta, and vegetables (including raw radishes with good oil and salt). The first course would be alici marinate, marinated anchovies served with a little bruschetta, paired with a bottle of stingingly cold Furore wine from winemaker Marisa Cuomo of Ischia. The next course would be succulent mozzarella en carozza, the Neapolitan version of a grilled cheese sandwich. You dredge fresh mozzarella di bufala in egg and then panfry it until the outside is crisp, while the inside oozes with hot mozzarella. Scialatielli ai gamberetti, fresh Amalfitana pasta with shrimp and zucchini, would follow. It is made of cake flour, milk, and pecorino, and has a particularly firm texture. The pasta is the only one found in the town of Amalfi, and it breaks all the rules about "no cheese with pasta." Stained green with basil, and cut a bit wider than fettucine but thinner than pappardelle, it represents everything I love about the city of Amalfi — a major sea power as far back as the eleventh century and home of the most beautiful duomo on the entire coast. The next course would be spaghetti alle cozze, hard pasta with spicy mussels. The finale to this shellfish extravaganza would be gamberoni all'acqua pazza, sautéed shrimp in a spicy fennel broth, and aragosta alla brace, grilled lobster with limoncello vinaigrette. I would finish with affogato al caffè, ice cream in a bath of chilled espresso, and baba al rum, a simple, yeasty sponge cake soaked in rum syrup. This would all be washed down with a sea of icy limoncello.

What would be the setting for the meal?

A small beachside trattoria on the Amalfi Coast, under a pergola of grapes.

What would you drink with your meal?

Lots of cold Fiano di Avellino.

Would there be music?

REM would play live with U2, and John McLaughlin would play acoustic with Paco de Lucía.

Who would be your dining companions?

My whole family, Joe Bastianich and his whole family, Tony Bourdain, Jim Harrison, Emeril Lagasse and his family, and the musicians and their families.

Who would prepare the meal?

The restaurant's chef — hopefully a sixty-something-year-old woman from the area.

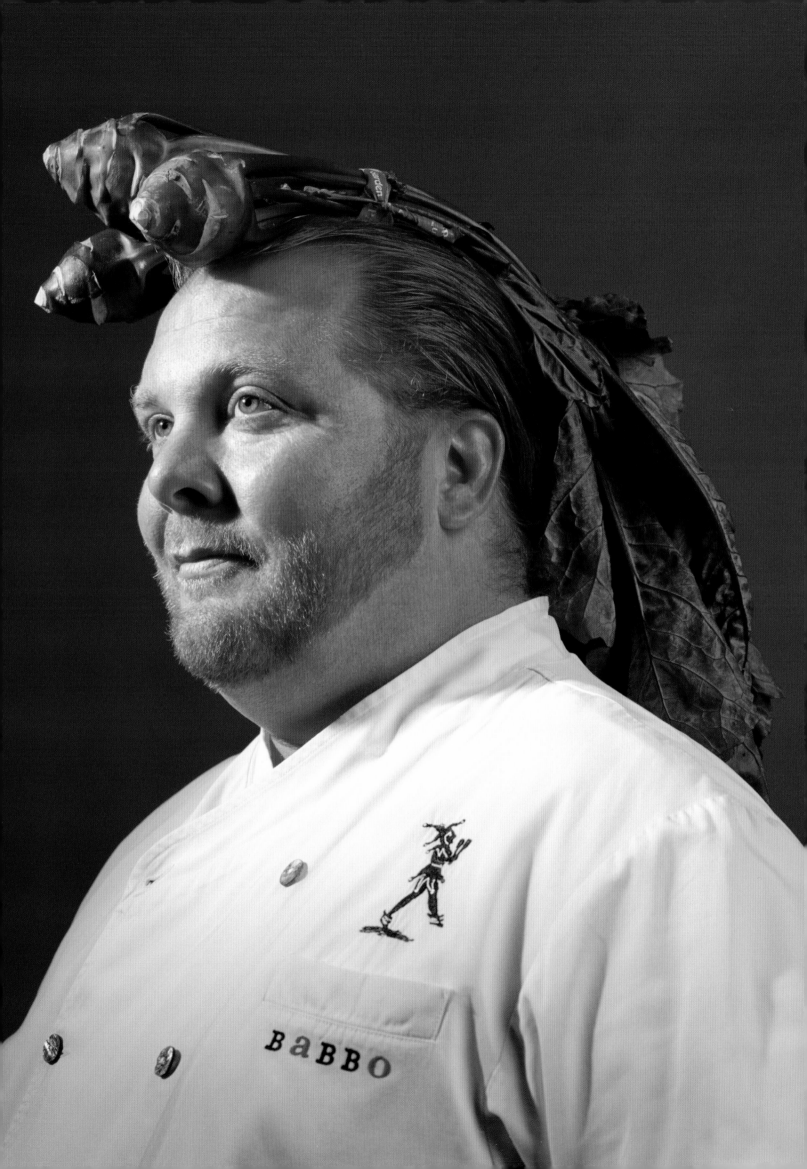

What would be your last meal on earth?

It would be something very simple that could be easily prepared, nothing too complicated or elaborate. Perhaps a first course of roasted foie gras, seasoned with course sea salt and cracked black pepper and then eaten out of the pan with some toasted sourdough. Next I would have seared Scottish scallops, seasoned in course sea salt and pepper, sautéed in a hot pan in the best olive oil money could buy, and served with sauce vierge. For the main course, either fresh Dover sole cooked in brown butter with capers, lemon juice, and parsley, or a beautifully aged piece of marbled, four-week-old beef, grilled or roasted in the oven till pink. I'd have a simple green salad on the side, with French dressing, and some thick-cut chips that have been cooked in duck fat and sprinkled with Malvern sea salt or fleur de sel. For dessert, either my mother's apple pie or her rhubarb crumble, topped with Bird's custard.

What would be the setting for the meal?

I would be in a field overlooking Tuscany or sitting in a lavender field, sunflower field, or fruit orchard in the French Riviera. The sun would be setting in the distance, warming my face and back, as I cooked over an open fire.

What would you drink with your meal?

Either a riesling or gewürztraminer, followed by a nice bottle of Château Margaux.

Would there be music?

Coldplay and Simon & Garfunkel.

Who would be your dining companions?

My girlfriend, family, and friends.

Who would prepare the meal?

Cooking is my love and life. If this is the last thing I get to do on earth, then I am going to have to do it myself.

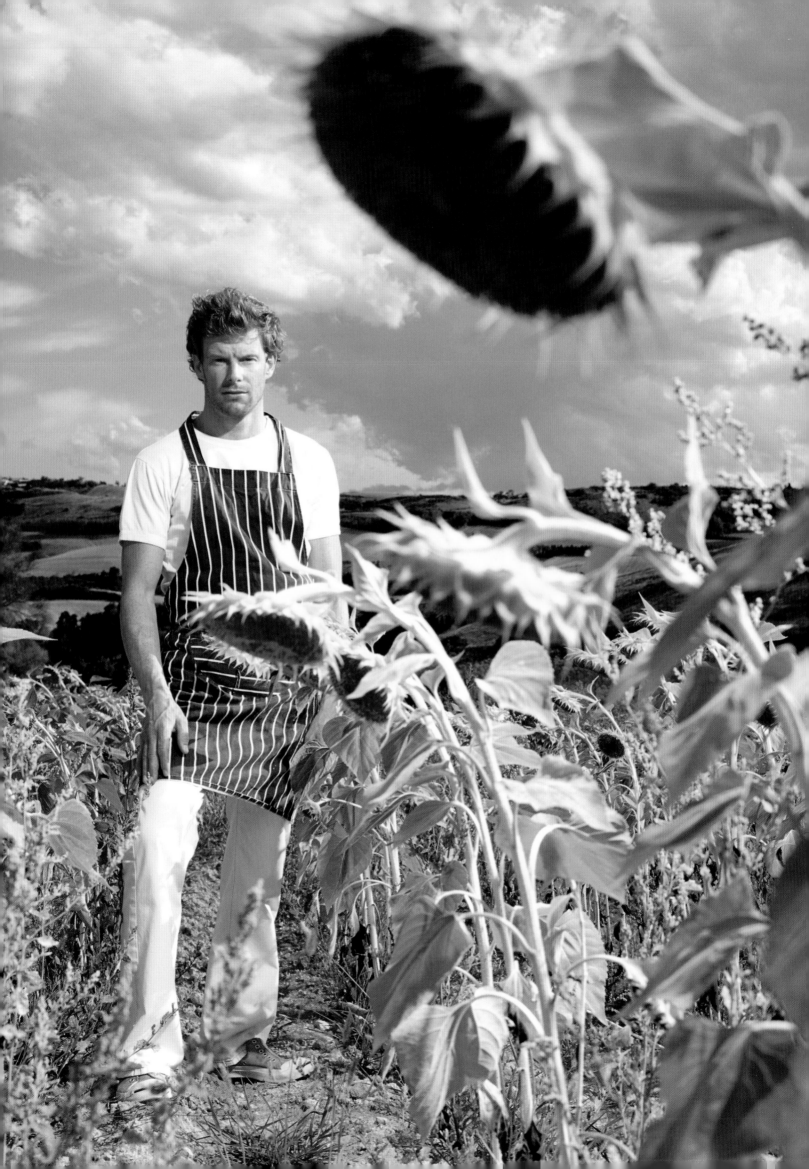

— JACQUES PÉPIN —

What would be your last meal on earth?

The menu for my last meal would be eclectic, relaxed, informal, and would go on for a very, very long time—years! I would eat all the things that I love in any order that I desired. I cannot conceive of anything better than the greatest baguette, deep golden, nutty, and crunchy, with a block of the sublime butter of Brittany and Bélon oysters. I would consume tons of the best beluga caviar with my wife, dispose of the best boiled ham and the most excellent Iberico ham, and would eat eggs cooked in butter, scrambled, mollet-style, or sunny-side up, with the ham. Roast squab with the tiniest and freshest peas would be part of the menu, along with a lobster roll and a perfect plump hot dog. I would gobble down tiny fingerling potatoes just out of the ground and sautéed in goose fat, along with a white escarole salad loaded with garlic and sprinkled with cracked pepper, just like my mother used to make. I would devour aged beaufort cheese that had a crystallized, salted surface, and fresh, white farm cheese covered with thick crème fraîche seasoned with chives, garlic, and cracked pepper. I would enjoy my friend Claude's pâté of pheasant (faisan) with black truffles and cognac, and super thin slices of salted lardo on thin, crusty farm bread covered with white truffles. I would eat roasted hazelnuts with bittersweet chocolate (giandujas), and the best apricots, cherries, and white and wine peaches, just off the tree. I would pile homemade apricot jam onto thin, buttery crêpes, hot from the pan and accompany them with a Bollinger Brut 1996 champagne.

What would be the setting for the meal?

These festivities would take place at my house.

What would you drink with your meal?

Bottles and bottles of fresh nouveau beaujolais, old red hermitage, and a grassy white sancerre would accompany the food, along with a few glasses of old bourbon, which I would sip very slowly to make last.

Would there be music?

We would play boules while listening to old French songs, classical music, and occasionally jazz like Dave Brubeck. We might also listen to Edith Piaf, Jacques Brel, and Nat King Cole, who would all alternate playing for us live.

Who would be your dining companions?

My family, a few close friends, and my dog, Paco, would stay until the end, while many other good friends would come by and have a few drinks, eat, and leave.

Who would prepare the meal?

We would cook, drink, and eat together until the end—weeks or months later—when I would die from the péché de gourmandise (sin of gluttony)!

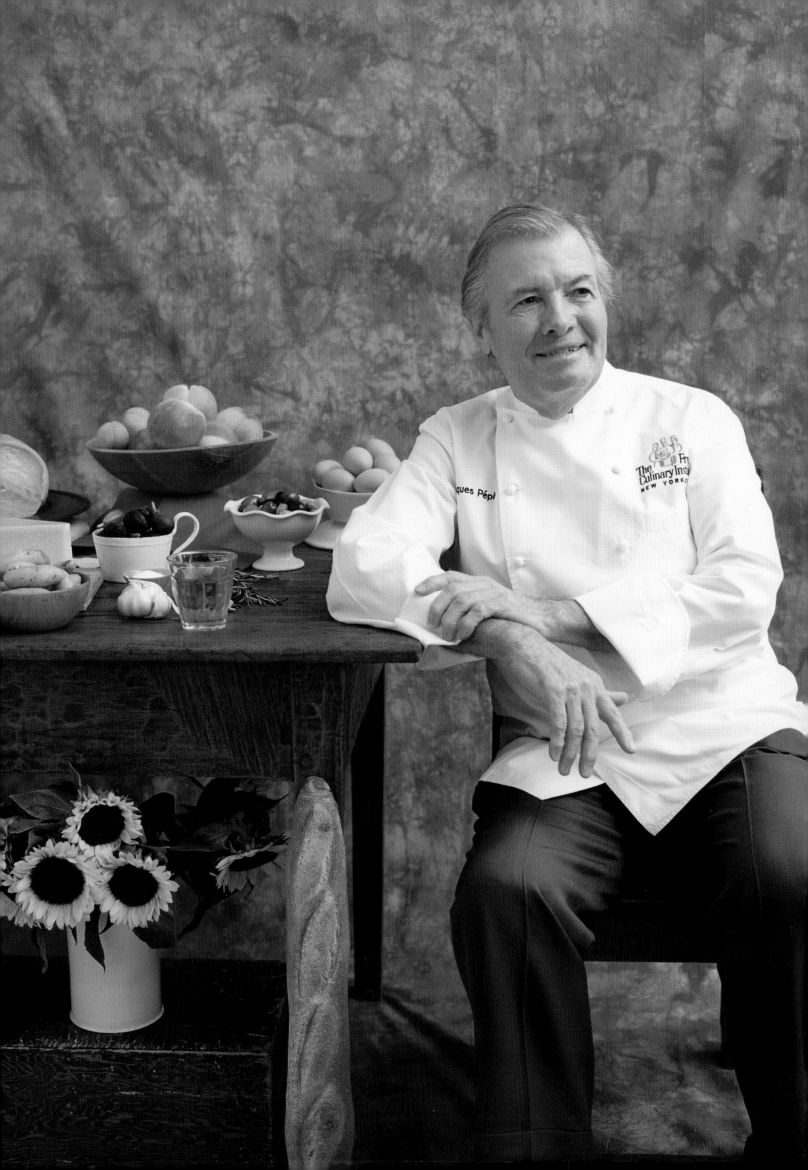

❦

What would be your last meal on earth?

How could you ask a chef what his last meal on earth would be? That's like asking Tiger Woods what the last swing of his last game would be like. Or asking an alcoholic what it would feel like for that last drop of whiskey to go down their throat. Ask any chef and he or she will all tell you the same thing: It's in our blood. We work our entire lives in search of the new flavor, the tucked-away gem, the perfect bite, and now this! The last one. It's not fair, frankly.

What would it be? Something that I've never tried before or something that I've had a million times? Would it be street food from Bangkok? Il Cibrèo in Florence? The degustation menu at Guy Savoy in the 17th arrondissement? Death by drowning in an ocean of Krug? These options are amateur hour, my friend. They sound great for a long weekend, but they are not experiences worthy of my last meal on earth. I see the last feast as a happy thing, like one of those sloppy Dean Martin celebrity roasts. "Dinner and a eulogy," I say. Everyone I know would be there, giving very inappropriate toasts to a dying man, saying things like, "Did you hear the one about the chef who couldn't get into heaven?" "No," everyone would rumble. "They were fully committed." It would all be very wrong. Funny, but wrong.

Since this is my last meal, I'm calling the shots with the food. No froufrou French. No snout-to-tail. No fucking foie gras. On the menu would be the classic Southern feast of my childhood. I want the last thing I taste to be the first thing I remember tasting. Crispy black-pepper fried chicken. Collards that have been cooking down with a ham hock for hours. Shrimp and grits with andouille sausage. Creamy black-eyed peas that have a little kick of Tabasco. Corn bread. Fried oysters. Biscuits and gravy. Butter beans cooked with bits of ham. And for dessert, peach cobbler with hand-churned bourbon ice cream.

What would be the setting for the meal?

Keith McNally would host the event at Balthazar in New York.

Would there be music?

How about a band? I wouldn't want a famous band like the Stones; they wouldn't come anyway. Maybe a great New Orleans jazz band playing a dirge—that slow, wailing death march that sounds like clarinets crying but ends up becoming a celebration with people dancing. Now that's what I call a party. At the end of the meal, Food Network would pick up the tab, I'd stand up and thank everyone for coming and stay until the last person had left. Then I would take a deep breath, walk over to the window, and turn the sign over to CLOSED.

Who would be your dining companions?

I would have my wife, children, and my whole family at the head table with me, and in the rest of the room would be the best in the business—Jean-Georges Vongerichten, Jacques Pépin, Emeril Lagasse. Julia, Bobby, and Daniel. And Bourdain would be there smoking in the corner. What a sight...

❦

WHO WOULD PREPARE THE MEAL?

*Definitely me. My
once for me, and it
raging fever and wa
the kitchen. That m
last!*

e has cooked only
s when I had a
po sick to set foot in
l was nearly my

What would be your last meal on earth?

Definitely a multicourse feast, starting with oysters and caviar, followed by some foie gras, then a nice piece of rib eye, and lastly some fromage.

What would be the setting for the meal?

At home. As a chef, I'm home too little, so it is always a great luxury to be in my house, seated in my favorite wingback chair, with my children bouncing and playing around me.

What would you drink with your meal?

I would begin with a couple of Crown Lagers; living in Australia for the last twelve years has made me appreciate Aussie beer. I would then open a bottle of 2000 Domaine Romanée-Conti Le Montrachet, followed by a bottle of 1961 Château Latour, and — I'm assuming there will be no hangover tomorrow — finish off with a single-malt whiskey.

Would there be music?

I love opera. I'd like to hear my favorite of all time, Verdi's La Traviata.

Who would be your dining companions?

My family. I have three daughters, aged one, four, and seven, and am very close to all my family in France. We're a very Latin bunch, so it would involve lots of talking, hugging, tears, and laughter.

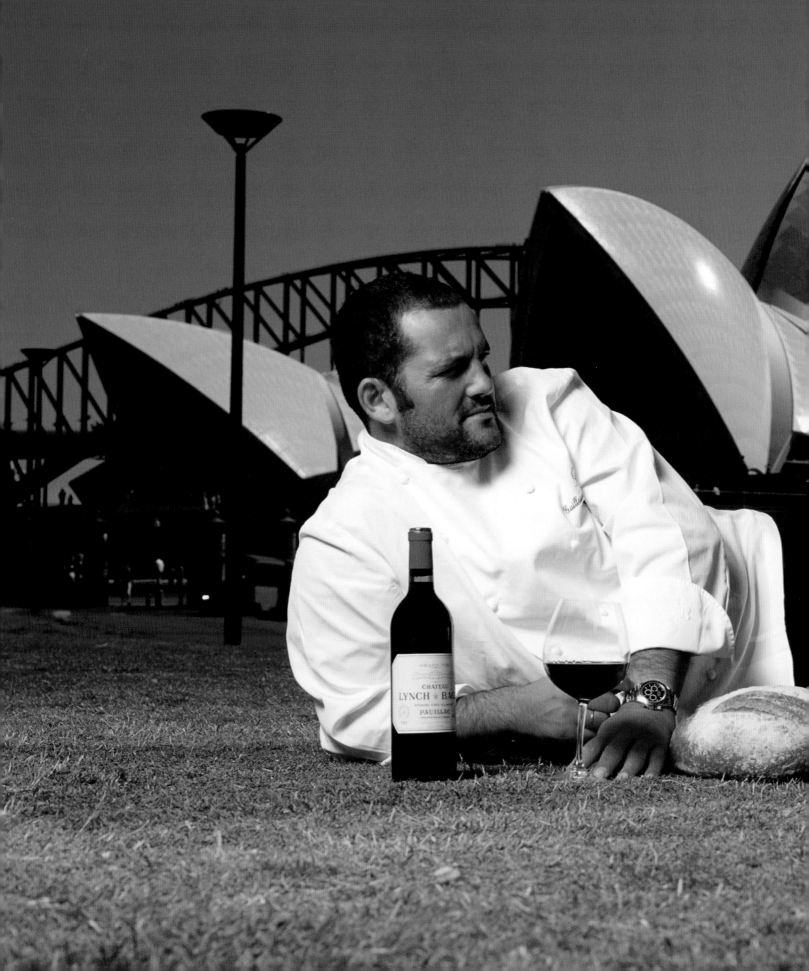

GUILLAUME BRAHIMI

— J O N A T H A N W A X M A N —

What would be your last meal on earth?

For my last meal I would have handmade tortilla chips with guacamole made from organic tree-ripened avocados, Don Julio tequila margaritas with limone verde; fresh gnocchi with grated Rhône Valley truffles; Roero arneis from a good producer; grilled porcini salad with butter lettuce, good olive oil, and sea salt; and condrieu from André Perret. Then, spit-roasted spring lamb from Sonoma Valley with new potatoes cooked in the ashes, followed by old, cave-aged gruyère. Dessert would be a milk chocolate and shortbread cookie ice-cream sandwich, served with wild strawberries.

What would be the setting for the meal?

Montmin, France, which is above Talliores, in the summer.

What would you drink with your meal?

I would pair a 1950 Château Margaux with the spring lamb; a great zinfandel with the gruyère; and a 1950 Château d'Yquem with dessert.

Would there be music?

I would like to listen to Miles Davis; Cream; Mozart; Bach cello; Ellington with Cat Williams solos; J.J. Johnson, the Hindemith Trombone Concerto; Beatles; and Airto.

Who would be your dining companions?

I would like to have the following people around me: my family; my brothers and their families; my wife's family including kids, my friends, in no particular order, Craig Schiffer and family, Colman Andrews and family, Ralph Meyer and family, Mark Williamson and toutes familtes ensemble (he has two wives). That's enough.

Who would prepare the meal?

My family.

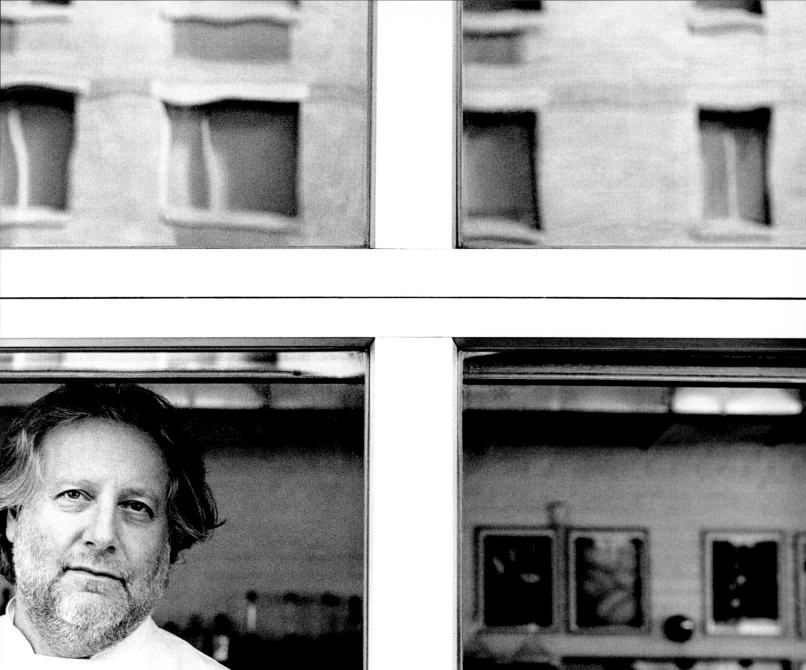

— LYDIA SHIRE —

⚜

What would be your last meal on earth?

My last meal on earth would have to include a thick, fourteen to sixteen-ounce super prime sirloin steak, with the fat kept on. I love parsnips too, so I would probably have a spoonful of parsnip purée and a big handful of thin, crispy fried parsnip chips.

What would be the setting for the meal?

I would dine in the Men's Café at Locke-Ober, and wear my most stunning black power suit, accessorized with fabulous jewelry.

What would you drink with your meal?

I would drink a burgundy, such as a Chambolle-Musigny-Georges Comte de Vogüé, or a Chambertin Georges Comte de Vogüé.

Would there be music?

I probably wouldn't have music, but if I did, maybe a little jazz. Jimmy Smith on the jazz organ, perhaps.

Who would be your dining companions?

My husband, Uriel, my son, Alex, and my friend Bill Reilly.

Who would prepare the meal?

I would make the meal myself, and as my dining companions arrived at Locke-Ober, I would serve them a cup of my own lobster and finnan haddie chowder with rum butter biscuits. Finally, after dinner, an Arturo Fuente cigar.

⚜

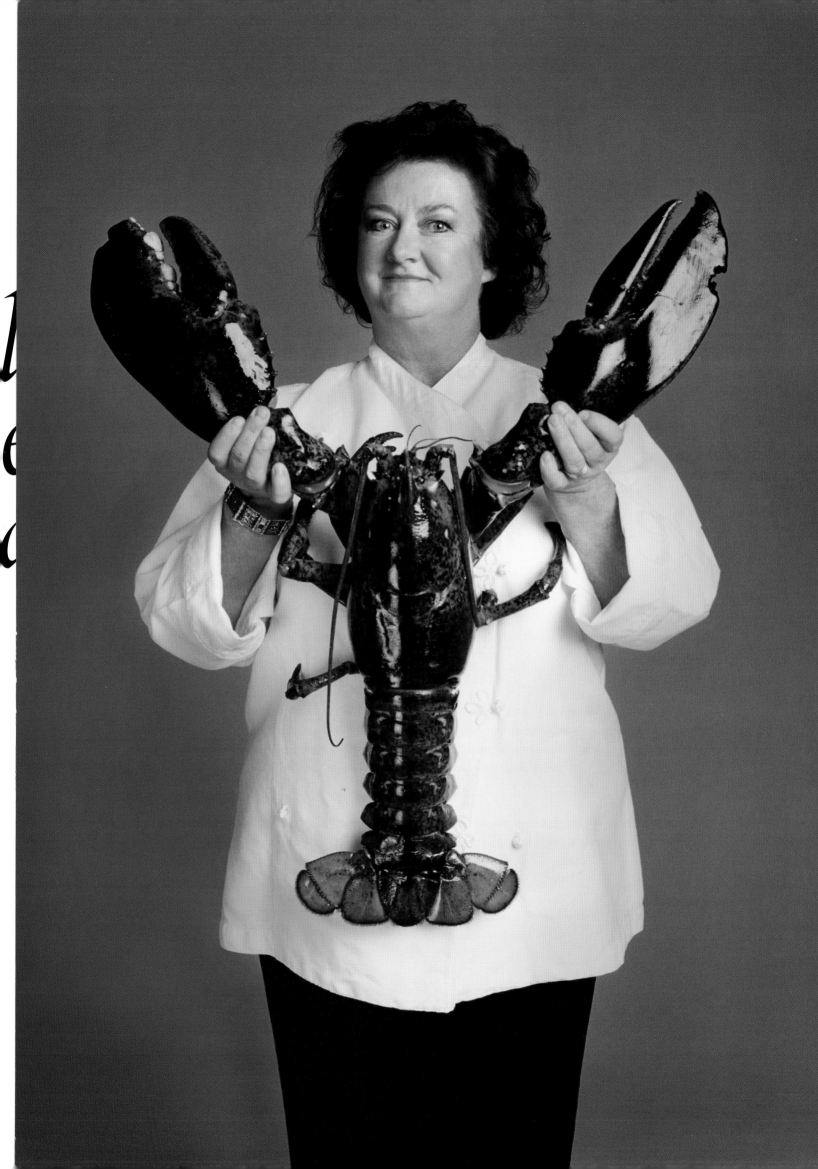

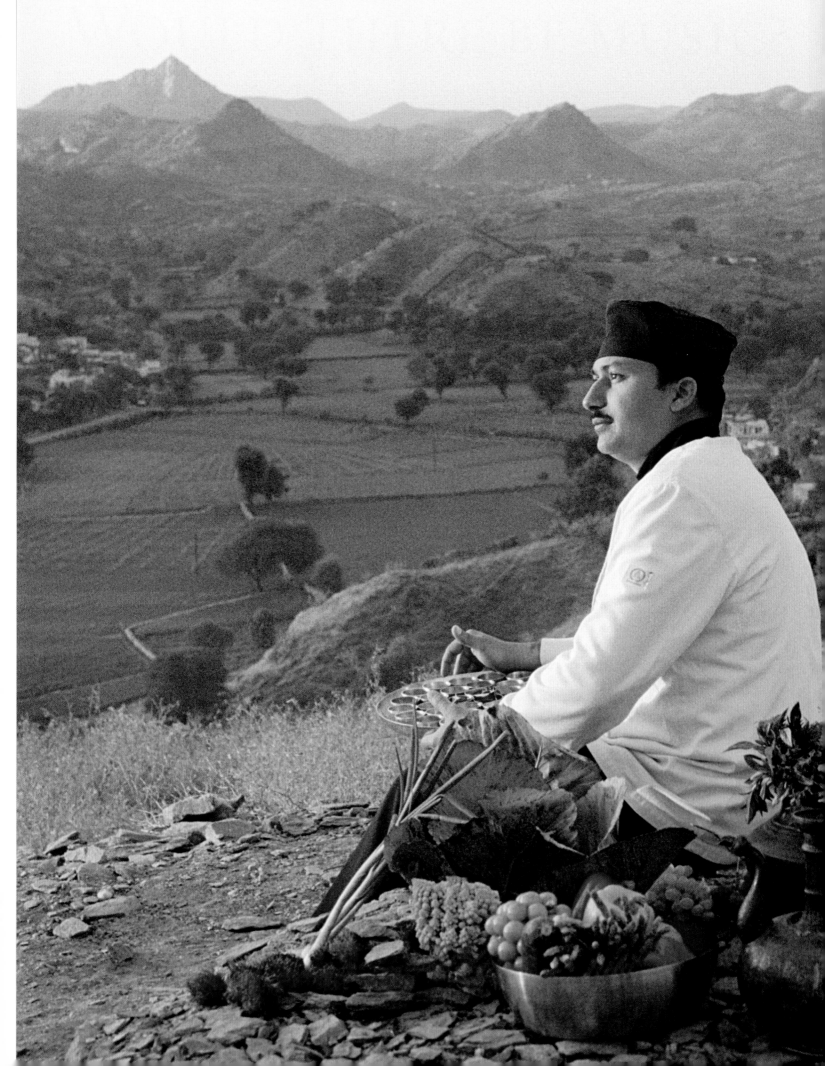

VIMAL DHAR

light duet of etween, I would ape...

... featuring my family's chuckles and some melodious songs sung by them. It's in the old tape recorder back in my parents' home.

What would be your last meal on earth?

I would consider it a blessing if I were fortunate enough to receive this invitation. If so, I would like to demand to eat with my hands like a baby. It would be a very basic Kashmiri meal featuring churma (crunchy lotus stems), rogan josh (lamb), meeth chaman (cottage cheese and fenugreek), dum olav (potatoes), monj haakh (spicy red gravy), chowk wangun (tangy eggplant), muj chuten (grated radish with curd), and some steamed rice.

What would be the setting for the meal?

It would be a formal kind of get-together in my home. Everyone would be arranged and sitting on a kaleen (carpet) with cushions and bolsters around. Kangaris (cane-covered heaters) would keep us warm, and everyone would wear ferans (traditional Kashmiri outfits).

What would you drink with your meal?

I'd have kehwa, which is Kashmiri tea with almonds, ginger, cinnamon, cardamom, and saffron. There would be aerated drinks for the kids, and my kehwa would be chilled, since I like it this way.

Who would be your dining companions?

I would dine with my parents and brothers with their wives and kids, my wife, Sangeeta, and Akshat.

Who would prepare the meal?

Sangeeta and I would prepare it together for the family.

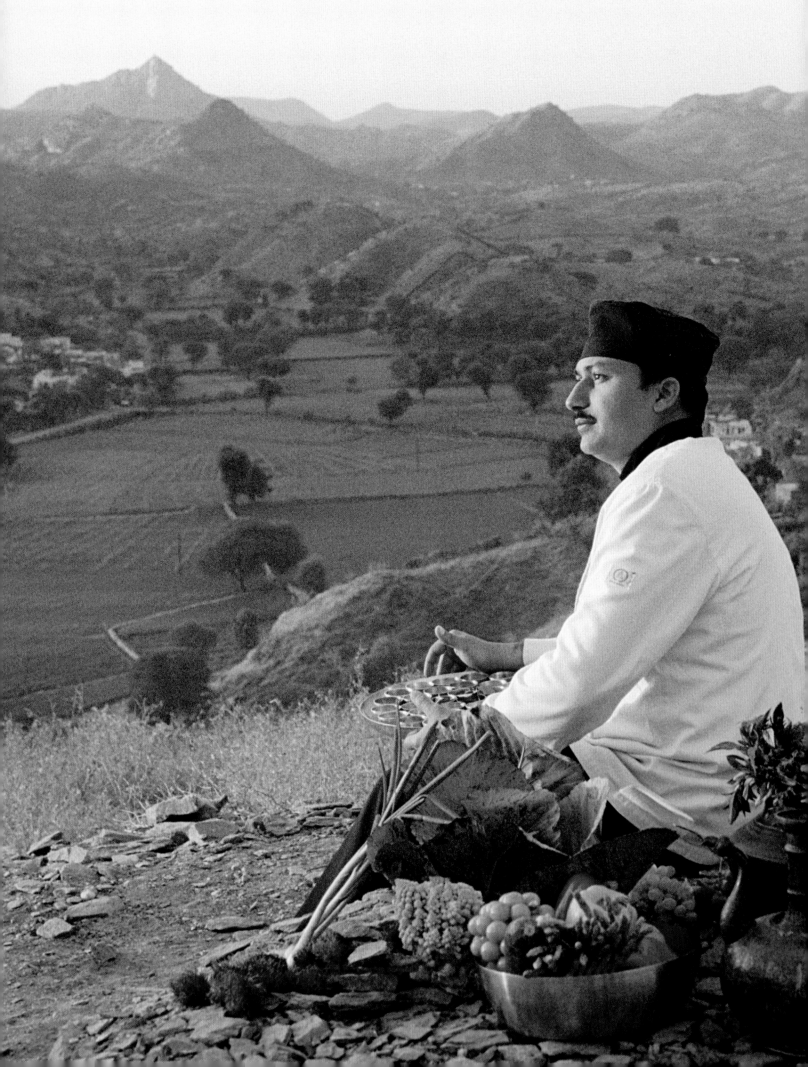

VIMAL DHAR

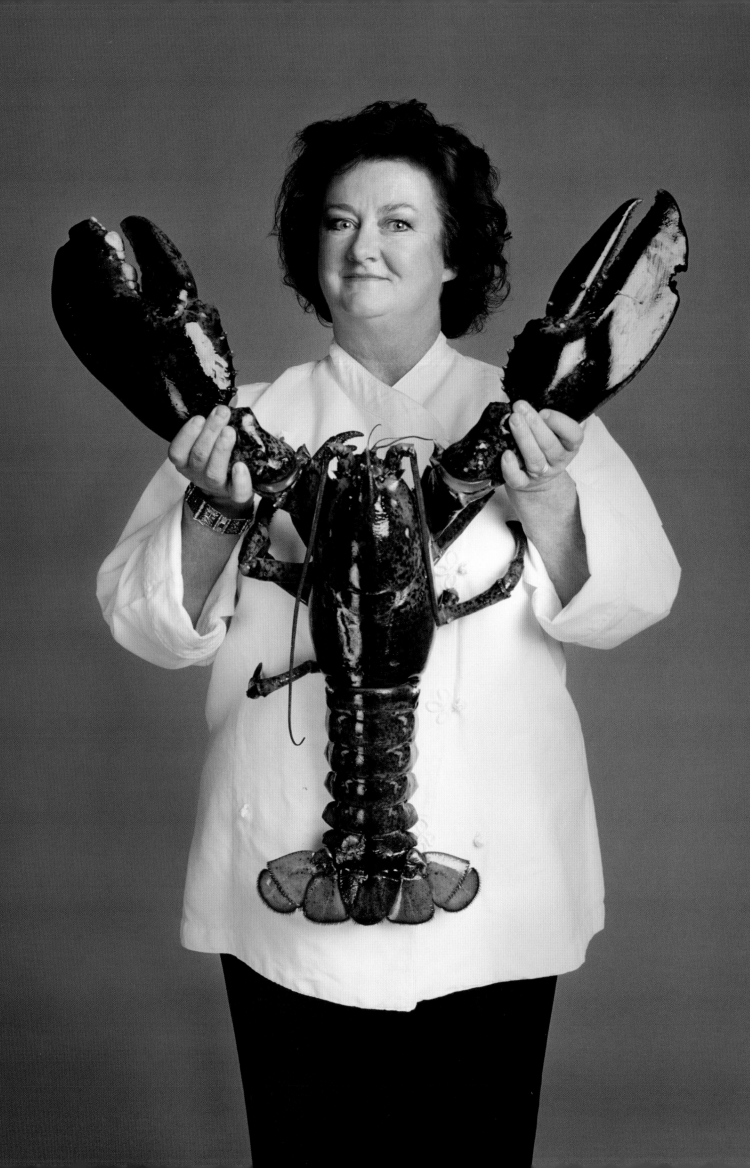

WOULD THERE BE MUSIC?

*The music would be
sarangi and tabla. I
love to play a casset*

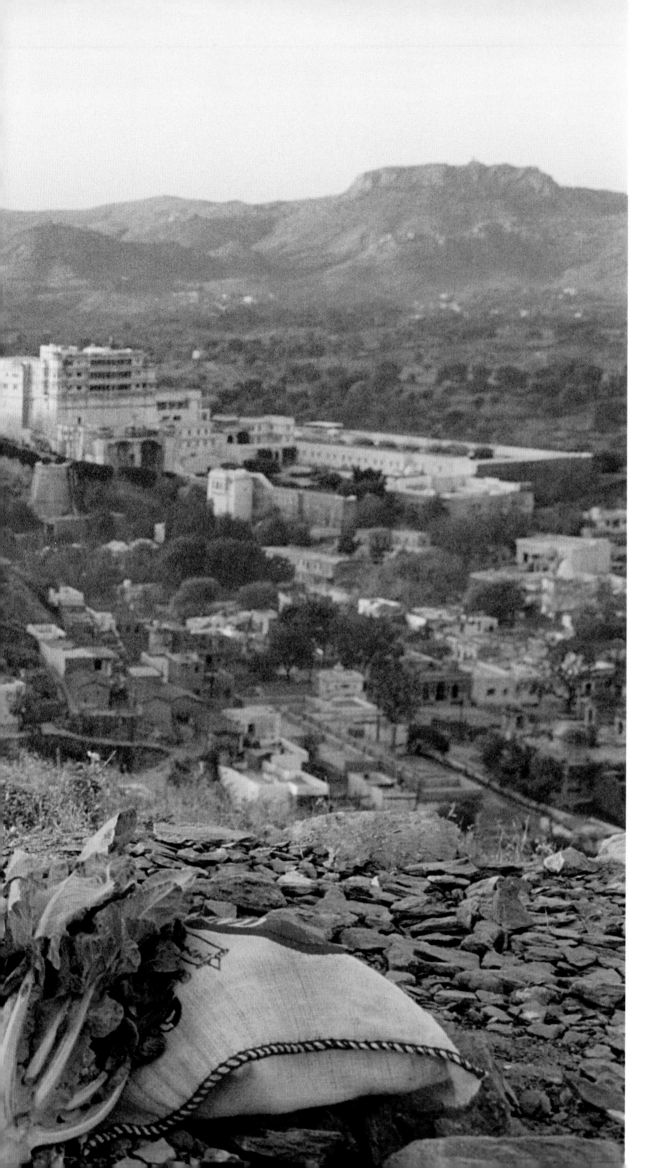

What would be your last meal on earth?

Where does one start when thinking of the last meal he or she will ever have? I've thought about it long and hard, and taken into consideration all the things I love, as well as the faith I've had throughout my life. I don't believe in a life of regret, but rather a life of self-correction and opportunity. I see mistakes as occasions for growth. When the time comes, and that page is turned, I would love to be on a higher plane mentally. That way, I could appreciate and absorb with gratitude of a whole different level.

With that, though, my last meal would definitely include fried chicken. I love good fried chicken that is crispy and tender, with a perfect, mild spiciness. I would want sweet corn, cooked on the cob and freshly cut off onto my plate. I can taste the plates of avocado, ravioli with truffles from Piemonte, and my mother's sausage and peppers. I would like goat roasted on a spit over charcoal, and whole fish cooked in lobster broth with baby tomatoes and freshly torn basil; piles of fried potatoes with herbs and peperoncino; risotto with seared foie gras, green apples, and twenty-five-year-old balsamico; sushi rice with glazed eel; Neapolitan gatto; and my girlfriend's borek with stewed eggplant and chopped beef. And maybe if I could just have some of Marcus Samuelsson's marinated salmon, and anything Daniel Boulud would care to cook. Oh, and some more white truffles, please...

What would be the setting for the meal?

A field on a warm and sunny, beautiful, early-autumn day. I'd be seated at a large table, covered with platters, spending time with the ones I love, and my mom, dad, brother, and sister.

What would you drink with your meal?

I'd have white wines from Burgundy, Alsace, and Austria, and red wines from Barolo, Burgundy, and Bordeaux — all from my friend Tom Black's cellar.

Would there be music?

Bob Dylan, Johnny Cash, old jazz, Willie Nelson, Beethoven, old and new R&B, Al Green, Mozart, and some 50 Cent would be the backdrop to conversations with my best friends and the woman I love (that's you, baby!).

Who would be your dining companions?

Old friends and new would join me, and family that I haven't gotten to know as well as I should have during my life. I'd also like to have some time with people that I need to correct things with, so that I could leave on the right foot.

Who would prepare the meal?

No one in particular. I would just want someone with a soulful feel for food, a warm smile, and a good sense of humor. It is, after all, a celebration. I would walk away from the table, with my faith leading me into the next phase of my life, happy that I extracted all that I could from my present. Oh, and one more sausage and pepper sandwich to go, please. I am not sure how long this trip is.

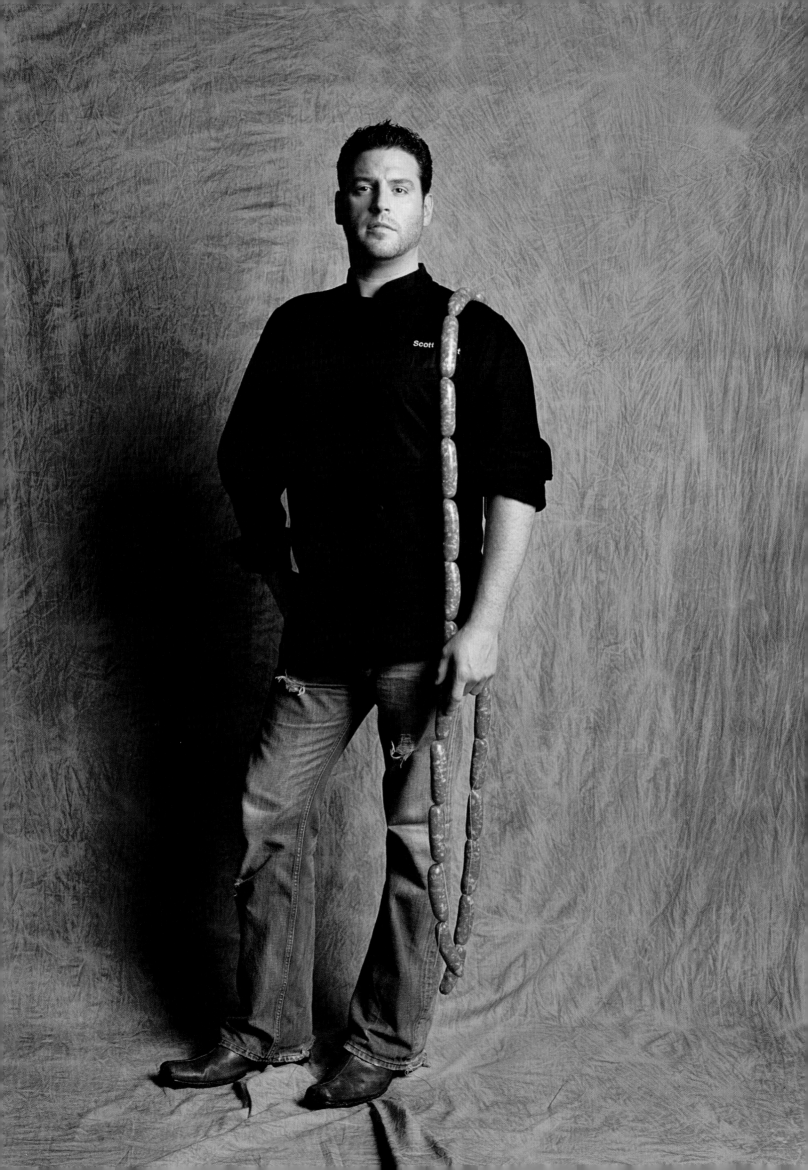

WOULD THERE BE MUSIC?

*I'd like live harp mu
the harp when I wa
miss it.*

. My sister played rowing up and I

My last meal on earth would be a multicourse feast made up mostly of local food that I had harvested, foraged, or caught within the last forty-eight hours, in the vicinity of my home on Long Island, simply prepared. We would start with sashimi: a sweet, Peconic Bay scallop still moving, a littleneck clam dug from Bird Island in the bay, a slice of fluke, sea bass, and striped bass, all line-caught that day, still almost crunchy from the freshness, from aboard my surrogate skiff, La Famiglia. These would be supplemented by a slice of otoro, the super fatty and silky belly of tuna, caught the day before in the ocean outside the inlet; some briny sea urchin; some osetra caviar so fresh it pops in the mouth; Japanese snapper and kanpachi—all dressed with just-picked shiso, chives, and scallions from my garden, fresh-grated wasabi, vintage shoyu, and a fresh, ripe and fragrant yuzu lemon. We'd take a break and then move on to some crab cakes, made from blue crabs from the cove, paired with local corn and my garden's tomatoes and basil. Then, a fried steamer clam, also from Bird Island, with tartar sauce made from last year's crop of gherkins, pickled. Next, a taste of lobster knuckle drenched in the best local butter with a touch of tarragon and Meyer lemon, then a cuttlefish egg sautéed in olive oil, garlic, parsley, and lemon. Another break would follow, and then a trio of Hudson Valley foie gras paired with fruits from my trees; a spit-roasted suckling pig, porchetta-style; some locally foraged mushrooms; a bite of dry-aged rib eye from the fatty outer muscle of the loin end, grilled rare; some broccoli rabe from the garden with rocambole garlic and extra-virgin olive oil; some roast squab with bacon and lentils; and some grilled Australian lamb. To round out the meal, there would be raw milk cheeses (with fresh fruit from the garden, of course), supplemented with some Kyoho grapes, muskmelon, and lychees. A berry crumble with vanilla ice cream, a decadent chocolate dessert, petits fours, pecan tartlets, and peanut butter cookies would be among the vast choices for dessert. And nothing would go to waste.

What would be the setting for the meal?

I would be at home on Long Island, with my view of the cove. (Although this waterfront property is not currently mine, it will be at the time of this dinner...)

What would you drink with your meal?

Each wine would be paired to each course. We would have only the finest shizuku daiginjo sakes with the sashimi, followed by fabulous vintages of champagne and German whites, then some old, legendary reds, and finish with some dessert wines older (and rarer) than myself.

Who would be your dining companions?

I would be surrounded by close friends and family.

Who would prepare the meal?

Taka Yoneyama (the only chef I've ever sent fan mail) would prepare the sashimi and choose the Japanese fruits, and I'd have Rocco DiSpirito make the bay scallops. Rebecca Charles from Pearl Oyster Bar would prepare the crab cakes, fried clam, and lobster knuckle. Gray Kunz and Ariane Daguin would prepare the trio of foie gras, Andrew Carmellini and Roberto Donna would prepare the pork. Traci Des Jardins would prepare the beef, Tetsuya Wakuda would prepare the lamb, Cielo from Murray's Cheese would choose the cheeses, and Martha Stewart would make my desserts and petits fours.

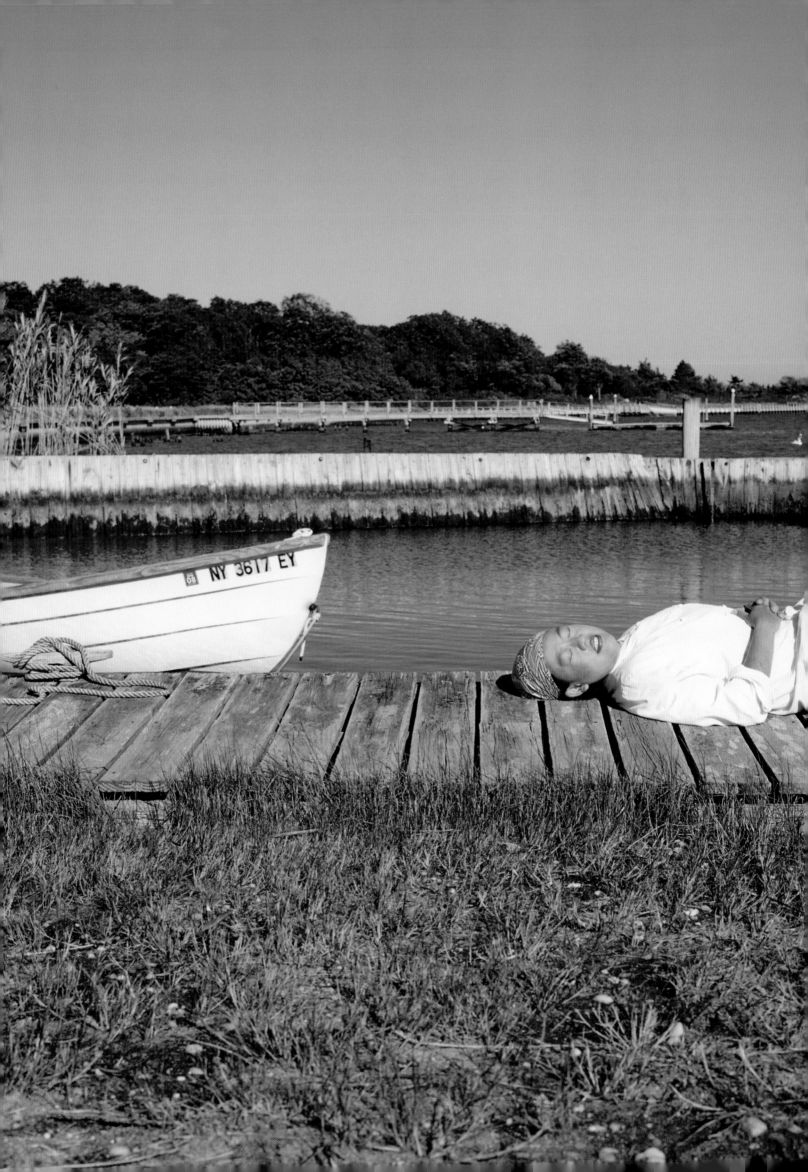

— A M I T C H O W D H U R Y —

WHO WOULD BE YOUR DINING COMPANIONS?

Just my wife.

What would be your last meal on earth?

I would begin with an essence of tomato and lentils, enhanced with tamarind and curry leaf. Then, to cleanse the palate, a sugarcane chili sorbet. For the main course, I would have char-grilled mustard prawns on steamed coriander pilaf, and for dessert, masala chai crème brûlée with cardamom mascarpone kulfi.

What would be the setting for the meal?

I would like to be at home.

What would you drink with your meal?

Grand Cuvée champagne.

Would there be music?

Some recorded music would be fine.

Who would prepare the meal?

I would prepare the meal myself.

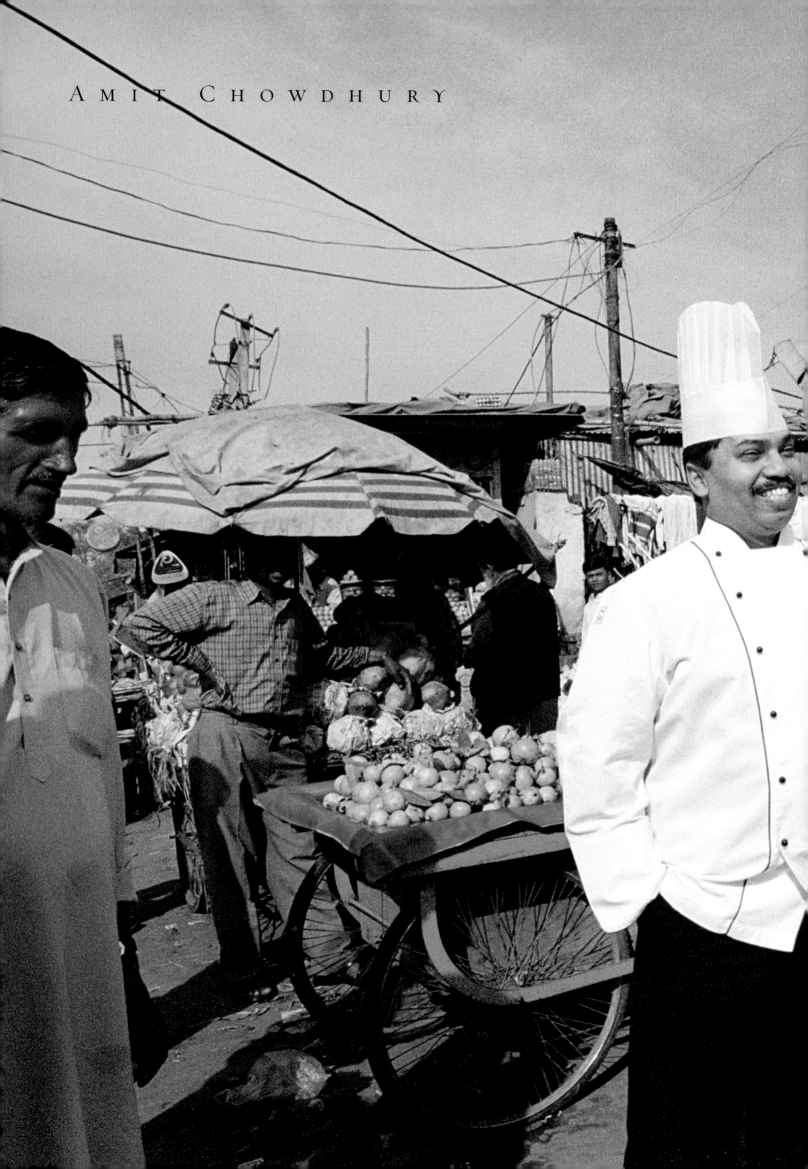

Amit Chowdhury

— A N G E L A H A R T N E T T —

What would be your last meal on earth?
We would have antipasti with Fellini salami, Parma ham, and some coppa, followed by roast meats like anolini stuffed with braised veal or lamb. Then we would have two kinds of pasta, one would be made with white truffles and the other would be pumpkin tortelli. For dessert we would have the zabaglione my grandmother used to make.

What would be the setting for the meal?
We would all sit around a long table in the garden at my grandmother's house in the Italian hills.

What would you drink with your meal?
Krug champagne and good wine.

Would there be music?
Tony Bennett would play live, and after he finished, there would be a brief appearance by Larry David and Jerry Seinfeld for entertainment.

Who would be your dining companions?
Family and close friends would join me.

Who would prepare the meal?
Family — we would do it all together.

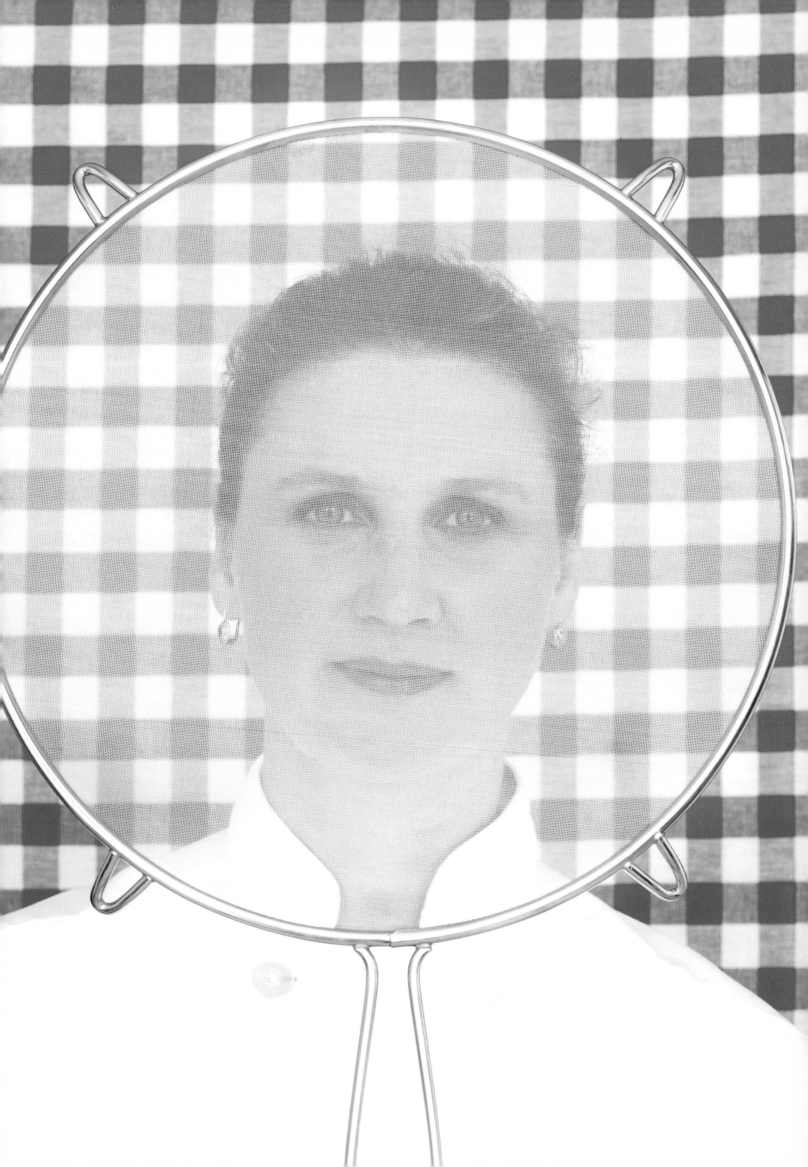

— P A U L K A H A N —

What would be your last meal on earth?

> *I would have a succulent roasted pig with homemade noodles and shaved black truffles, and a simple salad of young escarole and lemon. Then some cheese and grappa, followed by Swiss chocolate, because my wife, Mary, likes it.*

What would be the setting for the meal?

> *While backpacking the Appalachian Trail, we would camp on a ridge in the Great Smoky Mountains. It would be a cool summer evening. After a long day of hiking, we would watch the sun go down and enjoy the soft hue of the sky.*

What would you drink with your meal?

> *I'd have a J. L. Chave, Cuvée Cathelin, 1990.*

Would there be music?

> *We wouldn't listen to anything because, although music is a very important part of our lives, there is so much sound in nature that you don't want anything else.*

Who would be your dining companions?

> *No one would be there but Mary and me.*

Who would prepare the meal?

> *I would make the dinner with my wife, but only after someone flew by in a helicopter and dropped it out of the sky. Everything would have to have been packed perfectly so that nothing was damaged during the fall. And the helicopter guy would have to parachute in to tie up the bear bag once we were finished (because that is a pain to deal with) before taking off again.*

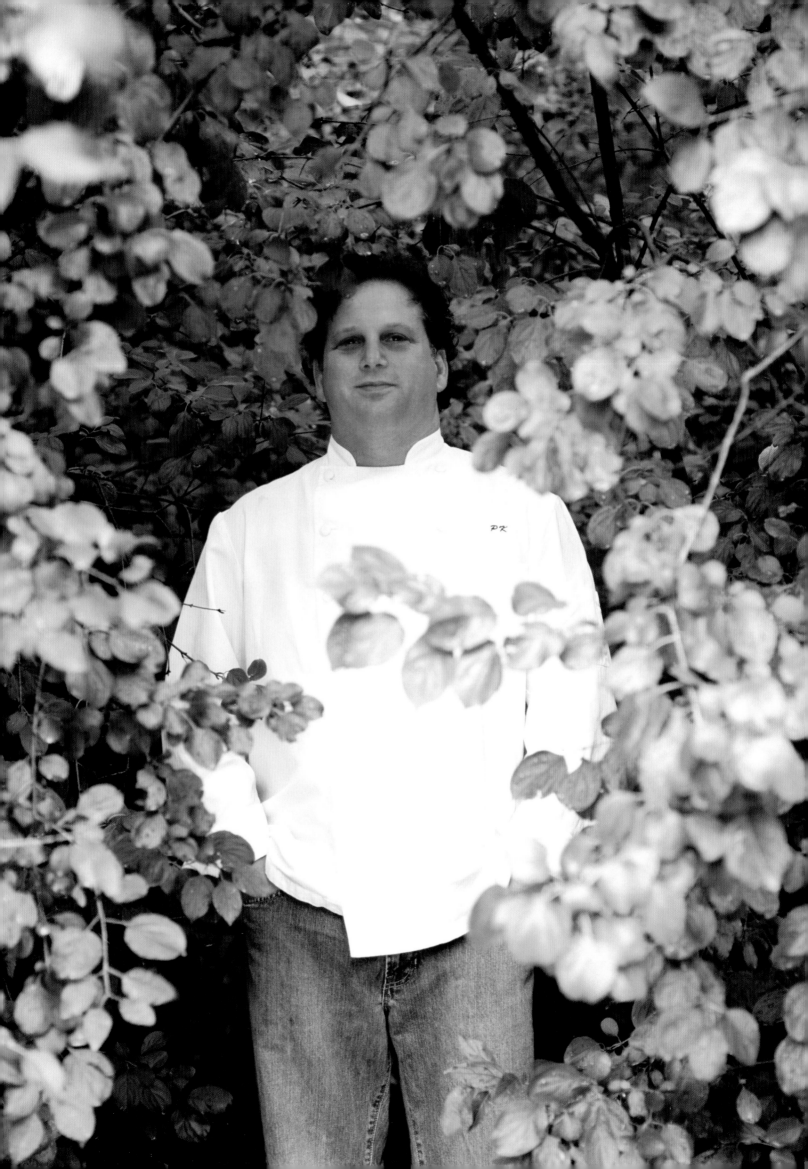

WHAT WOULD BE THE SETTING FOR THE MEAL?

*I would love to be a
beautiful day, sittin
After eating the cra
I would just jump i*

...e beach on a
...t a simple table.
...nd making a mess,
...he ocean.

What would be your last meal on earth?

I would love a simple dish like a sublimely fresh sashimi of yellowfin tuna, and some boiled mud crab with a little aioli on the side.

What would you drink with your meal?

This simple food would be perfect with a bottle of Jeffrey Grosset Polish Hill riesling from a great vintage that has about five years age on it.

Would there be music?

The sound of conversation and enjoyment would be all that was required, plus the breaking of the waves and a light breeze rustling the palms.

Who would be your dining companions?

I would love it to be my wife and children. I think it would also be great to gather up some world leaders to talk about how good food, love, peace, and harmony are the way to go. I would hate to see my children's world destroyed in the name of democracy.

Who would prepare the meal?

I would love to cook it myself, as it would be my last.

— R I C K B A Y L E S S —

What would be your last meal on earth?

My last meal would be the food they feature at Restaurante Arroyo, which is in the southern part of Mexico City. We would eat carnitas, pork cooked in its own fat until succulent and crispy; chicharrón, crispy crackling pork skins; barbacoa de borrego, salt-and-pepper lamb wrapped in agave leaves and cooked in a pit; consommé, a smoky vegetable consommé that's created in the pit as the meat cooks above the pot that contains it; guacamole; and huaraches, oval corn masa cakes filled with fava beans, doused with tomatillo salsa, and sprinkled with queso añejo (Mexican aged cheese) and cilantro.

What would be the setting for the meal?

At Restaurante Arroyo, specifically, after you exit the massive parking lot and walk up the covered stairs to the entrance. The stairs are lined with vendors selling fruit, flowers, gum, and candy. You enter via the kitchen, which has huge pits dug into the dirt floor where they cook the meat. From the makeshift host stand, you are taken to a communal table in one of three huge dining rooms. I would sit in the middle room, at the front, near the stage, with everyone else in the room surrounding me.

What would you drink with your meal?

Pulque curado de guayaba (guava-flavored pulque), and Herradura Reposado tequila — although this isn't the best tequila, it is the best they serve, and well made. There'd also be some mineral water and Bohemia beer.

Would there be music?

There would be lots and lots of music. At the restaurant they have a lot of bands that play all styles of music — like norteño and mariachi — while wandering around. And they also play requests.

Who would be your dining companions?

My friends and family would be around me.

Who would prepare the meal?

The restaurant would prepare all the food, and I would enjoy it just as it is.

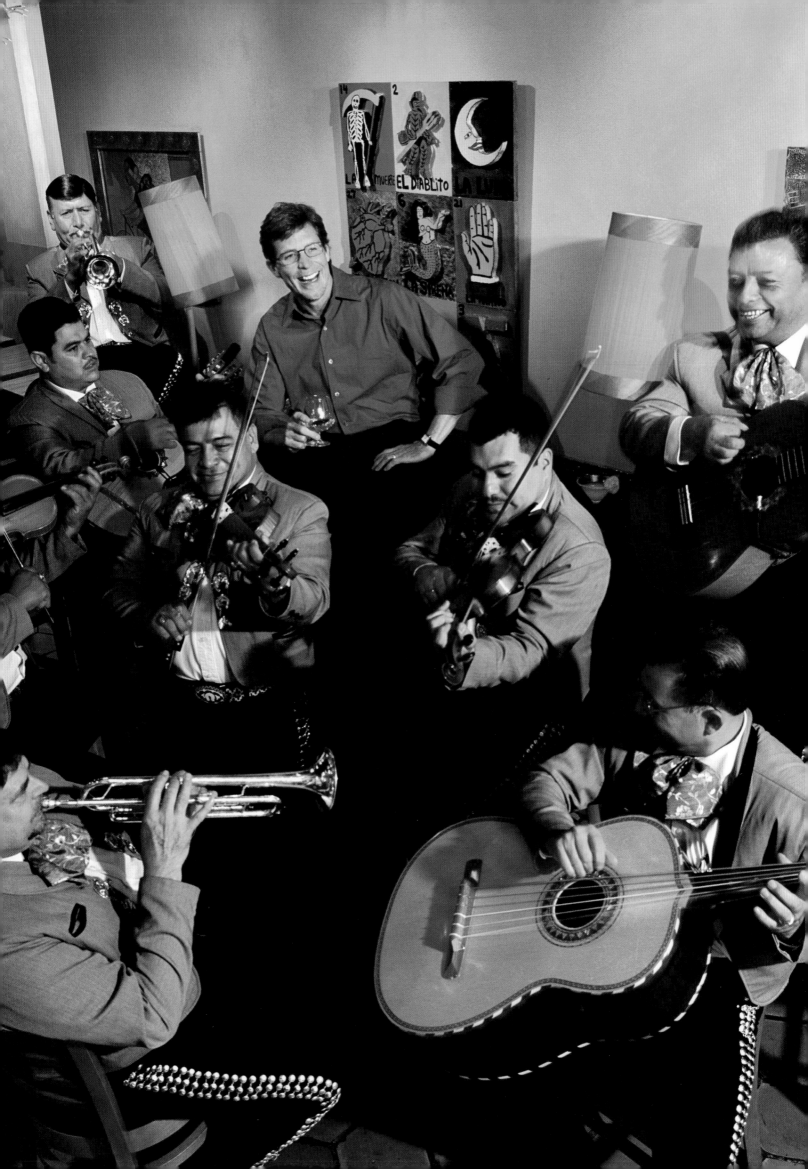

What would be your last meal on earth?

I imagine the food would be something humble and simple, something very casual with comfortable flavors, like a big, fat local saucisse de Morteaux with some gruyère to accompany it, and a crusty, traditional baguette. That would be just fine.

What would be the setting for the meal?

We would definitely be in France, somewhere near where my parents live in Besançon. Perhaps we can rendezvous in Burgundy, in Les Caves Des Beaunes, where I had one of my life's greatest moments. Monsieur Jadot organized a tasting for two hundred people there, and we sampled the greatest wines. Some of them had lost their body, but not their soul. Some say that the caves are the passageway to death.

What would you drink with your meal?

Rather than focus on the food, I would love to have the most incredible bottle of Clos de Vougeot burgundy. I was sixteen when I had it for the first time. I will never forget that moment, or that taste.

Would there be music?

The Rolling Stones come to mind. Afterward, I am likely to need peace and quiet, so Arvo Pärt, the Estonian composer, would perform his Spiegel im Spiegel. This will be perfect.

Who would be your dining companions?

I would dine with my friend René, who was my best friend since I was two. Since he is already dead, he could be a brilliant liaison for me! My two sons would have to be there, since they are not only my sons but my best friends as well. My partner, Natalia, would bring a little humor to the whole process. Being Russian, she has a great knowledge of the grieving process. The Russians love their dead and mourn them openly for years. Their cemeteries are in the woods, and they plant trees there to shadow the graves. Once a year they go to them with vodka and bread and let their grieving out. It's a much different approach than the English way.

Who would prepare the meal?

Paul Bocuse is probably the chef who has given the most to humanity over the last fifty years. He is a wonderful human being who has helped nurture many young people toward fame and fortune. He also has a wicked sense of humor and happens to be one of my best friends.

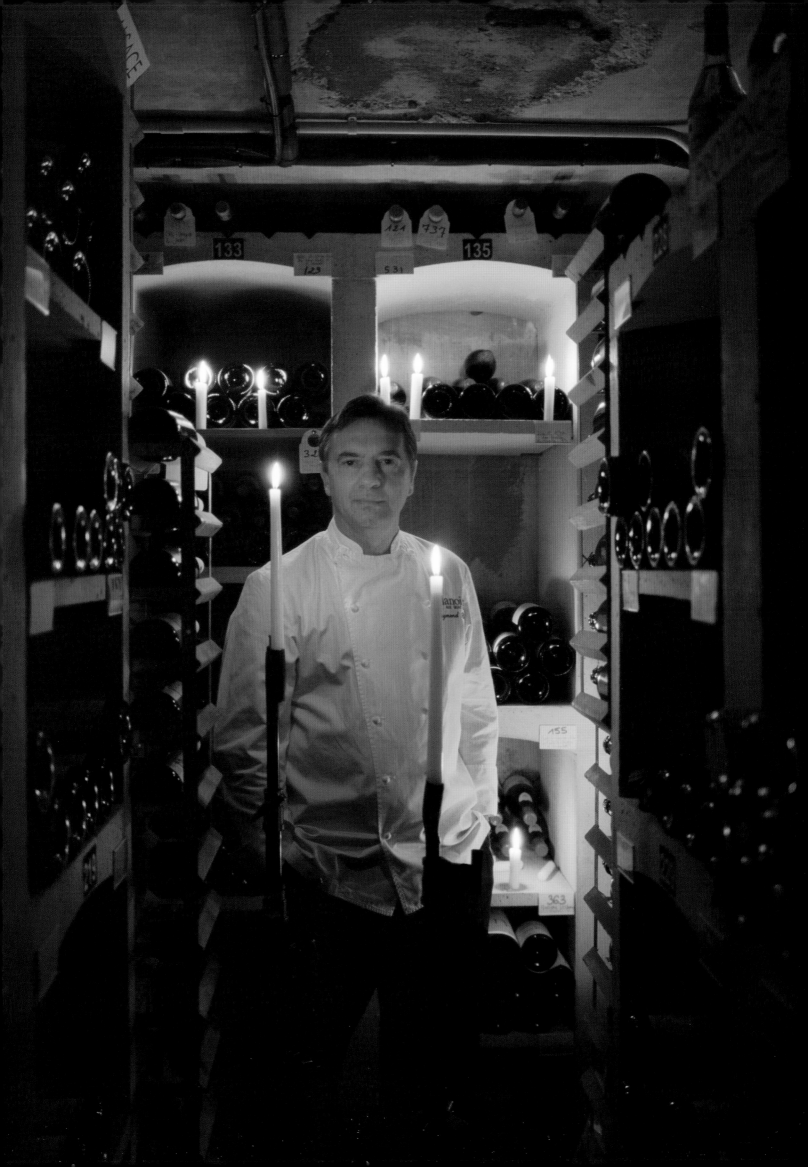

— MICHEL RICHARD —

What would be your last meal on earth?

> Roasted chicken with garlic and lemon, my wife Laurence's ratatouille, french fries, and maple-caramel ice cream.

What would be the setting for the meal?

> Anywhere with Laurence. An outdoor country café or an auberge would be nice, on a rainy day while sitting under a cover or umbrella of some kind.

What would you drink with your meal?

> I would start with champagne, a Krug Clos du Mesnil 1982. Then, a Corton-Charlemagne. After dinner, a pear brandy and a cigar.

Would there be music?

> No music, just the sound of the rain. Maybe we would even dine under a glass roof so that you could hear it. I love the rain. When I was a kid, we used to play inside a big box carton, like it was a tent, until the rain destroyed the box.

Who would be your dining companions?

> My wife, Laurence, and the kids, and all the people that I love. Well, maybe all the people I love could come later. We'll all meet in paradise anyway.

Who would prepare the meal?

> Pierre Gagnaire. But he would have to use Laurence's recipe for the ratatouille.

eally, has two basic
you've never had
eal you've already
nal dinner, I'd go

What would be the setting for the meal?

It would be held at my second home, located just outside the walls of a small hilltop town in Umbria called Panicale. I go every summer for a month, and during that time I have several wonderful, large parties, and my last supper would be just like one of those parties. When the guests first arrive, they would be greeted by a rustic wooden table overflowing with antipasti—seven types of salumi, four types of fresh mozzarella, a couple pecorinos, almonds, and olives. My house is not huge and does not allow for everyone to sit down at some grand table, so people would scatter about. There will be a few folks at the small table in the front porch, several more in the backyard, a dozen or so at the pergola, and others, of course, in the kitchen. Myself, I'll be roaming from group to group, relishing in the knowledge that they are having a grand time.

What would you drink with your meal?

For my parties, I tell everyone to bring at least one bottle of red wine. Some bring two or three, like my friend Bobby, who usually has a special bottle he'll tell only a few people about. I better be one of those people or poor Bobby might be having a last supper himself.

Would there be music?

We'll put some music on, mostly classic rock and Motown—some Bruce, Dylan, Neil Young, Rolling Stones, Elvis Costello, the Supremes, and Smokey. Not too loud. Yet.

A year ago one of my guests was an Englishman named Tony who is a professional drummer and teaches drumming in London. The guy, about fifty-eight, can really play. At the party, Bobby, the wine geek, set up several empty and nearly empty wine bottles and started playing them with spoons. The wine bottles were arranged in such an order that they seemed tuned like piano keys, each with a slightly different tone. As the party loosened up and more bottles emptied,

Tony took over. At the time we only had a handful of CDs, so we played Clapton's "San Francisco Bay Blues" and "Layla," and Van Morrison's "Brown Eyed Girl" about ten times each, over and over. It was magical. The music was loud, the crowd happy and drunk with good food and wine. We sang. Some danced. It was a joyous, rousing occasion I will never forget. That is how I'd want my last supper to be.

Who would be your dining companions?

Over the past several years I have met many people from Los Angeles who also spend part of the summer in Panicale. Although I don't see them often in Los Angeles, for that month in Umbria, they are my best friends. They would all be invited, along with, of course, my family: my father, Larry; my daughter, Vanessa; my sons, Ben and Oliver; and my sister, Gail, and her husband-to-be, Joel.

Who would prepare the meal?

I would dispatch friends to different parts of Umbria and Tuscany to gather the key ingredients for my farewell shindig. Margy and Robert will pick up the freshest, creamiest bufala and cow's milk mozzarella in Todi. Laurie and Jonathan will drive to Norica to pick up an array of salumi and Umbrian lentils from Castalucia. Gail and Joel will go to Pienze to get the best pecorinos. Enid and Richard and Linda will search out the best produce and the only good loaf of bread in my region. My son Oliver and I will take the scenic, windy drive to the town of Panzano in Chianti, home to Dario Cecchini, the most famous butcher in Italy. Dario will provide the pièce de résistance of this supper: his famous bistecca fiorentina. We will get the massive steak as well as a mound of seasoned whipped lardo, some fennel-dusted pork shoulder chops, sopprasetta, and the master's incomparable fennel salami and fennel sausage, and then grill it all.

The morning of the party, my friend Bradley will start gathering wild herbs that grow in my yard — thyme, rosemary, sage, and basil. He'll cut wildflowers for the tables and wrap the silverware in decorative napkins tied with twine. You see, it's almost all in the little details. My neighbor Franco will build the fire in my outdoor grill, and I'll start on the contorni — roasted onions with bay leaves and wild fennel, braised radicchio with balsamic vinegar and rosemary, grilled zucchini with wild mint, fresh borlotti beans with sage and garlic, lentils with extra-virgin olive oil and fresh basil. No party of mine is complete without a batch of pesto, pounded with my heavyweight mortar and pestle, to accompany the mozzarella. Pesto never tastes as good as when it's made in Italy. My friend Lissa will start placing the salumi on a huge olive-wood board (and she'll try to keep other helpers from sampling too much).

One of the moments I really enjoy is opening a bottle of Umbrian or Tuscan red as soon as we make some progress. We take a sip, get back to work, take another sip or two. I love this simple pleasure. By now the fire will be hotter than Hades, so Hiro, Lissa's husband and the chef at Terra in Napa Valley, will start searing the steaks and grilling the sausages and bread. I'll be finishing the wild arugula salad. The buffet table downstairs will be set, waiting only for the star of the meal, Dario's meat. After the meat has been cooked, rested, and then sliced, everything will go downstairs and folks will dig in buffet-style.

And that is how I'd want my last supper to be. When one thinks of a last supper, it is, quite naturally, a heartbreaking thought. But mine would be a celebration — a celebration of fresh foods, of family and friends, and of course, of bottles. Both drank and drummed.

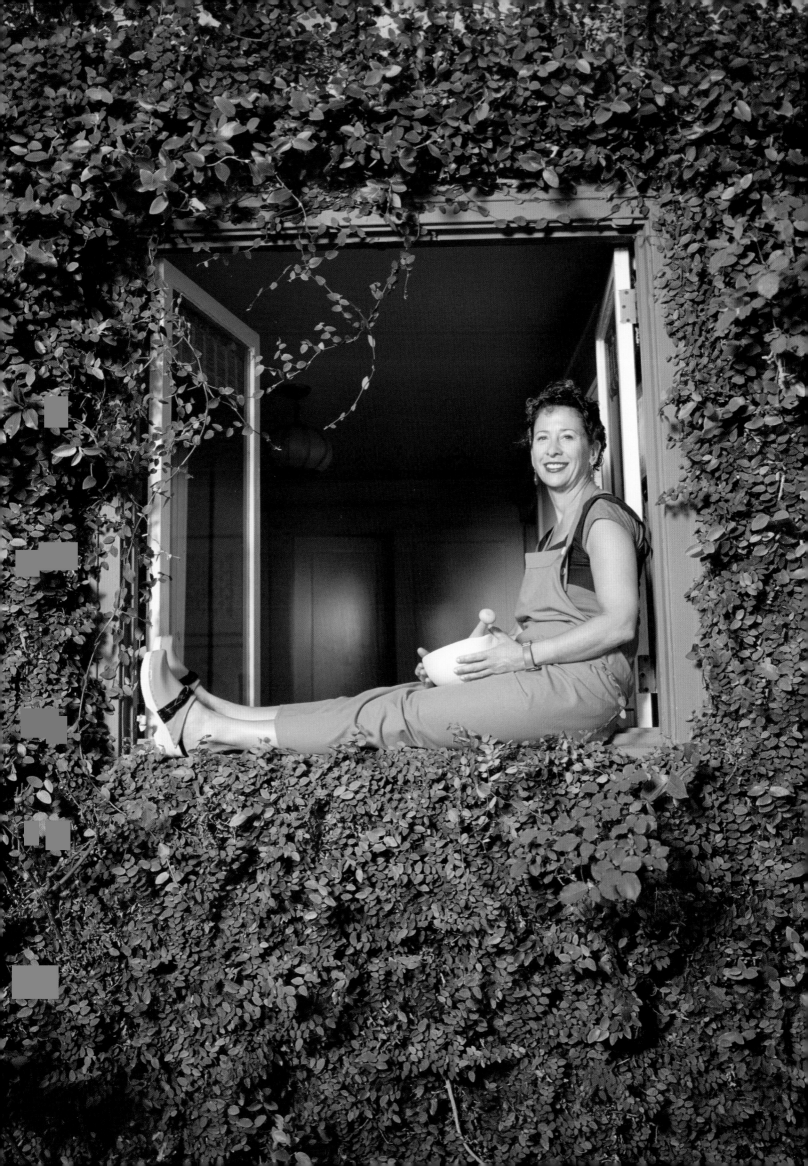

— CHARLIE TROTTER —

✳

What would be your last meal on earth?

I would eat many courses of raw, tiny, and delicate seafood. China plates would be full of wonderful oysters, crustaceans, sardines, and anchovies. Dishes like ahi tuna poke with soy-yuzu-cilantro sauce, or sea urchin and osetra caviar with vodka crème fraîche and daikon would also make an appearance.

What would be the setting for the meal?

I would like to sit at a huge, long table, outdoors, and high above the sea — something like the scene at the Château Eza on the Côte d'Azur. I want to take in the sweeping views of this gorgeous planet before I leave it.

What would you drink with your meal?

Frankly, I would love a bottle of 1900 Château Margaux to sip on for a couple of hours.

Would there be music?

Miles Davis would be live with Bob Dylan.

Who would be your dining companions?

I would like Fyodor Dostoyevsky, Ernest Hemingway, Charles Bukowski, Henry Miller, Tom Wolfe, Hunter S. Thompson, and F. Scott and Zelda Fitzgerald to join me.

Who would prepare the meal?

My chef Matthias Merges would be behind the scenes preparing everything.

✳

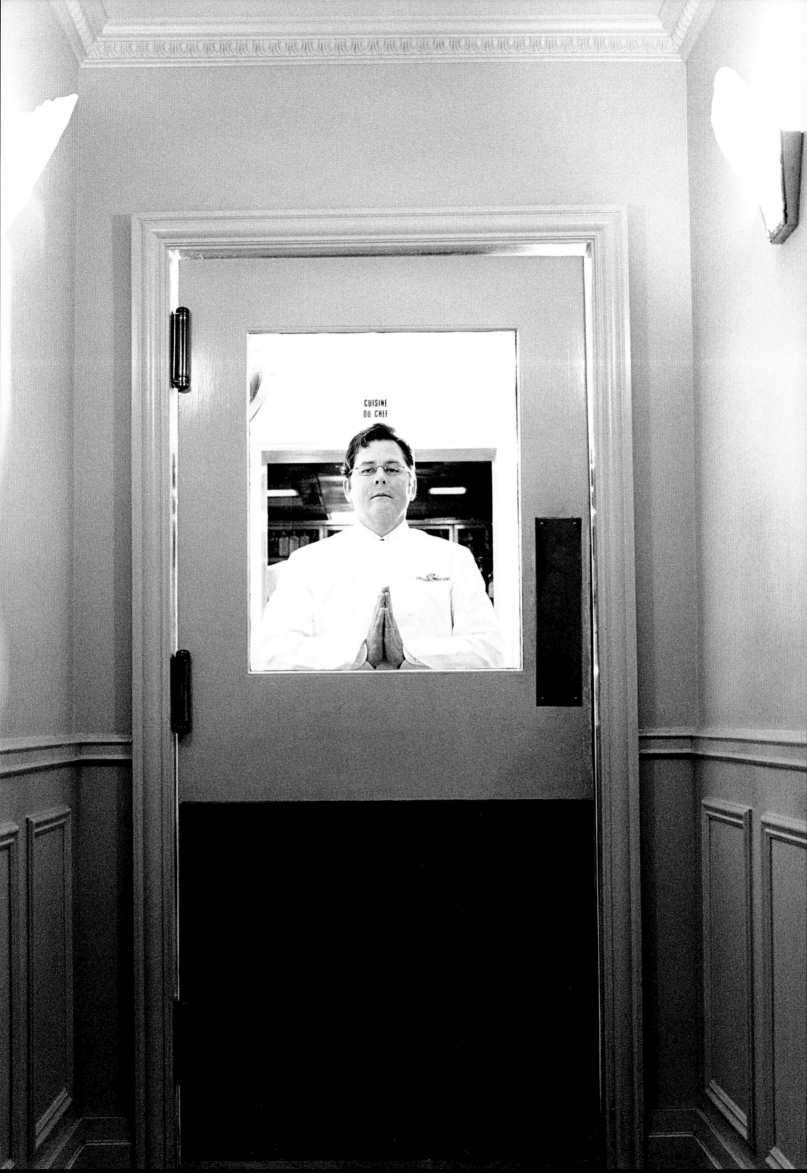

— JEAN-GEORGES VONGERICHTEN —

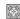

What would be your last meal on earth?

Visualize a royal banquet at the Grand Palace in Bangkok, which used to house the king. Some of the dishes featured might be shaved tuna; chili tapioca; Asian pear and lime lobster roll with dill and sriracha; crunchy squid salad; ginger, papaya, and cashews; char-grilled chicken with kumquat-lemongrass dressing; red curried duck; ginger fried rice; exotic fruit; and spiced lime salt.

What would be the setting for the meal?

The banquet would be served in the Royal Ballroom of the Grand Palace.

What would you drink with your meal?

We'd have Alsatian wines, like Tokay pinot gris, because they pair so well with Asian food.

Would there be music?

Dancers would perform accompanied by local Thai music.

Who would be your dining companions?

The king, his family, my family, and all my loved ones.

Who would prepare the meal?

The royal chef of the royal kitchen would prepare everything.

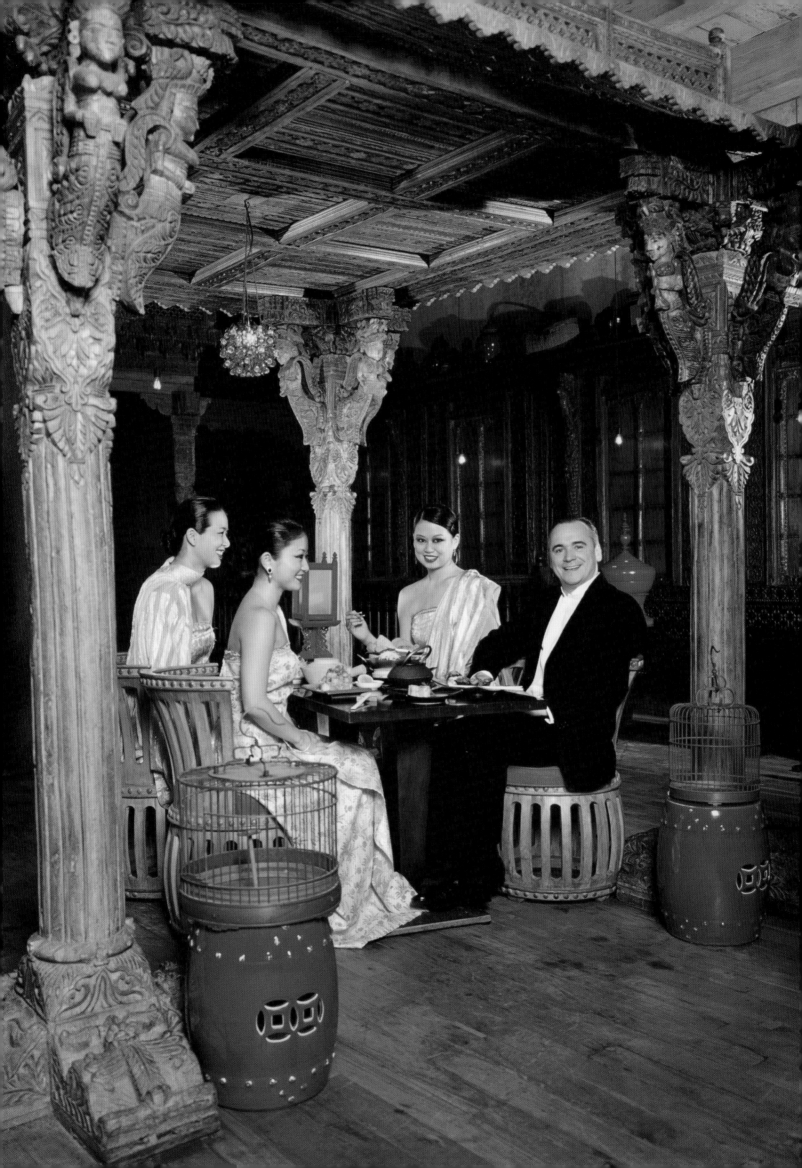

— Suzanne Goin —

What would be your last meal on earth?

I think it would be something really simple, served family-style: slices of amazingly ripe tomatoes with basil; sea salt and olive oil; great bread; butter; prosciutto and coppa; some roasted suckling pig with super crispy skin; and farm broccoli or rapini with garlic, shallots, and chili.

What would be the setting for the meal?

It would be on the beach, maybe on a deck, or in some sort of field or garden overlooking the beach. The seats and tables would be very comfortable and stylish, something sort of French Provençal.

What would you drink with your meal?

Billecart-Salmon vintage rosé champagne, probably followed by more rosé wine, and then maybe some Lang and Reed cabernet franc.

Would there be music?

Radiohead can play for me!

Who would be your dining companions?

If I can, I'd like to have brunch with my close friends and family, and dinner alone with my hubby.

Who would prepare the meal?

I would have someone extremely talented, but he or she would never be seen throughout the day.

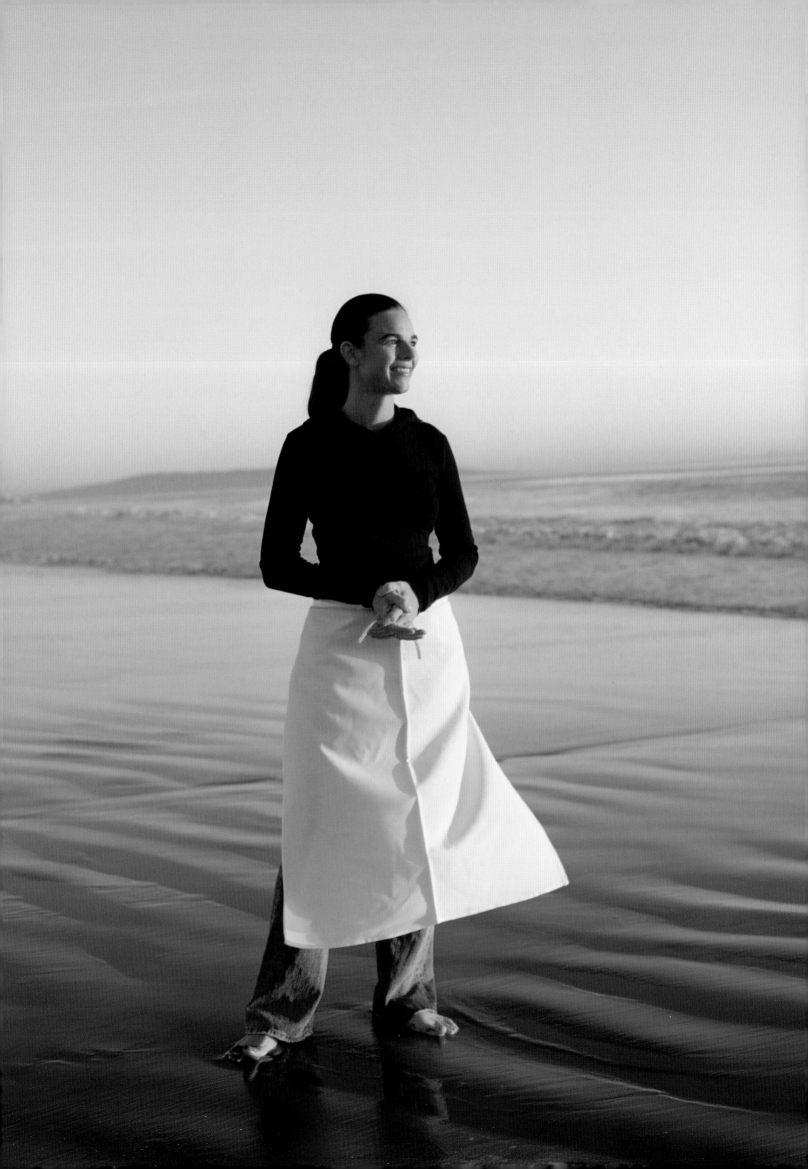

— MARTIN PICARD —

※

What would be your last meal on earth?

My last meal on earth would be a multicourse dinner. I would like to start with one kilo of caviar with blinis and the best butter, and with vodka, on an empty stomach. Then would come two truffles of one hundred grams each, one black and one white, minced on toasted bread from my restaurant, Au Pied de Cochon, with unrefined Guérande salt and olive oil. I would continue with cured foie gras on a boudin tart, with mustard and caramelized onions, and a snow goose, thinly sliced, marinated raw in a neutral oil, wine vinegar, and juniper berries from Île aux Oies. Next, a bluefin tuna flank from Nova Scotia, just caught, served raw with Au Pied de Cochon's homemade soy sauce and with a simple leaf of lettuce as the only vegetable, in honor of my mother. A mountain of snipes (in French, bécasse) hunted by myself and my hunter friends Marc Séguin and Hugue Dufour, prepared classically and according to the recipe in the 1984 edition of Larousse Gastronomique for bécasses rôties sur canapé. There wouldn't be any dessert served, because I never eat dessert unless it is made by Mostafa Rougabi, my neighbour and chef-owner of La Colombe, but I would need a deathbed to be able to look behind at the past.

What would be the setting for the meal?

It would be set in the forest during the fall, with winds that remind me of the cold air of the winter to come. This is the time for hunting white-tailed deer and finding vast fields of maple trees where you can feel free and no one owns anything. I would be full of the adrenaline of my last happiness.

What would you drink with your meal?

Philippe, my sommelier, would choose the wines, because he knows me, or else I'd order something. There would be Domaine de la Romanée-Conti and champagne, and vodka in Robidoux's memory to have with the caviar.

Would there be music?

I would listen to the recordings of Jean Leloup "the Wolf" Leclerc, Les Cowboys Fringants, and Bach as played by Glenn Gould.

Who would be your dining companions?

Jesus would dine with me, because he is used to having a last meal.

Who would prepare the meal?

My children would start to prepare the meal, but if they are misbehaving, their mother will stop them. Then Normand Laprise and Elena Faita, who are always there for me, will step in and finish the preparations.

※

WOULD THERE BE MUSIC?

*There would just be
water and the wind.*

e sounds of the

What would be your last meal on earth?
> My passion is fishing and boating. Since my favorite food in the world is tuna, I want my last meal to be like this: I would be on the boat, fishing; we would catch a tuna, let it settle for a few days, and then eat it. I would prepare it many ways—sashimi, carpaccio, lightly seared, tartare. This is a dream meal for me.

What would be the setting for the meal?
> On a boat of any size, any place; it doesn't matter to me as long as I am on the water.

What would you drink with your meal?
> I love cold sake, a really good one. A sake maker from Japan would make it for us.

Who would be your dining companions?
> I would be with my sailing teacher, John Whitehead, and my fishing teacher, Craig McGill.

Who would prepare the meal?
> Myself and Chef II. His name really is II.

TETSUYA WAKUDA

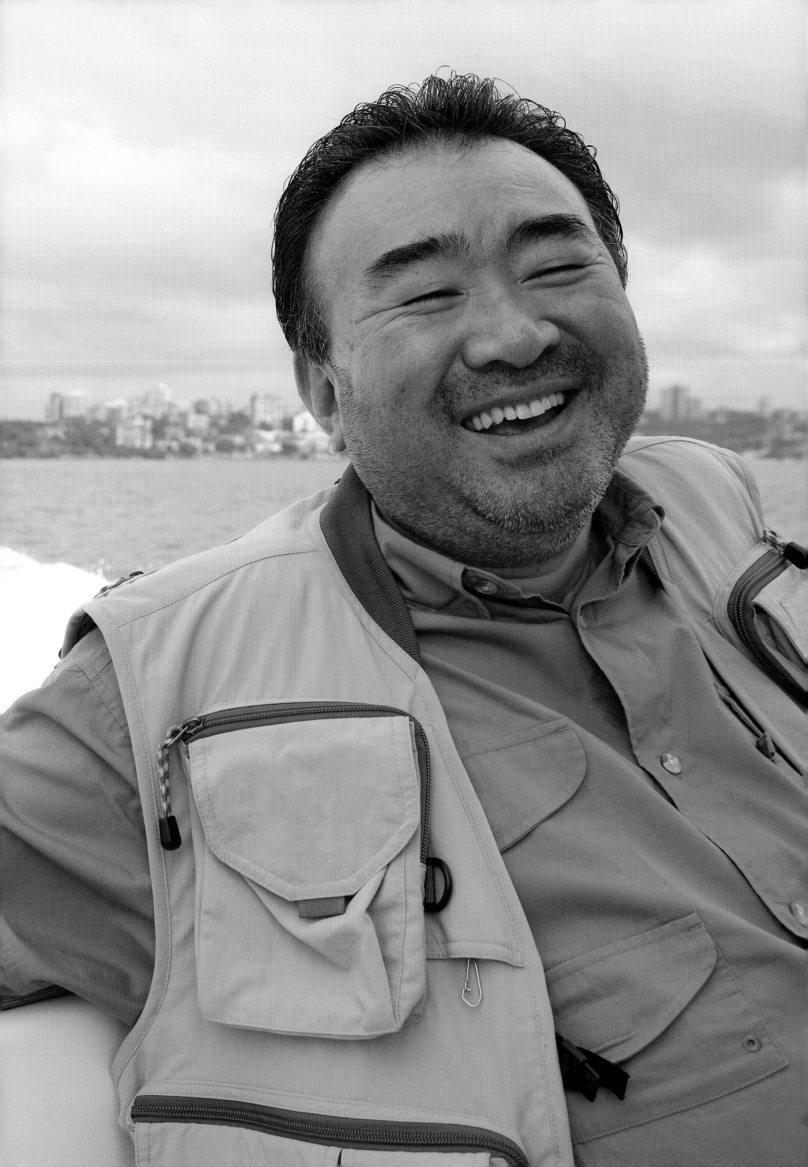

❋

What would be your last meal on earth? *To be honest, I would have the tuna BLT sandwich from the menu at BLT Fish Shack. I would have to add a little sriracha (a hot chili sauce). French fries with Heinz ketchup is also a must, and dessert would be a classic Krispy Kreme doughnut.* What would be the setting for the meal? *It would be a warm day on the beach in Mexico.* What would you drink with your meal? *I'd have beer — Corona with lime.* Would there be music? *Of course! U2 or the Rolling Stones would be playing live.* Who would be your dining companions? *My friends and family would dine with me.* Who would prepare the meal? *I would!*

❋

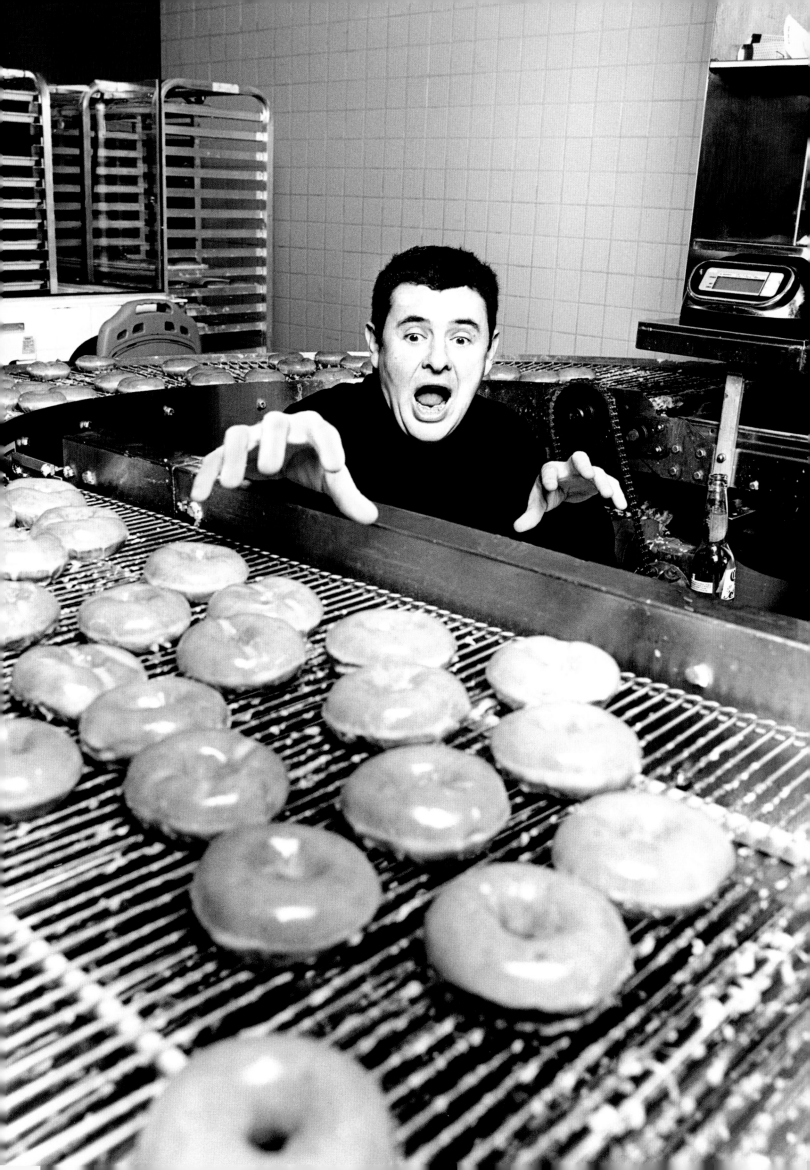

— W Y L I E D U F R E S N E —

WOULD THERE BE MUSIC?

Yes, and it would be
Dead would feature
1976 through 1979 r

ud. The Grateful
eavily, stuff from
tly.

What would be your last meal on earth?

It would be a very simple meal consisting of my personal favorites. Since it's my last one, there would be a definite comfort factor. I'd like loosely scrambled eggs with rye toast; a screaming rare cheeseburger with a fried egg on top, no bun; a nice steak with a traditional and very thick béarnaise sauce (the first sauce I learned to make); and some vegetables, just to placate my mom.

It's all there: breakfast, lunch, and dinner, and every course features eggs, my favorite food. The business cards at my restaurant feature an egg for this reason. My last meal would be chock-full of them.

What would be the setting for the meal?

It would be at the restaurant. Although it sounds clichéd, I really like eating standing up in my kitchen. There's a skylight there, and on sunny days in the afternoon the kitchen fills with light. The floor is blue, which adds to the feeling of airiness and lightness. I really like the atmosphere in the kitchen during the day. We listen to music, and it's usually very peaceful. Everyone's working hard and focusing on the task at hand. I feel very lucky to have a kitchen this beautiful, and to have such a hardworking crew. It's a special place for me.

What would you drink with your meal?

Wine. One of the advantages of being a chef is exposure to some very nice wines. I'm no expert, but I know what I like. My dad, Dewey Dufresne, does some of the wine selection for the restaurant, along with Glen Goodwin. I'd trust them to pair me with some egg-friendly vintages.

Who would be your dining companions?

It would be my friends and family.

Who would prepare the meal?

I'd scramble the eggs and whip up the béarnaise. But that's it. I'm not in charge on my last day. I'd trust my guys in the kitchen to do the rest.

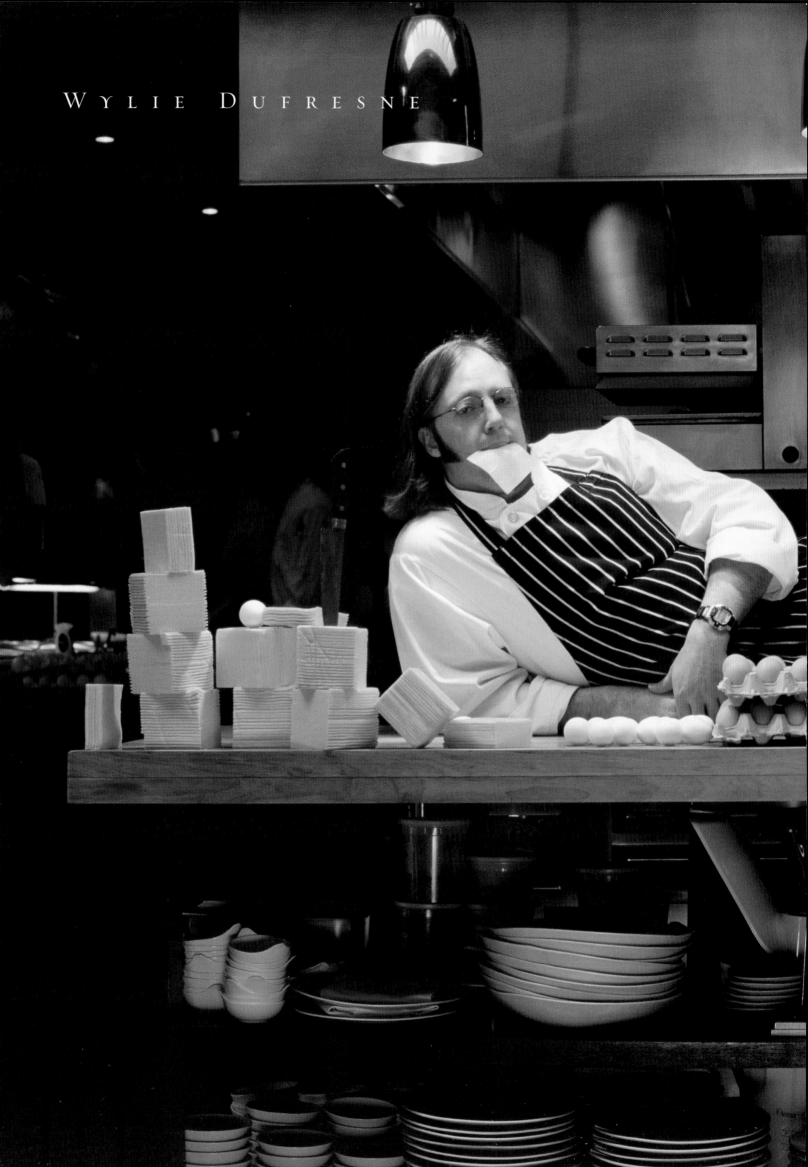

WYLIE DUFRESNE

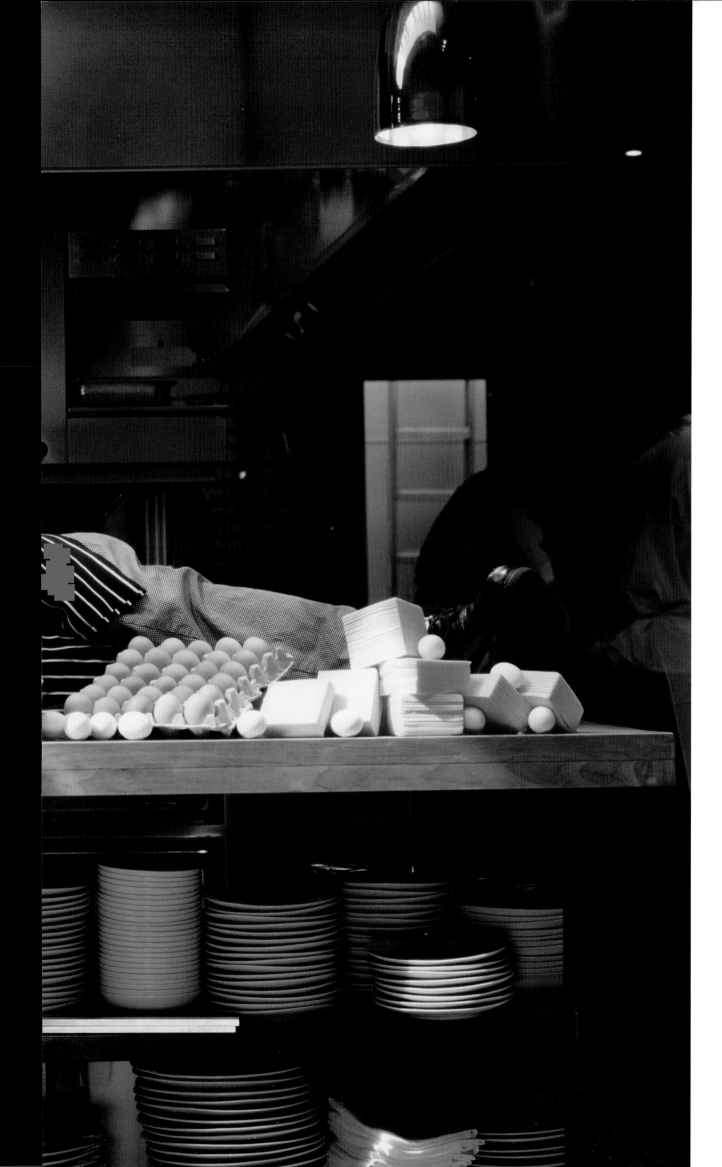

— J O S É A N D R É S —

*

What would be your last meal on earth?

That is a hard question. Dining at El Bulli is a once-in-a-lifetime experience, and I would certainly consider returning there. In the end, though, my favorite meals usually haven't taken place in a restaurant. For my last meal, I would want to re-create a wonderful Asturian barbecue that I once had in a beautiful old mill in Tazones, a small village in Asturias.

We began with warm tortillas and potato omelets, then picked at piles and piles of percebes (gooseneck barnacles), which are an absolute delicacy, followed by llámpares (a mollusk similar to snails) that someone had stewed with tomato and garlic. This was followed by rodaballo (turbot), which we had grilled over real charcoal. A few of the young men were fishermen and that afternoon they had pulled the real prize of the meal from local waters: centollo. Centollos are huge, almost prehistoric-looking spider crabs. These were so fresh they were still covered in seaweed. We cooked them on the grill and you can't imagine how good it was! The meat is so sweet and smoky. This being Asturias, we ended the meal with beef and blue cheese. Asturias is rainy and green and ideal for raising cattle. It produces some of the best beef in the world, and cabrales, the local blue cheese, is wonderful. It is a classic pairing, and to celebrate we grilled huge steaks worthy of Pedro Picapiedra — that is Fred Flintstone to you.

What would be the setting for the meal?

I would want to be in that mill in Tazones, or some place very, very similar. Asturias has a unique greenness and is surrounded with plenty of fresh air and the smell of the sea.

What would you drink with your meal?

Bottles of young albariño, a dry white wine from Galicia. It is very aromatic, full of flowers and fruit, and very acidic — perfect for all the seafood. We could also have famous Asturian cider. You pour it from high above your head while turning the bottle. This gives the cider oxygen and makes it almost carbonated, so it must be drunk quickly before the sparkle dissipates.

Would there be music?

No music would be necessary. There would be enough noise from the conversation and laughter!

Who would be your dining companions?

I would definitely want my wife and our girls there.

Who would prepare the meal?

I love to cook for people, so I would do much of the cooking. Maybe I would ask my friend Pedro Morán of Casa Gerardo to assist and prepare a fabada, the famous Asturian bean stew.

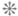

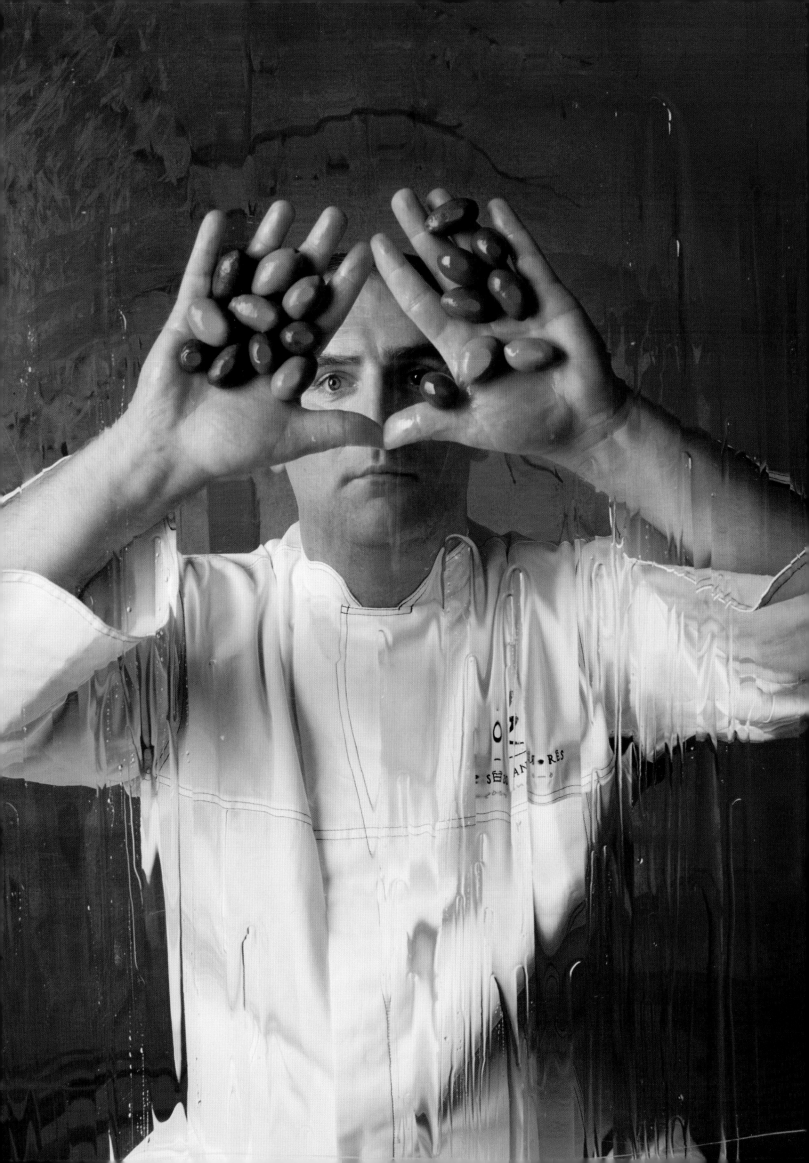

— C H U I L E E L U K —

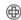

What would be your last meal on earth?

Assuming that I will be in good health and aware of the upcoming event, I would seek out the peace and comfort of familiar foods that have emotional meaning for me. I think I would have a meal of chili mud crab, braised tofu with prawn and pork, stir-fried snow pea leaf, and steamed rice, all followed by red bean pancakes with jasmine tea.

What would be the setting for the meal?

It would be a luxury to be at home, since I never get to spend much time there. It would allow me to bring to the private domain what I offer to the public on a daily basis. Everyone comes to my restaurant to experience my particular sense of hospitality and cuisine, and now I could reclaim that, sharing those things with my loved ones as a personal expression of my love and appreciation of them.

What would you drink with your meal?

I would have to have champagne, as it is my favorite. I'd chose one of the great vintages of the grand houses, perhaps Salon or Taittinger Comte de Champagne from 1998, or Dom Pérignon from 1989.

Would there be music?

I'd invite my friend Henry, a passionate and talented violinist, to serenade the group.

Who would be your dining companions?

At this point in time it would be my family and close friends. If you are asking who is on my fantasy list of invitees, I would hope that I'd already met them and dined with them by the time of my last supper. But among the living I would choose people like John Lanchester, whose book The Debt to Pleasure *drew all the threads of culinary history together for me, and David Thompson, whose writing also inspires me and whose wicked sense of humor would be much appreciated on such a black occasion.*

Who would prepare the meal?

I would. It has always calmed and focused my mind to engage in the physical act of preparing food, and it would be important to achieve this level of calm at this moment more than ever. It's my last opportunity to say good-bye to the craft that's given me so much happiness. There is a selfish reason for this, too. I imagine I would behave as I always have, and endlessly meddle with the dishes as I cooked them. Should I substitute the Queensland mud crab for the Tasmanian crayfish, or toss some deep-fried soft-shelled crab into the chili sauce? I'd wonder if perhaps some foie gras would go with the crab if I toned down the sauce, and if some Perigord truffles would be a good foil for the snow pea leaf. I try to live my life with the thought that no question should be left unanswered and no experience untried. By the time of this last supper, I would hope that I had already answered all the questions in my life, so that I could focus on saying good-bye.

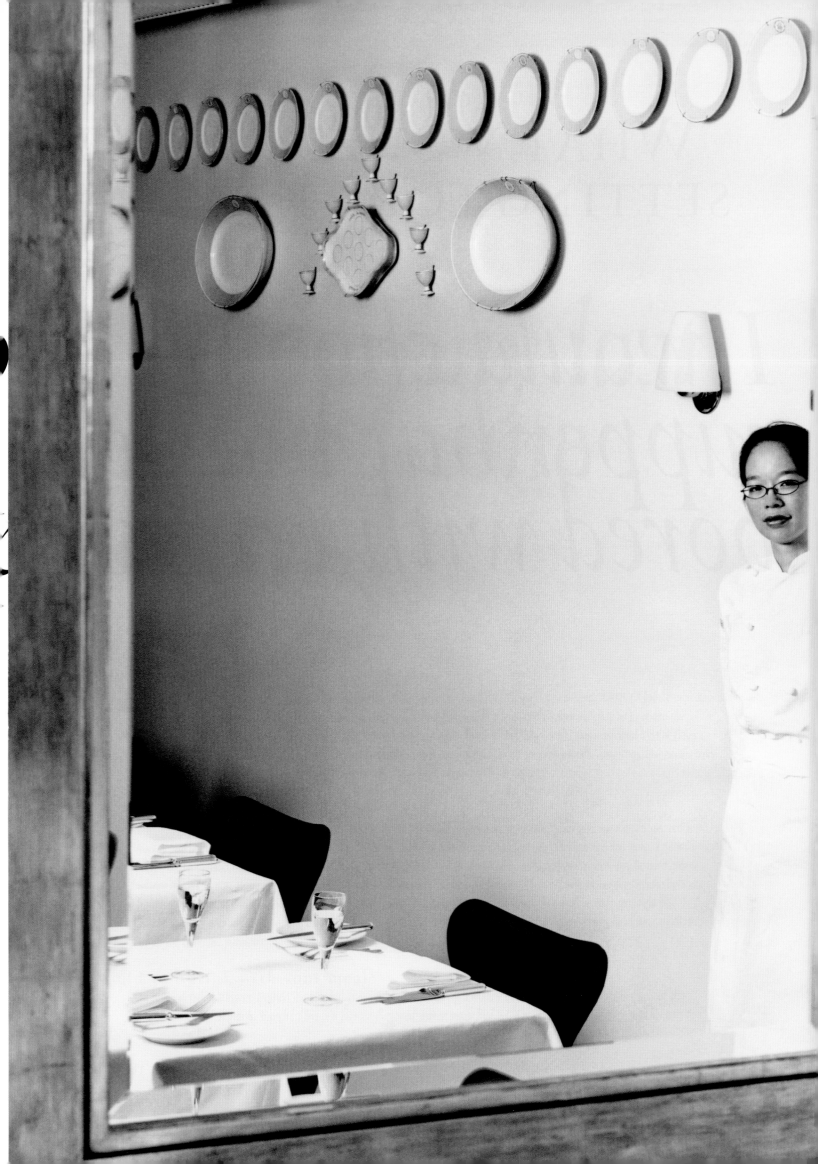

— Alain Ducasse —

Would there be music?

A tune would probably float in my mind — the song written in 1954 by Bart Howard and immortalized ten years after by Frank Sinatra: "Fly Me to the Moon." Can you hear it?

Who would be your dining companions?

I would have three companions: Takayama Tatsuhiro, chef of a tiny restaurant, surprisingly called Tout Le Monde, in Osaka, Japan. He is one of the most sophisticated chefs in Japan and a master of both contemporary Western techniques and Japanese millenary traditions. Jean-Paul Veziano, who, in the old district of Antibes on the French Mediterranean coast, is one of the most inspired bakers and keeps alive the authentic Provençal tradition of pissaladière (a tart of onions flavored with pissalat, a condiment made from the salting and subsequent fermentation of tiny anchovy-like fish). And Joseph Minocchi, a farmer whose ranch, White Crane Springs, is in Healdsburg, in northern California. The herbs (like sage and marjoram) and vegetables (like miner's lettuce and watercress) he produces are just outstanding. All three are bridges between yesterday and today, between the land and the plate, and between cultures. They embody various manners of eating well and responsibly.

Who would prepare the meal?

Alain Souliac, who is the chef at Ostapé, the country inn I opened in the French Basque region a couple of years ago. Who else could it be? Here on Earth, I prepare food for the astronauts in the same ultratechnological laboratory where I prepare very traditional, peasant-style boudin noir (a black sausage made of pork blood). I like that such different foods, representing old and new, can emerge from one place. It pushes our idea of food in new directions, and celebrates the pleasure of eating, whatever the situation.

Mars for my last I have become pleasures.

The reason for this remote location is that, because of my training and consulting department, ADF (Alain Ducasse Formation), I've been commissioned by the European Space Agency and the French Space Agency to prepare the "special event meals" for the astronauts of the International Space Station. I've also been commissioned by the ESA to create meals the astronauts of the Mars mission could eat not only during their several-month-long trip, but meals they could continue to eat after their arrival by growing the actual ingredients on Mars!

What would be your last meal on earth?

I would begin with a caponata. This is a Sicilian specialty made of peppers, tomatoes, and zucchini and flavored with honey and almonds. It is a light and delicious way to start the meal, with a definitive Mediterranean note. I would then have roasted quails in a Madiran wine sauce. With this dish, we move to the southwest of France, my home region, where the Madiran wine is from. Then would come smooth celeriac (celery root) purée with nutmeg, whose delicate lightness would pair marvelously with these small birds. I would finish with "melt-in-your-mouth apple slices." These four recipes are some of the ones we created for the astronauts in the French Space Agency, and we call them "food for extreme pleasure."

What would you drink with your meal?

I would drink a Flower Power, an alcohol-free cocktail created by Thierry Hernandez, director of the bar at the Plaza Athénée, in Paris, Earth. This is a flower-flavored water, enriched with revitalizing oxygen — a futuristic thirst-quencher.

— A L A I N D U C A S S E —

Would there be music?

A tune would probably float in my mind — the song written in 1954 by Bart Howard and immortalized ten years after by Frank Sinatra: "Fly Me to the Moon." Can you hear it?

Who would be your dining companions?

I would have three companions: Takayama Tatsuhiro, chef of a tiny restaurant, surprisingly called Tout Le Monde, in Osaka, Japan. He is one of the most sophisticated chefs in Japan and a master of both contemporary Western techniques and Japanese millenary traditions. Jean-Paul Veziano, who, in the old district of Antibes on the French Mediterranean coast, is one of the most inspired bakers and keeps alive the authentic Provençal tradition of pissaladière (a tart of onions flavored with pissalat, a condiment made from the salting and subsequent fermentation of tiny anchovy-like fish). And Joseph Minocchi, a farmer whose ranch, White Crane Springs, is in Healdsburg, in northern California. The herbs (like sage and marjoram) and vegetables (like miner's lettuce and watercress) he produces are just outstanding. All three are bridges between yesterday and today, between the land and the plate, and between cultures. They embody various manners of eating well and responsibly.

Who would prepare the meal?

Alain Souliac, who is the chef at Ostapé, the country inn I opened in the French Basque region a couple of years ago. Who else could it be? Here on Earth, I prepare food for the astronauts in the same ultratechnological laboratory where I prepare very traditional, peasant-style boudin noir (a black sausage made of pork blood). I like that such different foods, representing old and new, can emerge from one place. It pushes our idea of food in new directions, and celebrates the pleasure of eating, whatever the situation.

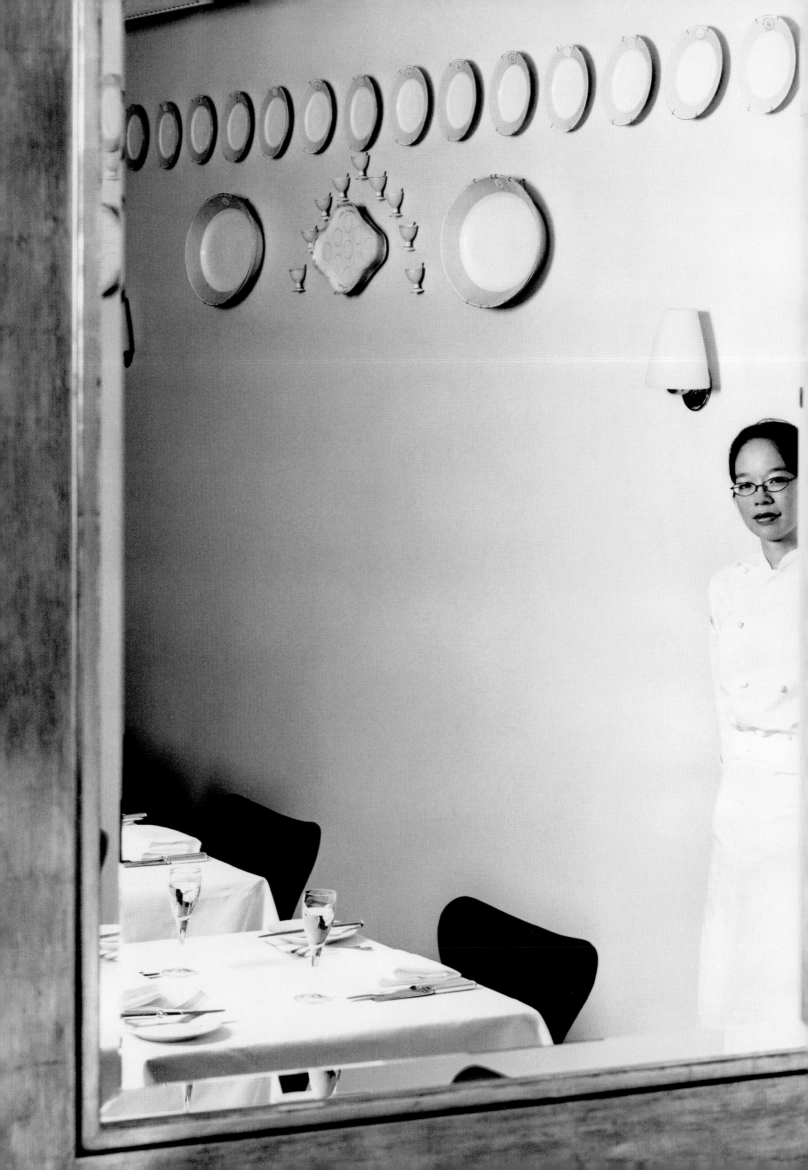

─ A L A I N D U C A S S E ─

WHAT WOULD BE THE SETTING FOR THE MEAL?

❋

I would choose to go
supper, but not beca
bored with terrestri

❋

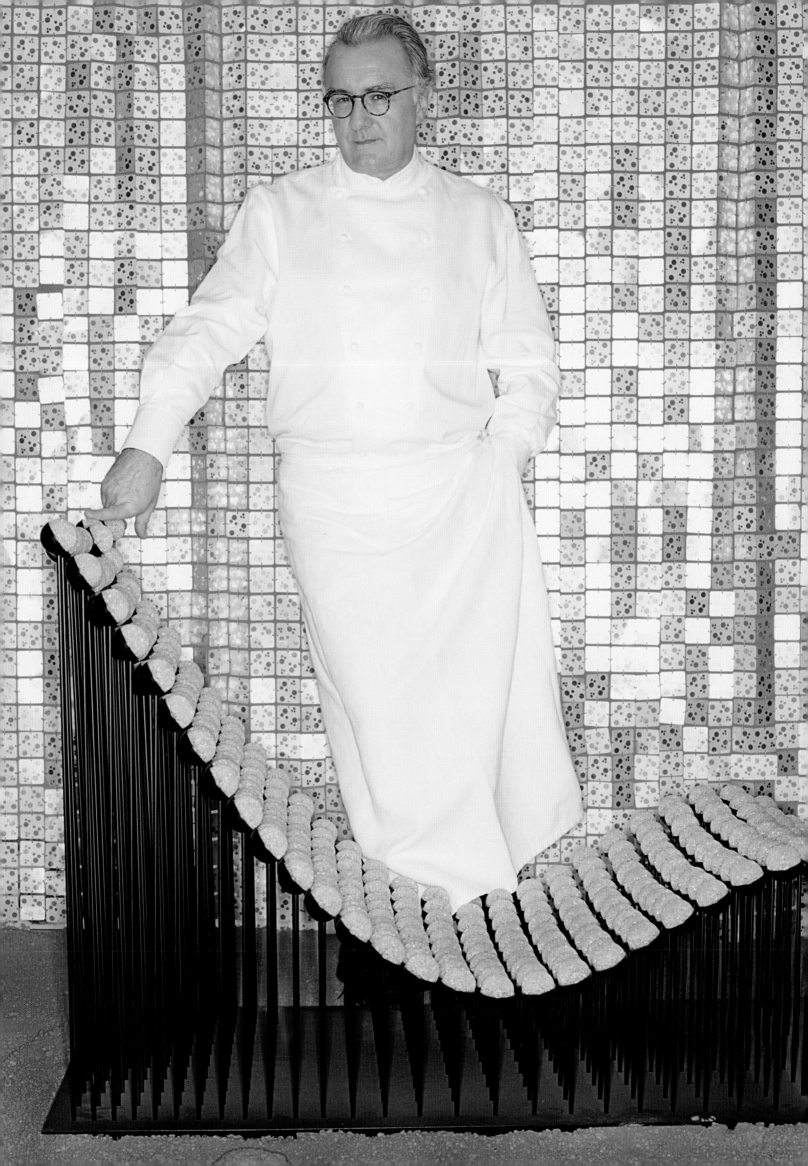

Dear Madam,

I thank you for your note, and am touched by your admiration.
Nevertheless, I have a phobic rapport with death, and because of this, will never discuss my last meal!
This returns me to my life's philosophy: I talk about openings, not closings.

Receive, dear Madam, my best wishes,

Guy Savoy

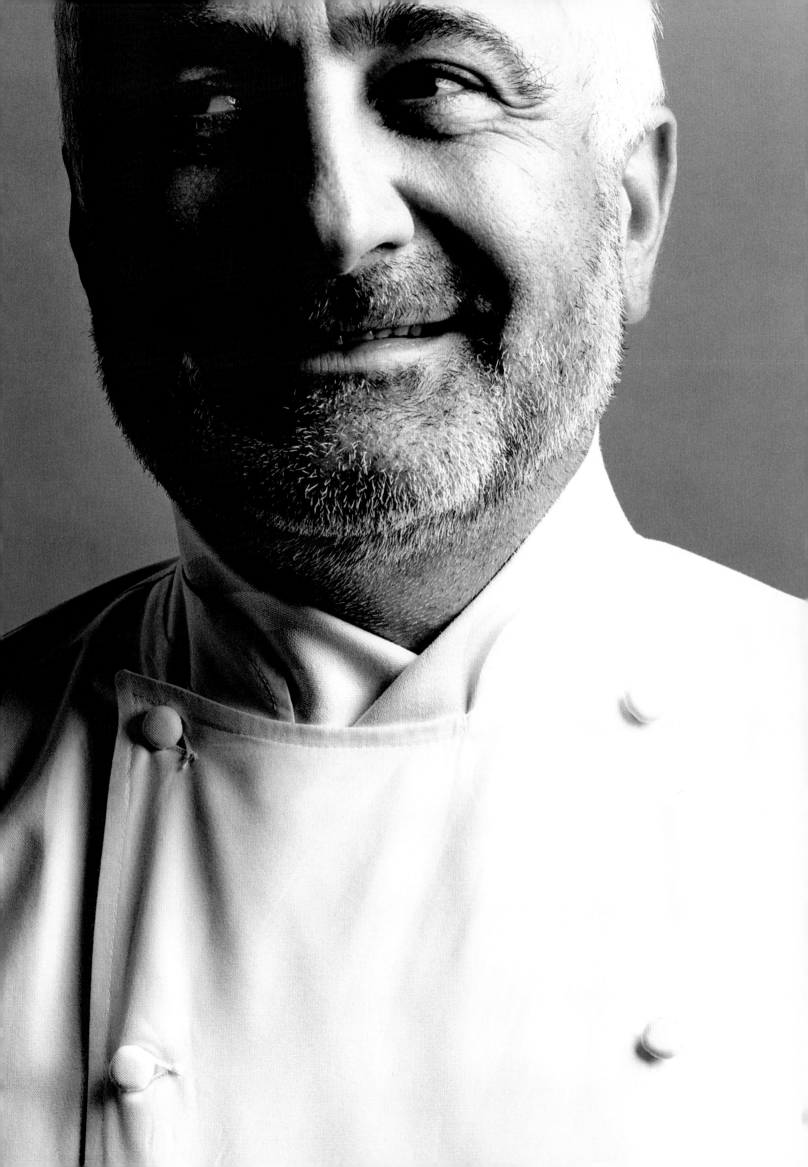

RECI

PES

Serves 4

3 tbsp/45 ml olive oil
2 cloves garlic, crushed
½ chili pepper
10½ oz/300 g cod trimmings and bones
1 cup/235 ml heavy cream (double cream)
Salt and freshly ground black pepper to taste
2¼ lbs/1 kg pork spareribs
1 cup/235 ml sunflower oil
½ cup/120 ml white wine
½ cup/120 ml plus 4 tbsp/60 ml honey
1 cup/235 ml water
6½ tbsp/90 g fondant sugar paste
6½ tbsp/90 g glucose
4 baby onions
2 eggs

Special Equipment:
1½ litre iSi soda siphon
1 N₂O cartridge
2 Silpat baking sheets

To Prepare the Cod Foam:
Heat the olive oil over low heat. Add the garlic and chili and sauté until lightly browned. Add the cod trimmings and sauté for 1 minute. Next, stir in the cream and turn the heat up to medium. Allow the mixture to simmer for 15 minutes. Remove the mixture from the heat and refrigerate it for 6 hours. Then using a spatula or wooden spoon, push the mixture through a fine sieve three times. Add salt and pepper to taste. Load the siphon with the strained mixture and refrigerate for 12 hours.

To Prepare the Honey-Flavored Pork Stock:
Preheat the oven to 390°F/200°C. Cut the pork spareribs into 3-in/7½-cm pieces and place them in a large roasting

pan, toss in half of the sunflower oil, and season them with pepper. Roast the spareribs until they are brown and completely cooked through, approximately 2 to 2½ hours. Remove the ribs once they are thoroughly roasted and set them aside. Immediately deglaze the roasting pan with the wine, being careful to scrape all the drippings from the bottom. Place the roasting pan on the stove top over medium heat, add ½ cup/120 ml of honey to the pan, and allow it to caramelize, approximately 2 minutes. Transfer the contents of the roasting pan to a medium saucepan, add the water, and simmer on very low heat until the mixture is reduced by half. Skim off the fat and strain.

To Prepare the Honey Caramel:
Line a sheet pan (baking tray) with wax paper. Place the fondant sugar paste, the glucose, and the 4 tbsp/60 ml of honey in a pan over medium heat. Cook until a thermometer registers 320°F/160°C. Remove the resulting paste from the heat and spread it over the wax paper at a thickness of approximately ¾ in/2 cm. Set it aside and allow it to cool. Once the sugar mixture has cooled and hardened, cut it into 2-in/5-cm squares. Place one of the squares between two Silpat baking sheets and heat in a 340°F/170°C oven until the caramel has melted, approximately 5 minutes. Leaving the melted caramel between the Silpat sheets, use a rolling pin to roll out the caramel until it is ¼ in/½ cm thick. While it's still warm, cut the caramel into 10-in/25-cm squares.

To Prepare the Baby Onions:
Blanch the whole onions in boiling water for 30 seconds. Drain and cool in an ice-water bath. Peel the onions, ensuring they remain whole. Heat the remaining ½ cup/120 ml of sunflower oil in a small saucepan over low heat. Add the whole onions and cook, stirring occasionally, until they are soft, approximately 25 minutes. Remove them from the oil, drain them on a paper towel, and cut each onion vertically down the middle. Heat 4 tbsp/60 ml of the prepared pork stock in a small sauté pan over medium heat. Add the sliced onions, cut-side down, and sauté for 1 minute. Remove from the heat and keep warm.

To Prepare the Soft-Boiled Eggs:
Bring a pot of water to boil and add the eggs. After 3½ minutes, remove one egg and set it aside. Allow the other egg to cook for an additional minute and then remove. Allow both eggs to cool, then peel and roughly chop the eggs together. Add salt and pepper to taste.

To Serve:
Using the soda siphon, spray a garland of cod foam around the edge of a shallow dish. Place 1 tbsp/14 g of soft-boiled egg in the center of the garland. Cover the eggs with more of the cod foam. Place 2 onion halves on top of the foam with the caramelized side facing upward. Finish by arranging a few pieces of broken honey caramel on top of the onions and the foam.

Serves 2

⅓ cup/80 ml plus 6 tbsp/90 ml olive oil
2 banana shallots, finely diced
1 clove garlic, finely diced
1 cup/235 ml fish stock
4 San Marzano tomatoes, chopped into ½-in/1-cm dice
Juice of one lemon
1 tsp fresh basil, finely chopped
1 tsp fresh chives, finely chopped
1 tsp fresh tarragon, finely chopped
Coarse sea salt and pepper
4 extra large scallops
1 tsp/5 g butter

To Prepare the Sauce:
In a large sauté pan, heat 3 tbsp/45 ml of olive oil over low heat. Add the shallots and garlic and sauté until the shallots are tender, about 2 to 3 minutes. Next, add the fish stock and reduce the liquid by two-thirds. Once the stock is reduced, add ⅓ cup/80 ml of olive oil, the tomatoes, and the lemon juice and allow the sauce to simmer gently for 4 to 5 minutes. Remove the sauce from the heat and stir in the basil, chives, and tarragon. Season generously with salt and pepper.

To Prepare the Scallops:
While the sauce is simmering, heat the remaining 3 tbsp/45 ml of olive oil in a sauté pan over high heat. Add the scallops and cook for 1 minute on each side, then add the butter and toss the scallops in the butter until they are golden all over.

To Serve:
Place the scallops into 2 bowls and spoon the sauce over them.

— José Andrés —
Centollo-Filled Piquillo Peppers
(Piquillos Rellenos de Centollo)

Serves 6

Centollos are the huge, almost prehistoric-looking spider crabs of Asturias. The best way to cook them is simply. First, weigh your centollo. For every 3½ oz/100 g of crab, you need 4¼ cups/1 l of water. In a large pot, bring the water to a boil, immerse the centollo, and cook for 1 minute. Remove the crab from the water and cut off the legs. Then return the crab to the boiling water and cook for 1 minute for every 3½ oz/100 g. For example, for 1 lb/½ kg of centollo, you need 1 ⅓ gal/5 l of water and you would cook it for 5 minutes.

6 hazelnuts, crushed
½ tsp parsley, very finely chopped
1 tsp/5 ml Spanish extra-virgin olive oil
1 tsp/5 ml sherry vinegar
1½ cups/12 oz/340 g crabmeat picked from the cooked centollo
Salt and white pepper to taste
1 8-oz/225-g jar whole roasted piquillo peppers (approximately 12 peppers)

In a small sauté pan, toast the hazelnuts over low heat until they turn light brown, about 3 minutes, stirring regularly to ensure they don't burn. Remove the pan from the heat and set aside.

In a bowl, whisk together the parsley, olive oil, sherry vinegar, and toasted hazelnuts to create the dressing. Fold the crabmeat into the dressing with a spatula. Add salt and pepper to taste. Stuff the piquillo peppers with the crabmeat mixture and serve.

—Juan Mari Arzak—
Boiled Egg and Truffle Flowers in Goose Fat with Chorizo and Date Mousse

Serves 4

3½ tbsp/50 g white grapes
2 tbsp/30 g black grapes
½ cup/120 ml plus 5 tsp/25 ml extra-virgin olive oil
2 tbsp/30 ml rice vinegar
½ tsp ground ginger
3 tbsp/40 g chopped parsley
Salt and pepper to taste
½ cup/110 g dates
5¼ oz/150 g plus 2 oz/55 g chorizo
1 cup/235 ml water
2 tsp chopped garlic
2 tbsp/30 g finely chopped chanterelle mushrooms
2 tbsp/30 g finely chopped boletus mushrooms
2 oz/55 g bacon, chopped
1 cup/225 g bread crumbs
4 oz/120 ml truffle juice
3 egg yolks
4 eggs
2 tsp/10 ml truffle oil
1½ tbsp/20 g goose fat
1 tbsp/15 g chopped spring onion
4 to 5 chervil leaves, chopped

To Prepare the Grape Vinaigrette:
Seed the grapes, chop them into small cubes, and place them in a small mixing bowl. Add ½ cup/120 ml extra-virgin olive oil, the rice vinegar, ¼ tsp of ginger, and

1 tbsp/15 g of parsley. Season to taste with salt and pepper.

To Prepare the Chorizo and Date Mousse:
Grind the dates, 5¼ oz/150 g chorizo, ½ cup/120 ml of

— J U A N M A R I A R Z A K —
B O I L E D E G G A N D T R U F F L E F L O W E R S
I N G O O S E F A T W I T H C H O R I Z O A N D D A T E M O U S S E

water, and the remaining ¼ tsp of ginger to a fine paste in a food processor. Using a spatula, press the mixture through a fine sieve and set aside.

To Prepare the Mushroom Garnish:
Heat 3 tsp/15 ml of olive oil in a sauté pan over medium heat. Add 1 tsp of the garlic and both varieties of mushroom. Sauté until the mushrooms are soft, approximately 2 to 3 minutes. Add the remaining 2 tbsp/25 g of parsley and remove from the heat.

To Prepare the Bread Crumb Garnish:
Chop the remaining 2 oz/55 g of chorizo, and place it with the bacon, bread crumbs, and remaining 1 tsp of garlic in a medium sauté pan over low heat and cook until the mixture is golden brown. Stir in the remaining ½ cup/120 ml of water and the truffle juice and continue cooking the mixture on low heat for an additional 5 minutes. Remove from the heat and keep warm.

To Prepare the Egg Yolks:
Mix the yolks lightly and add 2 tsp/10 ml extra-virgin olive oil. Season with salt and pepper.

To Prepare the Eggs:
Spread 4 small sheets of plastic wrap that are approximately 5 in/13 cm square on a cutting board. Brush each piece of plastic wrap with olive oil and carefully crack one egg in the center of each piece. Sprinkle 6 drops of truffle oil, 3 drops of goose fat, and a pinch of salt over each egg. Gather up the plastic wrap around the egg and tie a knot at the top, forming a small pouch. Cook the wrapped eggs in boiling water for 4½ minutes each. Use a slotted spoon to remove the eggs from the water. Cut the top of the plastic to remove the eggs and keep warm in a covered dish.

To Serve:
Place the hot egg in one corner of a square dish. Trace two parallel lines, ½ in/1 cm wide, underneath it, one of bread crumbs, the other of the mousse. Sprinkle 1 tbsp/15 ml of the egg yolk on top of the eggs and spoon 1 tbsp/15 ml of the grape vinaigrette over the top. Finish off with a sprinkling of chopped spring onions and a sprig of chervil. Garnish with 1 tbsp/15 g of the sautéed mushrooms.

— DAN BARBER —
BRAISED PIG SALAD

❧

Serves 6

¼ cup/60 ml orange juice
2 tbsp/30 ml verjus
½ cup/110 g dried apricots, in a ¼-in/½-cm dice
1 pig's foot, braised and shredded
(see following Braised Pig's Foot, Tail, Ear, and Snout recipe)
1 pig's tail, braised and diced
1 pig's ear, braised and julienned
¼ cup/60 ml plus 2 tbsp/30 ml reserved pig braising liquid
2 shallots, finely diced
2 sprigs thyme
1 pig's snout, braised
3 heads Bibb lettuce
1 cup/225 g mixed herbs — parsley, tarragon, chervil, thyme, mint, cilantro, chives — leaves whole, do not chop
1 cup/225 g soybeans
½ cup/110 g unsalted pistachios, shelled
Salt and pepper
Lemon Vinaigrette (see following recipe)
5 tbsp/70 g diced pancetta
5 tbsp/70 g diced guanciale
2 tbsp/30 ml balsamic vinegar

In a small saucepan, gently combine orange juice and verjus. Bring to a simmer, add the dried apricots, and cook until the apricots begin to soften, 3 to 4 minutes. Remove from the heat and allow the apricots to cool in the saucepan. Once they're cooled, strain and set aside.

In a medium saucepan, combine the prepared pig's foot, tail, and ear. Add ¼ cup/60 ml of the pig braising liquid, shallots, and thyme, and lightly warm. In a small sauté pan, sear the prepared pig snout on all sides, then remove it from the heat and slice thinly.

In a large bowl, combine the Bibb lettuce, herbs, soybeans, pistachios, and the prepared apricots. Season the salad with salt and pepper and lightly dress it with lemon vinaigrette and 2 tbsp/30 ml of the pig braising liquid. Toss in the foot, ear, and tail.

In a small pot over low heat, add the diced pancetta and guanciale until the fat melts from both. Add the balsamic vinegar.

To Serve:
Plate the salad adding the seared snout just before serving. Drizzle the warm pancetta vinaigrette on the salad tableside.

— DAN BARBER —
BRAISED PIG SALAD

❧

Braised Pig's Foot, Tail, Ear, and Snout

2 tbsp/30 ml grape seed oil
2 carrots, peeled; 1 chopped, 1 diced
2 onions, peeled; 1 chopped, 1 diced
1 stalk celery, chopped
1 leek, chopped
4 cloves garlic
1 cup/235 ml red wine
1 pig's foot
1 pig's tail
Bouquet garni (1 bay leaf, 4 sprigs thyme, 1 tsp black peppercorns, and 2 juniper berries)
1 pig's ear
1 pig's snout

In a medium pot, heat the oil over medium to low heat. Add the chopped carrot, onion, celery, leek, and 2 cloves of garlic and sweat for 4 to 5 minutes. Add the wine and reduce by half. Add the pig's foot and tail, cover with cold water, bring to a simmer, and skim well. Simmer covered for approximately 2½ hours. After 1 hour, add the bouquet garni. Check the tail first; if it's very tender, remove it and continue cooking the foot until tender. Cool the tail and foot and set aside. Strain the liquid and reduce by half and then set aside.

In a medium pot, lightly brown the ear and snout; add and brown the diced onion, carrot, and 2 cloves of diced garlic. Add the reserved stock and bring it to a simmer. Cover and cook the ear and snout until tender. Remove from the liquid and cool. Reserve the liquid for the salad recipe.

Lemon Vinaigrette

½ tbsp Dijon mustard
¼ cup/60 ml lemon juice
¼ cup/60 ml Lemon Oil (see following recipe)
½ cup/120 ml olive oil
Salt and pepper to taste

In a medium bowl, combine the mustard and lemon juice. Slowly whisk in the lemon oil and olive oil. *Season to taste.*

Lemon Oil

4 cups/945 ml canola oil
1 tsp lemon zest
¼ bunch lemon thyme
¼ stick lemongrass

In a medium saucepan, combine all the ingredients and place them over a very low heat for 1 hour. Do not let the oil boil. Remove the oil from the heat, cool, and strain. Refrigerate until ready to use.

— LIDIA BASTIANICH —
PEACH GRANITA
(GRANITA DI PESCA)

☙

Serves 6

2 cups/470 ml water
1 pound/450 g unpeeled ripe peaches
⅓ cup/75 g sugar
2 tablespoons/30 ml fresh lemon juice
1 drop vanilla extract
Mint leaves for garnish

Bring the water to a boil in a medium saucepan. Add the peaches and sugar and simmer gently over low heat for 30 minutes. Allow the peaches to cool thoroughly in the liquid and pass the contents of the pan through a fine-mesh strainer, scraping the solids to extract as much pulp as possible. Pour the strained liquid into a stainless steel or glass bowl and stir in the lemon juice and vanilla extract. Freeze for 45 minutes to 1 hour, scraping the ice crystals that form around the edges into the center every 10 minutes with a spatula. The mixture should be of an even, grainy consistency when ready.

To serve, scoop the granita into chilled serving glasses and garnish with mint leaves.

— MARIO BATALI —
SHRIMP IN CRAZY WATER
(GAMBERONI ALL'ACQUA PAZZA)

Serves 4

6 tbsp/90 ml extra-virgin olive oil
1 medium Spanish onion, chopped into ½-in/1-cm dice
4 garlic cloves, thinly sliced
2 tbsp chopped fresh hot chilies
1 fennel bulb, chopped into ½-in/1-cm dice, fronds reserved
1 28-oz/828-ml can tomatoes, crushed by hand, with juice
2 cups/475 ml dry white wine
½ cup/120 ml seawater, or ½ cup/120 ml water mixed with 1 tsp salt
16 jumbo shrimp, peeled, head and tail on
Freshly ground black pepper

In a 6-qt/5½-l soup pot, heat the oil over medium heat until smoking. Add the onion, garlic, chilies, and diced fennel and cook until soft and light golden brown, about 8 to 10 minutes, stirring occasionally.

Add the tomatoes, wine, and water and bring to a boil. Lower the heat and simmer for 10 minutes. Add the shrimp and simmer until they are cooked through, about 5 minutes. Season to taste with freshly ground black pepper.

To serve, pour into a soup tureen and garnish with the fennel fronds.

Serves 10

Sunday is carnitas day in Mexico. Walking the neighborhoods or market perimeters on Sunday in practically any part of Mexico, especially Central and West Central and Michoacán, you'll find folks with huge hand-hammered copper cauldrons filled with joints of pork bobbing about in its own fat. Chunks of the roasty-looking meat are sold by the kilo for making tacos with warm tortillas, guacamole, salsa, and, usually, a little cactus salad.

½ cup/120 ml fresh lime juice
1 tbsp salt
5 lbs/2¼ kg boneless pork shoulder
About 4 lbs/1¾ kg rich-tasting pork lard
About 4 dozen corn tortillas
About ½ lb/225 g crackling-fresh chicharrón (crisp-fried pork rind sold in Mexican markets)
4 cups/910 g cactus salad
3 cups/680 g guacamole
1 cup/225 g spicy salsa

In a large bowl, mix the lime juice and salt. Cut the pork into slabs roughly 3 in/8 cm thick; try to get them all about the same thickness so they will cook evenly. Place the meat in the bowl and turn to coat it on all sides with the lime juice mixture. Cover the bowl and let it stand for 1 hour, turning the meat occasionally.

Over medium heat, melt the lard in a very large pot.

I like to use a 12-qt/11-l stockpot or a 9-qt/8½-l Dutch oven, but whatever you choose should be deep enough so there is at least 4 in/10 cm between the top of the lard and the top of the pot—you don't want the hot fat splashing out. Carefully slip the pork into the melted lard, scraping in any accumulated juices at the bottom of the bowl; the lard should completely cover the pork. After a few minutes, the lard will come to a very gentle boil. Adjust the temperature as necessary to maintain an easy boil of large bubbles (nothing too vigorous) and cook, occasionally moving everything around with long-handled tongs to prevent sticking, until the meat is tender when pierced with a fork, about 2 hours.

Next, raise the temperature to medium high. Continue gently moving the slabs of pork regularly as the temperature rises. The bubbles will become smaller, and the sound will be that of noisy frying. Let the meat cook for about 30 more minutes, or until the exterior of each piece is crispy and golden. Since the pork will appear a little lighter when it is submerged, use tongs and a spatula or slotted spoon to lift out the pieces when they don't look quite as dark as you'd like them. Turn on the oven to the lowest setting. Drain the carnitas on paper towels, transfer to a baking sheet, and keep warm in an oven set at 200°F/90°C.

To Serve:
Steam the corn tortillas. Spread the chicharrón evenly on a baking sheet and put them into an oven set at 200°F/93°C. Bake for about 7 minutes to warm and recrisp the chicharrón.

Spoon the cactus salad, guacamole, and salsa into serving bowls, move the carnitas to a warm serving platter, break the chicharrón into large pieces and pile in a big basket, and nestle the warm tortillas into a cloth-lined basket.

Set everything out as a buffet and let your friends dig in. You may want to position yourself at a cutting board near the carnitas, to help your guests cut pieces of meat into the perfect sizes for making tacos—though I think part of the fun of this informal meal is twisting off a little hunk of meat onto my plate, then pulling it into shreds with my fingers, to wrap into tortillas with whatever flavoring strikes me at the moment.

Hint:
The carnitas will keep covered in the refrigerator for several days; they also can be frozen. Reheat them uncovered in a 350°F/175°C oven.

MICHELLE BERNSTEIN

POTATO AND APPLE PANCAKES

❧

Makes about 5 pancakes

1 lb/450 g russet potatoes, peeled
1 Granny Smith apple, peeled and cored
1 large egg
¼ cup/55 g flour
Salt and black pepper
Canola oil for frying
Crème fraîche (optional)
Caviar (optional)

Shred the potatoes and apple together in a food processor, working quickly to avoid discoloration. Place the mixture in a colander or strainer and press with a spatula to remove any excess liquid. Put the mixture into a bowl and add the egg and flour. Mix well, adding salt and pepper to taste.

In large nonstick skillet, heat enough oil to cover the bottom of the pan. Spoon the batter into the pan to create the desired-size pancakes, being careful not to crowd the pan. Cook until the pancakes are crisp and golden on each side, about 2 minutes per side. Drain on paper towels.

To serve, top the pancakes with crème fraîche and caviar.

Serves 4

This dessert graced my childhood home in many guises. Here, I have used apples, but plums or cherries would be equally delicious—use the best seasonal fruits available.

1 cup/225 g all-purpose flour
11 tbsp/155 g unsalted butter, diced, at room temperature
¼ tsp sea salt
1 large egg, organic
6 Cox, Worcester, or Braeburn apples, peeled, cored, and cut into 8 segments each
2 tbsp plus 2 tsp castor or superfine sugar
1 tbsp/15 ml lemon juice
2 tsp confectioners' sugar (icing sugar)

To Prepare the Pastry:
In a large bowl, mix the flour, 8 tbsp/115 g of butter, and the salt with your fingertips until the ingredients become sandy in texture. Create a well in the center of the mixture and add the egg. Work the flour and butter mixture into the egg, and press the mixture together to form a ball. Lightly flour your work surface and knead the pastry with the palms of your hands until all the ingredients are blended, no longer than 30 seconds. Be careful not to knead the pastry too much or you will develop the gluten in the flour and the pastry will not be crumbly once it is cooked.

To Make the Tart:
Preheat the oven to 425°F/220°C. Roll the pastry out to a thickness of 1/16 in/2 mm. Line a 7-in/18-cm flan ring with the pastry. Place the ring on a tray lined with wax paper and refrigerate for 20 minutes. Then arrange the apple segments, tightly packed, on the pastry. Melt the remaining 3 tbsp/40 g of butter and combine it with 2 tbsp of castor sugar and the lemon juice. Brush the mixture over the apples. Dust the apples liberally with the remaining 2 tsp of castor sugar, and place the tart in the preheated oven for 10 minutes.

Turn the oven down to 375°F/190°C, brush the apples once again with the remaining melted butter, sugar, and lemon juice mixture and continue to cook for another 20 minutes until the pastry becomes a light sandy color and the apples soften and caramelize. Remove from the oven and allow to cool slightly. Dust with confectioners' sugar and serve warm.

— GUILLAUME BRAHIMI —
BASIL-INFUSED TUNA WITH SOY VINAIGRETTE

Serves 4

1 lb/450 g sashimi-quality tuna, in one piece
1 bunch basil
Salt and pepper
2 tbsp/30 ml extra-virgin olive oil
2 tsp/10 ml soy sauce
2 tsp mustard seeds
Juice of 1 lime
Mixed salad greens to serve

To Prepare the Tuna:
*Cut the tuna into four steaks of equal size. Pick the basil
leaves from the stalks, blanch the leaves in boiling water,
and then plunge them into icy water. Drain the basil
leaves in a colander and set aside. Season the tuna steaks
with salt and pepper, and then carefully wrap each one in
basil leaves. Steam the tuna pieces for 45 seconds. The
tuna should be warm but not cooked.*

To Prepare the Vinaigrette:
*In a mixing bowl, whisk together the olive oil, soy sauce,
and mustard seeds, adding lime juice to taste.*

To Serve:
*Brush the tuna with the vinaigrette and serve on a bed of
mixed greens.*

— ANTHONY BOURDAIN —
ROAST BONE MARROW AND PARSLEY SALAD

Serves 3

12 3-in/7½-cm pieces veal marrowbone
1 bunch flat-leaf parsley, leaves picked from the stems
2 shallots, peeled and very thinly sliced
2 tbsp/30 g capers
2 tbsp/30 ml extra-virgin olive oil
Juice of 1 lemon
Coarse sea salt
Freshly ground black pepper
Toasted bread to serve with the bones

To Prepare the Bones:
Put the marrowbone pieces in an ovenproof frying pan or roasting pan and place in a 450°F/230°C oven. The roasting process should take about 20 minutes, depending on the thickness of the bone. You are looking for the marrow to be loose and giving, but not melted away, which it will do if cooked too long. Traditionally the ends of the bones would be covered to prevent any seepage, but I like the brown coloring and crispness at the ends.

To Prepare the Parsley Salad:
While the bones are roasting, lightly chop the parsley — just enough to discipline it — and mix it with the shallots and capers. Immediately before serving, dress the salad with the olive oil and lemon juice and add salt and pepper to taste.

To Serve:
This is a dish that should not be completely seasoned before leaving the kitchen, rendering a last-minute seasoning necessary by the actual eater. My approach is to scrape the marrow from the bone onto the toast and season it with coarse sea salt. Then I put a pinch of parsley salad on top and eat it right away. Of course, once you have your pile of bones, salad, toast, and salt, it is diner's choice.

Serves 4

1 lb/450 g sashimi-quality tuna, in one piece
1 bunch basil
Salt and pepper
2 tbsp/30 ml extra-virgin olive oil
2 tsp/10 ml soy sauce
2 tsp mustard seeds
Juice of 1 lime
Mixed salad greens to serve

To Prepare the Tuna:
Cut the tuna into four steaks of equal size. Pick the basil leaves from the stalks, blanch the leaves in boiling water, and then plunge them into icy water. Drain the basil leaves in a colander and set aside. Season the tuna steaks with salt and pepper, and then carefully wrap each one in basil leaves. Steam the tuna pieces for 45 seconds. The tuna should be warm but not cooked.

To Prepare the Vinaigrette:
In a mixing bowl, whisk together the olive oil, soy sauce, and mustard seeds, adding lime juice to taste.

To Serve:
Brush the tuna with the vinaigrette and serve on a bed of mixed greens.

Serves 2

I would like Alain Ducasse to create the menu for my last supper, and to prepare it as well. Prior to this meal, one could only serve something simple and sublime, something requiring a minimum of preparation but made with the most exquisite ingredients. I could easily consume 200 grams of caviar on my own, but would happily share it with a willing partner prior to Alain's dinner.

Salt (for cooking the potatoes)
12 small German Butterball or Yukon Gold potatoes, washed
3½ to 7 oz/100 to 200 g golden osetra or sevruga caviar
½ cup/110 g organic crème fraîche
1 lemon, sliced into quarters
1 tbsp finely minced chives

Bring enough salted water to cover the potatoes to a boil in a medium saucepan. Add the potatoes and cook until tender, about 8 to 10 minutes. Drain the potatoes and cut each one in half. Line an elegant basket or bowl with a linen napkin. Place the cooked potatoes inside the napkin to keep them warm.

Place the caviar tin over crushed ice and serve with crème fraîche, lemon, and chives on the side. Provide mother-of-pearl spoons to serve the caviar. Allow guests to enjoy the sensual experience of assembling their own hors d'oeuvre of potatoes, caviar, and crème fraîche.

Serves 12

2 14-oz/415-ml cans condensed milk
1½ cups/340 g all-purpose flour
½ cup/110 g plus 3 tbsp confectioners' (icing) sugar (or more to taste)
½ lb/225 g unsalted butter, chilled, cut into ¼-inch/⅔-cm pieces
¼ tsp salt
3 egg yolks, lightly beaten
8 to 10 bananas
2 cups/475 ml heavy cream (double cream)
Seeds of 1 vanilla bean
3 tbsp/40 g grated bittersweet chocolate

To Prepare the Filling:
Place the cans of condensed milk in a pot and cover them with water. Bring the water to a boil and let the cans boil continuously for 4 hours. Check the water level occasionally to ensure that the cans remain covered with water the entire time. Remove the cans from the pot and let them cool overnight.

To Prepare the Dough:
Sift the flour into a mixing bowl, then add the ½ cup/ 110 g of sugar, butter, and salt. Knead the mixture with your hands until it resembles fine bread crumbs. Then add the egg yolks and continue to knead the mixture until the egg is incorporated and the dough is smooth. Form the dough into a ball, wrap it in plastic wrap, and refrigerate it for 1 hour.

Cut the dough into 2 or 3 large pieces. Grate the dough with a large-tooth box grater onto the base of an 11-in/28-cm tart pan and press it evenly around the base, then the sides. The dough should be a little less than ¼ in/⅔ cm thick on the base and ½ in/1 cm thick on the sides. Prick the bottom with a fork, then freeze the dough for 15 minutes.

To Construct the Pie:
Bake the pie shell at 350°F/175°C for 15 minutes or until brown all over. Allow the pie shell to cool.

Next, peel and thinly slice the bananas on the bias. Arrange half of the bananas on the base of the pie in concentric circles, starting from the outside and working your way to the center. Gently dollop the caramelized condensed milk on top of the pie, and spread it to evenly cover the bananas. Follow with another layer of bananas. Cover the tart with plastic wrap and chill it in the refrigerator for 15 minutes.

While the pie is chilling, whisk together the cream, vanilla seeds, and the remaining 3 tbsp of confectioners' sugar to taste, until soft peaks form. Remove the pie from the refrigerator and then spread the whipped cream over it, completely covering the top layer of bananas. Sprinkle the grated chocolate over the top and chill the pie in the refrigerator until ready to serve.

Serves 4

This dessert graced my childhood home in many guises. Here, I have used apples, but plums or cherries would be equally delicious—use the best seasonal fruits available.

1 cup/225 g all-purpose flour
11 tbsp/155 g unsalted butter, diced, at room temperature
¼ tsp sea salt
1 large egg, organic
6 Cox, Worcester, or Braeburn apples, peeled, cored, and cut into 8 segments each
2 tbsp plus 2 tsp castor or superfine sugar
1 tbsp/15 ml lemon juice
2 tsp confectioners' sugar (icing sugar)

To Prepare the Pastry:
In a large bowl, mix the flour, 8 tbsp/115 g of butter, and the salt with your fingertips until the ingredients become sandy in texture. Create a well in the center of the mixture and add the egg. Work the flour and butter mixture into the egg, and press the mixture together to form a ball. Lightly flour your work surface and knead the pastry with the palms of your hands until all the ingredients are blended, no longer than 30 seconds. Be careful not to knead the pastry too much or you will develop the gluten in the flour and the pastry will not be crumbly once it is cooked.

To Make the Tart:
Preheat the oven to 425°F/220°C. Roll the pastry out to a thickness of ¹⁄₁₆ in/2 mm. Line a 7-in/18-cm flan ring with the pastry. Place the ring on a tray lined with wax paper and refrigerate for 20 minutes. Then arrange the apple segments, tightly packed, on the pastry. Melt the remaining 3 tbsp/40 g of butter and combine it with 2 tbsp of castor sugar and the lemon juice. Brush the mixture over the apples. Dust the apples liberally with the remaining 2 tsp of castor sugar, and place the tart in the preheated oven for 10 minutes.

Turn the oven down to 375°F/190°C, brush the apples once again with the remaining melted butter, sugar, and lemon juice mixture and continue to cook for another 20 minutes until the pastry becomes a light sandy color and the apples soften and caramelize. Remove from the oven and allow to cool slightly. Dust with confectioners' sugar and serve warm.

Serves 4

4 large potatoes
4 tbsp/55 g butter
Salt
2 tbsp/30 g chopped shallots
3½ tbsp/50 ml tawny port
6¾ oz/200 ml truffle juice
1⅔ cups/400 ml concentrated meat stock
2 tbsp/30 g chopped spring onion
Pepper
4 truffles, each weighing 1½ oz/40 g
3 tbsp/45 ml heavy cream (double cream)

To Prepare the Potatoes:
Preheat the oven to 300°F/150°C. Peel the potatoes and, using a small knife, cut them into cylinders that are about 2 in/5 cm in height. Carve petal shapes around the top of each cylinder by making small notches with a knife along the outer edge. Using a melon baller, scoop out the inside of the cylinders, leaving a width of ¼ in/½ cm for the walls and ¼ in/½ cm for the base.

Rub the potatoes with butter and sprinkle liberally with salt. Roast the potatoes at 300°F/150°C until they are cooked and golden brown in color, approximately 20 minutes.

To Prepare the Sauce:
Melt 2 tsp/10 g of butter in a small saucepan over low heat. Add the shallots and cook until they are soft and translucent, then add the port. Reduce until only about 1 tbsp/15 ml of liquid remains. Then add the truffle juice and the meat stock. Continue to cook until it has been reduced to half its original volume. Strain the sauce, stir in 1 tbsp/15 g of the spring onion and season with salt and pepper to taste.

To Prepare the Stuffed Truffles:
Clean the truffles and cut off a slice from the top of each. Put them aside to use later as lids. With a small teaspoon, hollow out the inside of each truffle. Mince the scooped-out truffle very finely. Place the minced truffle in a very small skillet over low heat, together with the remaining 1 tbsp/15 g of the spring onion, and the heavy cream. Reduce for 2 minutes. Add salt to taste.

In a small sauté pan, heat 1 tbsp/15 g of butter over low heat. Sauté the hollowed-out truffles for 2 minutes, turning occasionally. Season to taste with salt and pepper. Set aside the truffles, along with any juice remaining in the sauté pan.

To Serve:
Stuff each truffle with the minced truffle mixture and place these inside the roasted potatoes. Heat the stuffed potatoes at 250°F/120°C until warm, approximately 5 to 7 minutes. Put a spoonful of sauce in the center of each dish and place a stuffed potato on top.

— AMIT CHOWDHURY —
MASALA CHAI CRÈME BRÛLÉE

Serves 6

1 tbsp/15 g Assam Darjeeling tea leaves
4 cups/900 ml heavy cream (double cream)
2 cups/450 g granulated sugar, plus more for topping
1 tsp masala tea spice
10 egg yolks
2 egg whites

Place the tea leaves in the center of a square of cheesecloth and tie the cheesecloth with a piece of kitchen twine to form a pouch. Place the pouch in a medium saucepan with the heavy cream. Heat the cream until small bubbles form on the sides of the pan, then stir in 2 cups/450 g of sugar and the masala tea spice. Continue stirring until the sugar dissolves completely. Remove the pan from the heat and slowly whisk in the egg yolks. Strain the mixture through a fine sieve. Whip the egg whites in a mixing bowl until soft peaks form. Fold the beaten egg whites into the strained mixture.

Place six 6-oz/175-ml ramekins into a baking dish or pan that is at least 1 in/2½ cm deep. Fill the ramekins with the cream mixture. Pour hot water into the baking dish to a level halfway up the sides of the ramekins and bake in a 300°F/150°C oven for 30 to 35 minutes, until the custard sets. Allow the crème brûlées to cool, then sprinkle sugar evenly over the top of the each. Heat the sugar with a torch until it's caramelized.

Serves 4

5 tbsp/75 ml extra-virgin olive oil
3 small shallots, finely chopped
Pinch of crushed red pepper
1 cup/225 g Vialone Nano or arborio rice
½ cup/120 ml dry white wine, such as sauvignon blanc
4 cups/945 ml low-salt chicken broth, kept at a simmer
1 cup/225 g peeled and diced Granny Smith apple
4 slices foie gras, each ¾ in/2 cm thick
Kosher salt and freshly ground black pepper
8 sprigs fresh thyme
1 tbsp/15 g unsalted butter
2 tbsp/30 g grated parmigiano-reggiano
⅓ cup/80 ml Vinegar Reduction, using balsamic vinegar (see following recipe)

In a wide, heavy-based saucepan, heat 3 tbsp/45 ml of the olive oil over medium-high heat until very hot. Add half of the chopped shallot and the crushed red pepper and stir until the shallot is barely browned, about 2 minutes; take the pan off the heat if the shallot starts to scorch. Add the rice and cook over medium-high heat, stirring with long strokes, until each grain is coated with the oil, another 1 to 2 minutes. Pour in ¼ cup/60 ml of the wine and boil until the wine is almost completely absorbed (but do not let the pot become completely dry).

Add a couple ladlefuls of the hot chicken broth to the rice and stir well every minute or so until almost all the liquid has been absorbed. On medium-high heat, the risotto bubbles away throughout, which is fine. To see if it's time to add more liquid, drag the spoon through the rice; if the liquid doesn't immediately fill in the space, it's time to add more. Fifteen minutes into the cooking, add the diced apple to the pan. Add another ladleful of stock, the remaining ¼ cup/60 ml of wine, and 1 tbsp/15 ml of olive oil. Continue to cook, adding more stock as needed and stirring, until the risotto looks creamy but still al dente, 20 to 25 minutes.

Meanwhile, heat the oven to 250°F/120°C. Heat a large, ovenproof sauté pan over high heat. Season the foie gras well on both sides with salt and pepper. When the pan is very hot, add the foie gras slices and sear them well on one side. This will take just a couple of minutes and will render much fat. Add the remaining shallot and the thyme sprigs to the pan once you see some of that fat. Turn the foie gras over and let it finish cooking in the oven for a few minutes while you finish the risotto.

Remove the rice from the heat and let it stand for 30 seconds. Drizzle in the remaining 1 tbsp/15 ml of olive oil, the butter, and the cheese and stir with a wooden spoon until well combined and cohesive. Season to taste with salt, if needed.

To Serve:
Divide the risotto among four warm rimmed plates or shallow wide bowls. Drizzle the vinegar reduction around the perimeter of the risotto. Top each with a slice of foie gras. Drizzle just a little of the fat from the pan over the foie gras and top with a crispy thyme sprig. Serve immediately.

Vinegar Reduction

Makes ⅔ cup/160 ml

This simple sauce has a really full flavor with a slight hint of the herbs. You can make it ahead of time and use it to finish a simple piece of beef, lamb, or chicken. I especially like it with spice-crusted lamb.

1 tsp/5 ml olive oil
1 shallot, thinly sliced
1 sprig thyme
Pinch crushed red pepper
3 tbsp/45 ml balsamic vinegar or red wine vinegar
¼ cup/60 ml low-salt chicken broth
1 cup/235 ml chicken reduction diluted with water until a little thicker than chicken stock

Heat the olive oil in a small saucepan over medium heat. Add the shallot, thyme, and crushed red pepper and cook, stirring occasionally, until the shallot is golden brown. Add the vinegar, increase the heat to medium high, and cook until reduced by half. Add the chicken broth and the chicken reduction and cook until the liquid is reduced and somewhat thickened, about 15 minutes.

Makes about 25 blini

This is a simple ingredient-based recipe. The cooking of the blini is what makes them extraordinarily delicious. They should have crispy edges and be served hot. If you have leftover batter, the blini are excellent served larger, like regular breakfast pancakes, with maple syrup.

BOWL 1
1 cup/225 g all-purpose flour
1 tbsp sugar
1 tbsp or 1 package dry yeast
1 cup/235 ml milk

BOWL 2
1 cup/225 g buckwheat flour
2 tsp kosher salt
¾ cup/175 ml milk
2 egg yolks
2 egg whites
4 tbsp/60 ml heavy cream (double cream)
Clarified butter or vegetable oil for frying

To Prepare the Batter:
Mix the dry ingredients in their separate bowls as listed. Warm the milk to body temperature, approximately 94°F/35°C. In Bowl 1, whisk 1 cup/235 ml of the warm milk into the dry ingredients and set aside.

Lightly beat the egg yolks with ¾ cup/175 ml of the warm milk, then whisk into the flour mixture in Bowl 2. Cover both bowls with plastic wrap and let them rest, unrefrigerated, for 1 hour. After 1 hour, the batter in Bowl 1 should be bubbly and alive. Combine both batters into one bowl with a spatula. Whisk the egg whites until soft peaks form and fold them into the batter. Next, beat the heavy cream until soft peaks form and gently fold it into the mixture. Cover the bowl with plastic wrap and

allow the batter to rise for 1 hour, unrefrigerated.

To Cook the Blini:
Coat a nonstick pan with enough oil to form a thin layer over the bottom of the pan, and warm over medium heat. Drop 1 tbsp/15 ml of the blini batter into the hot oil—it should start cooking immediately—and cook until a golden brown edge has formed. Turn and cook until golden on the bottom. Drain the blini on a paper towel.

To Serve:
Serve the warm blini immediately with a dot of crème fraîche, a dollop of caviar, thinly sliced smoked salmon, or sturgeon.

— HÉLÈNE DARROZE —
MY FRIEND SUZIE'S BEST FRENCH FRIES IN THE WORLD

Serves 8

6½ lbs/3 kg russet potatoes
1⅓ gal/5 l sunflower oil
Sea salt to taste

Wash and peel the potatoes, then cut them into large slices, approximately ½ in/1 cm thick. Working with one handful at a time, dry the sliced potatoes in paper towels until no moisture remains.

Heat the sunflower oil in a large pot over medium heat until the temperature of the oil registers 340°F/170°C. In small batches, cook the potatoes in the hot oil for 7 minutes. Remove immediately, and drain on paper towels. At this point, the potatoes should be pale and partially cooked.

Right before you are ready to eat, plunge the fries in the same pot of oil, at 340°F/170°C for 6 minutes. After 6 minutes, they will come out brown and crispy. Season with sea salt to taste and serve immediately.

— VIMAL DHAR —
TANGY EGGPLANT
(CHOWK WANGUN)

Serves 4

1 large eggplant
¼ cup/60 ml plus 3 tbsp/45 ml vegetable oil
2 cloves
¼ tsp hing (asafetida)
4 tbsp/55 g roasted fennel powder
1 tsp ginger powder
2 tbsp dry mango powder
1½ tbsp red chili powder
2 tsp turmeric powder
1 tsp/5 ml water
1½ cups/340 g finely diced tomato
Salt and pepper to taste

Rinse the eggplant and cut it lengthwise into four pieces. In a large sauté pan, heat 3 tbsp/45 ml of vegetable oil over medium heat. Add the eggplant slices and cook until they are soft, turning once during cooking, about 3 minutes on each side. Set the sautéed eggplant aside.

In a separate sauté pan, heat ¼ cup/60 ml of vegetable oil over low heat. Add the cloves, hing, fennel powder, ginger powder, mango powder, red chili powder, turmeric powder, and water. Cook for one minute, stirring constantly to avoid burning the spices. Add the tomatoes and cook for 7 to 8 minutes or until the tomatoes are soft. Then add the eggplant slices, toss them with the tomato and spices, and cook until the eggplant is warm throughout. Remove from the heat and add salt and pepper to taste.

Serves 10

2 lbs/910 g Golden Delicious apples
3½ tbsp sugar
1½ tsp vanilla-infused sugar
2 tbsp/30 g butter
8½ tbsp/125 ml apple liqueur

Wash, peel, and core the apples, then slice them into quarters. Place the quartered apples in a large mixing bowl and cover them with the sugar and vanilla-infused sugar.

Over low heat, melt the butter in a large sauté pan until the butter is lightly browned. Add the sugar-covered apple quarters and toss them in the butter, taking care not to caramelize the sugar. Add the apple liqueur and set alight. Once the flames have burned out, remove the apple quarters and allow them to rest on a wire rack over a sheet pan (baking tray). When the apples have cooled, place them on the sheet pan and bake them in a preheated 250°F/120°C oven until they are tender and slightly moist, about 20 minutes. Serve warm.

— WYLIE DUFRESNE —
THE BURGER RECIPE

Serves 4

Generally speaking, when it comes to burgers, I'm a traditionalist. I don't get excited about all the various toppings finding their way onto burgers these days. I prefer to forgo the lettuce, tomato, and even the bun. In my mind, a blood-rare burger, covered head to toe in American cheese, is a perfect meal. However, I do make one very decadent, very delicious addition to my burgers from time to time: a sunny-side up egg. When that soft warm yolk mixes with those beef juices and melted cheese, all seems right with the world. It's breakfast, lunch, and dinner all in one deliciously messy package.

1½ lbs/680 g ground beef, made with 80 percent chuck or
round and 20 percent sirloin
4 eggs, fried sunny-side up
4 slices American cheese (processed cheese)
Salt and pepper to taste

The starting point for this great burger is flavorful cuts of meat. Both ground chuck and ground round are excellent cuts for flavor. I also think a bit of sirloin, finances permitting, is a nice addition. I recommend a blend of 80 percent chuck or round and 20 percent sirloin for balanced flavor. The other key factor is fat content. Ask your butcher for ground beef with a fat content between 15 and 20 percent for maximum flavor. One and a half pounds of ground beef, well seasoned with salt and pepper, will serve four people.

When forming the burger, remember that the less you handle the meat, the better the burger. Think of it as if you are handling pastry dough. Grill or sauté to your liking and top each with American cheese and a fried egg (bun optional, napkins required).

— TYLER FLORENCE —
TYLER'S ULTIMATE FRIED CHICKEN

❧

Serves 4

1 3 to 4-lb/1⅓ to 1¾-kg chicken, cut into 10 pieces
Kosher salt
3 cups/680 g all-purpose flour
2 tbsp garlic powder
2 tbsp onion powder
2 tbsp sweet paprika
2 tsp cayenne
Freshly ground black pepper
2 cups/475 ml buttermilk
2 tbsp/30 ml hot chili sauce, such as sriracha
Peanut oil for frying
¼ bunch fresh thyme
3 big sprigs fresh rosemary
¼ bunch fresh sage
2 fresh bay leaves
½ head garlic, smashed, husk still attached
Lemon wedges, for serving

Put the chicken pieces in a large bowl, and cover the chicken with water. Add 1 tbsp of salt for each qt/l of water used. Cover and refrigerate at least 2 hours or overnight.

In a large shallow platter, mix the flour, garlic powder, onion powder, paprika, and cayenne until well blended; season generously with salt and pepper. In another platter, combine the buttermilk and hot chili sauce; season with salt and pepper.

Drain the chicken and pat it dry. Dredge the pieces, a few at a time, in the flour mixture, then dip them into the buttermilk. Dredge them again in the seasoned flour. Set aside and let the chicken rest while you prepare the oil.

Put about 3 in/8 cm of oil into a large, deep pot; the oil should not come more than halfway up the side of the pot. Add the thyme, rosemary, sage, bay leaves, and garlic to the cool oil and heat over medium-high heat until the oil registers 350°F/175°C on a clip-on, deep-fry thermometer. The herbs and garlic will perfume the oil with their flavor as the oil heats.

Working in batches, carefully add the chicken pieces to the pot, 3 or 4 at a time. Fry, turning the pieces once, until golden brown and cooked through, about 20 minutes. When the chicken is done, take a big skimmer and remove the chicken pieces from the pot, shaking off as much oil as you can, and lay them on a paper towel or brown paper bag to soak up the oil. Sprinkle all over with salt and a dusting of ground black pepper. Scatter the fried herbs and garlic over the top. Serve hot, with big lemon wedges.

ITALIAN BROCCOLI WITH GARLIC, SHALLOTS, AND CHILI

⚜

Serves 4

2½ tbsp plus 2 tsp salt
1½ lbs/680 g baby Italian broccoli
½ cup/120 ml extra-virgin olive oil
3 cloves garlic, thinly sliced
2 shallots, thinly sliced
1 tsp fresh thyme leaves
1 chili d'arbol, thinly sliced on the bias

Bring 1 gal/3¾ l of water to a rolling boil with 2½ tbsp of salt. Blanch the broccoli for 1 to 2 minutes until just al dente, then cool on a platter or sheet pan (baking tray).

Heat ¼ cup/60 ml of olive oil in a large, heavy-bottomed sauté pan over high heat. Add the garlic, shallots, thyme, and chili. Cook for a few minutes until the shallots are translucent and just starting to caramelize.

Add the broccoli and 1 tsp of salt. Toss or stir well so that the shallots do not brown. Add the remaining ¼ cup/ 60 ml of olive oil and sauté for 2 minutes, tossing often. Season the broccoli with the remaining 1 tsp of salt.

Serves 2

4 large eggs
2 tbsp/30 ml heavy cream (double cream)
1 tbsp/15 g salted butter
Coarse kosher salt
Freshly ground black pepper
1 tsp freshly chopped flat-leaf Italian parsley

Crack the eggs into a shallow bowl and beat well with a fork. Add the cream and beat to incorporate. Heat the butter in a small nonstick skillet over low heat until the butter starts to foam. Pour in the egg mixture. Stir the eggs rigorously and continuously with a spatula until they are set and softly scrambled, with very small curds. They should look creamy and pale and moist. This can take a lot longer than you think, as the constant stirring slows down the cooking time.

Transfer the eggs to a warm plate, season with salt and pepper, and sprinkle generously with the freshly chopped parsley.

Serves 8

12 amaretto biscuits
1 oz/30 ml brandy
1 oz/30 ml whiskey
10 large egg yolks
1 cup/225 g castor or superfine sugar
1 cup/235 ml sweet dessert wine, such as marsala or muscatel

*Crush the amaretto biscuits into crumbs with a rolling
pin and place them in a bowl. Add the brandy and
whiskey and mix well. Line the bottom of eight martini
or other serving glasses with the crushed biscuits and
set aside.*

*Fill a large pan halfway with water and bring it to a boil.
In a bowl large enough to rest securely over the pan of
water, whisk together the egg yolks and sugar. Then add
the dessert wine and whisk until it's incorporated into the
egg and sugar mixture. Place the bowl on top of the pan
of boiling water. Be sure that the water does not touch the
bottom of the bowl. Whisk the egg mixture constantly
until it becomes quite thick and frothy, about 10 to
15 minutes. Once you can draw a line with your whisk
in the top of the mixture and the line holds, it is ready.
Pour the mixture into the prepared glasses.*

*The zabaglione can be served warm, or you can allow it
to set in the fridge overnight.*

— FERGUS HENDERSON —
SEA URCHINS

Live sea urchins, at least one per person

*Using a thick towel or glove to protect your hands from
the spines, turn the urchin onto its back and stick the
point of a very sharp pair of scissors or kitchen shears into
the soft mouth. Cut around the mouth with your scissors,
creating a hole large enough to insert a teaspoon. Remove
and discard the mouth and any loose shell fragments.
Serve the urchins right away, and let everyone scoop out
the delicious orange coral from the spiky shells.*

Serves 4 to 6

2 cups/450 g all-purpose flour
3 egg yolks
1 tsp salt
¼ cup/60 ml water
1 tbsp/15 g butter
4 to 5 tarragon leaves
Salt and pepper to taste
4 Perigord black truffles

Put the flour in a large mixing bowl and make a small depression in the center of the flour. Put the egg yolks and salt into the depression. Mix together with your hands, adding the water 2 tbsp/30 ml at a time, until the dough is stiff and easy to roll. Divide the dough into 4 balls and roll out 1 ball at a time through a pasta machine until the sheets of pasta are the thickness of linguini. Cut the sheets into 1½-in/4-cm wide noodles. Next, place the cut noodles on a lightly floured cutting board and let them dry, about 1 hour. Bring a large pot of salted water to a boil, then add the dried noodles and cook until just al dente. Drain the noodles, reserving about ¼ cup/60 ml of the pasta cooking water.

Melt the butter in a sauté pan over medium heat. Add the noodles, the reserved pasta cooking water, and the tarragon leaves. Toss until the noodles are coated with the butter and pasta water. Season with salt and pepper, and remove the pan from the heat. Liberally shave truffles over the top of the pasta. Serve immediately.

—THOMAS KELLER—
MY FAVORITE SIMPLE ROAST CHICKEN

Serves 2

1 2 to 3-lb/1⅓-kg farm-raised chicken
Kosher salt and freshly ground black pepper
2 tsp minced thyme (optional)
Unsalted butter to taste
Dijon mustard to taste

Preheat the oven to 450°F/230°C. Rinse the chicken, then dry it very well with paper towels, inside and out. Salt and pepper the cavity, then truss the bird.

Trussing is not difficult, and if you roast chicken often, it's a good technique to feel comfortable with. When you truss a bird, the wings and legs are tied close to the body, and the ends of the drumsticks cover the top of the breast and keep it from drying out. Trussing helps the chicken to cook evenly, and it also makes for a more beautiful roasted bird.

Next, salt the chicken with about 1 tbsp of salt—I like to rain the salt over the bird so it has a nice, uniform coating that will result in a crisp, salty, flavorful skin. When it's cooked, you should still be able to make out the salt baked onto the crisp skin. Season to taste with pepper.

Place the chicken in a sauté pan or roasting pan and, when the oven is up to temperature, put the chicken in the oven. I leave it alone—I don't baste it, I don't add butter; you can if you wish, but I feel this creates steam,

which I don't want. Roast for about 45 to 50 minutes, until the juices run clear. Remove it from the oven and add the thyme, if desired, to the pan. Baste the chicken with the juices and thyme and let it rest for 15 minutes on a cutting board.

Remove the twine. Separate the middle wing joint and eat that immediately. Remove the legs and thighs. I like to take off the backbone and eat one of the oysters, the two succulent morsels of meat embedded there, and give the other to the person I'm cooking with. But I take the chicken butt for myself. I could never understand why my brothers always fought over that triangular tip—until one day I got the crispy, juicy fat myself. These are the cook's rewards. Cut the breast down the middle and serve it on the bone, with one wing joint still attached to each half. The preparation is not meant to be super elegant. Slather the meat with fresh butter. Serve with mustard on the side and, if you wish, a simple green salad. You'll start using a knife and fork, but you'll finish with your fingers because it's so good.

— A N I T A L O —
MORICHES BAY FRIED SOFTSHELL CLAM
WITH TARTAR SAUCE

Serves 4

4 large Moriches Bay steamer clams, dug 24 hours in advance
⅓ cup/75 g plus 1 tsp kosher salt, plus more to taste
⅓ cup/75 g cornmeal
2 East Moriches Organic Herb Farm egg yolks, room temperature
1 tsp/5 ml Dijon mustard
1⅓ cups/320 ml soy oil, plus more for deep-frying
7 tsp/35 ml olive oil
Lemon juice to taste
1 tbsp/15 g chopped pickled gherkins
2 tbsp/30 g capers, drained
1 tbsp/15 g finely chopped fresh shallots
1 tbsp finely chopped garden chives
1 cup/225 g all-purpose flour
½ tsp freshly ground Tellicherry black pepper, plus more to taste

To Prepare the Clams:
Place the clams in a large bowl filled with water. Add
⅓ cup/75 g salt and the cornmeal. Refrigerate for at least
3 hours or overnight. Next, blanch the clams in boiling
water very briefly, no more than 30 seconds, and
immediately place them in an ice-water bath to cool.
Shuck the clams and remove the outer membrane, then
rinse off any remaining grit.

To Prepare the Tartar Sauce:
Prepare a homemade mayonnaise by placing the egg yolks
in a large bowl and stirring in the mustard. Blend
1⅓ cups/320 ml of soy oil with the olive oil and slowly
add it to the yolks, whisking constantly to emulsify.
Season to taste with lemon juice, salt, and pepper, then

add the gherkins, capers, shallots, and chives. Taste again
and adjust the seasonings. (As an alternative, you can
substitute Hellmann's mayonnaise seasoned to taste with
lemon juice for the homemade version above, then add the
gherkins, capers, shallots, and chives.)

To Fry the Clams:
Mix the flour with 1 tsp of salt and ½ tsp of pepper. Heat
a pot of soy oil for deep-frying to 375°F/190°C. Dredge
the shucked, rinsed clams in the seasoned flour and deep-
fry until they are golden brown. Drain on a paper towel.

To Serve:
Serve the clams in 4 small tasting portions with a dollop
of tartar sauce.

MACKEREL IN HERB CRUST AND BROCCOLI
WITH GARLIC AND CHILI

Serves 4

2 tbsp trimmed and roughly chopped fresh parsley
2 tbsp trimmed and roughly chopped rosemary, plus 4 sprigs
2 tbsp trimmed and roughly chopped basil
2 tbsp trimmed and roughly chopped sage
7 tbsp/100 g bread crumbs
7 tbsp/100 ml olive oil
4 medium-size mackerel, gutted
4 garlic cloves, crushed, plus 2 garlic cloves, thinly sliced
Salt and pepper to taste
2 heads of broccoli, separated into florets
1 red chili, deseeded and sliced

To Prepare the Herb Crust:
Place the parsley, chopped rosemary, basil, and sage in a food processor with the bread crumbs and 1 tbsp/15 ml of the olive oil, and mix at low speed. Slowly add 3 tbsp/ 45 ml more oil and mix for an additional 30 seconds. Transfer to a large tray or plate.

To Prepare the Mackerel:
Heat a griddle pan over high heat. Lightly season the inside of the fish with salt and pepper, and stuff each one with 1 rosemary sprig and 1 crushed garlic clove. Season the outside of the fish with salt and pepper. Brush 2 tbsp/30 ml of the oil over the fish, then roll the fish in the herb crust mixture, making sure the bread crumbs

cling well. Place the mackerel on the hot griddle pan and cook for about 4 to 5 minutes on each side, depending on the size, so that it marks well but doesn't burn (turn down the heat if necessary).

To Prepare the Broccoli:
While the fish is cooking, blanch the broccoli in boiling salted water for about 1 minute, just to soften. Heat a sauté pan over low heat, add the remaining 1 tbsp/15 ml of olive oil, followed by the sliced garlic and chili, and cook without browning the contents of the pan. Add the broccoli and sauté without allowing the vegetable to color, until just soft. Season with salt and pepper and serve with the mackerel.

— CHUI LEE LUK —
PRAWN AND RICE NOODLES
(NYONYA)

Serves 4

10 shallots
5 red chilies
1 head of garlic, cloves peeled
1 tbsp shrimp paste (blachan), roasted in oven until dryish and crumbly
2 cups/475 ml fresh coconut cream
1 cup/235 ml coconut milk
3 tbsp/40 g yellow beans, puréed (taucheong)
½ cup/120 ml tamarind paste
7 oz/200 g dried rice noodles (meehoon)
1 bunch garlic chives, roughly chopped
8¾ oz/250 g bean sprouts, rinsed and cleaned with roots removed
1 red pepper, flesh shredded finely
12 medium green prawns, shelled and deveined

To Prepare the Prawn and Yellow Bean Sauce:
In a food processor, grind the shallots, red chilies, garlic, and shrimp paste to a fine paste and set aside. Simmer the coconut cream in a large pan over medium heat until it begins to separate. Add the ground, aromatic mixture and simmer for 30 minutes. Stir in the coconut milk and the yellow bean purée and simmer for 2 more minutes, then add the tamarind. The sauce should be spicy hot, a little sour, sweet and salty.

To Prepare the Noodles:
Blanch the rice noodles in boiling water until they are just soft. Drain and set aside. Heat the prepared sauce to a slow boil. Blanch the garlic chives, bean sprouts, and red pepper in separate batches in the prawn and yellow bean sauce until they are just soft. Combine the vegetables and rice noodles to form a colorful salad.

To Prepare the Prawns:
Bring the prawn and yellow bean sauce to a boil and poach until the prawns are pink and cooked through.

To Serve:
Spoon the sauce over the prawns and serve with the noodle salad.

Serves 6

3½ oz /100 ml Japanese red vinegar
1 tbsp plus 1 tsp salt
½ tbsp/7 ml mirin
4 tbsp/55 g plus 1 tsp granulated sugar
1½-in/4-cm square sheet of konbu (Japanese kelp)
3¼ cups/720 g short-grain sushi rice
4 cups/930 ml cold water, plus more for rinsing
1 tbsp prepared wasabi
2 lbs/910 g sashimi-grade fish of choice

To Prepare the Vinegared Sushi Rice:
Preparing the rice is the single most important element in the whole sushi experience.

Bring 2 ½ oz/75 ml of the red vinegar to a simmer in a small pan over medium heat with the salt, mirin, and sugar until the sugar dissolves. Do not allow the vinegar to boil. Add the konbu, remove the pan from the heat, and allow it to cool to room temperature. When it's cool, add the remaining vinegar (this is done because the heating tends to destroy the bouquet of the vinegar). This will make enough sushi rice vinegar to make two batches of sushi rice of the size given here.

Thoroughly rinse the rice in repeated changes of cold water. When the water is no longer cloudy, the washing is complete. Once the rice is clean, soak it in cold water for 30 minutes in the winter or 15 minutes in the summer. Drain in a sieve.

Transfer the rice to a heavy saucepan and add 4 cups/930 ml of fresh cold water to the rice. Bring to a boil over high heat, and allow to boil for 1 minute, then reduce the heat to low and cook for 5 more minutes. Then increase the heat to high again for 10 seconds only. Remove the pan from the heat and allow the cooked rice to sit, covered, for about 15 minutes. Drain off any excess water.

While the rice is still hot, wipe the inside of a rice tub or similar wide, shallow container thoroughly with a piece of konbu that has been soaked in the vinegar mixture. Next, spread the cooked rice over the bottom of the tub in a thin layer. Using a slicing motion, mix the rice with a rice paddle or flat wooden spoon as you sprinkle half the prepared vinegar evenly over the rice. When slicing with the rice paddle, the action should be swift and rhythmic. Be careful not to overstir, as this will make the rice sticky.

Cut through the rice from the bottom up so that it is well turned over. Continue to blend in the vinegar, slicing diagonally and moving the rice to one side of the tub. Cover with a well-wrung damp cloth until ready to use (but use the rice before it becomes too hard).

To Prepare the Sushi:
With one finger, press about a tablespoon of vinegary sushi rice into a firm oval in the palm of your hand. Spread with wasabi as desired and place the slice of fish, about ⅛ in/3 cm thick, over that to cover the rice fairly neatly.

Serves 4

I was shown how to make this pasta all'arrabiata by a fantastic cook at the Selvapiana wine estate in Tuscany, where I buy my wine. I'm not saying this is the smartest dish in the world, but it's my favorite comfort food on a night off at home. I don't know why exactly—it probably has something to do with the fact that I think I'm addicted to chili so a big hit of it keeps me happy. Traditionally it is made with penne, but I think it works really well with spaghetti.

I also love it with pangrattato (bread crumbs), which is a hangover from the old peasant days, when the rich people had parmesan, and the rest couldn't afford it, so they would fry up stale bread, maybe with a little thyme, or garlic, or chili, to make it really tasty and crispy and then sprinkle it over pasta to give that same feeling of richness that you get from grated parmesan or pecorino. Over arrabiata, I think it is a joy.

7 tbsp/100 ml olive oil, plus more for drizzling
2 dried red chilies or peperoncino, crumbled or finely chopped
4 cloves garlic, finely sliced
1 red onion, finely chopped
3 14-oz/400-g cans good plum tomatoes, sieved, or 3½ cups/800 ml passata
Sea salt and freshly ground black pepper
18 oz/500 g spaghetti
1 tsp/5 ml red wine vinegar
3 tbsp/45 g stale bread crumbs
1 tbsp fresh thyme, chopped (optional)
Fried sage leaves (optional)

Heat about 5 tbsp/75 ml of the oil in a large sauté pan over low heat. Add the chilies, garlic, and onion, and cook gently for around 3 minutes. Add the tomatoes and let them cook until the sauce is quite thick, about 20 minutes.

Meanwhile, bring a large pan of salted water to a boil. Cook the spaghetti in the salted boiling water according to the packet instructions. Drain the pasta, reserving about ¼ cup/60 ml of the cooking water.

Once the sauce has thickened, add the red wine vinegar and season to taste with salt and pepper.

To make the pangrattato, heat the remaining oil in a pan over medium heat. Add the bread crumbs and thyme, if desired, and fry until the bread crumbs are crispy, about 3 minutes.

Add the drained pasta and the reserved pasta water to the sauce, and toss to coat. Drizzle with extra-virgin olive oil and serve with the pangrattato over the top. If you like, you can garnish with fried sage leaves.

Serves 4

As children, my brother and I would sit and watch my mother prepare crêpes and eat them as quickly as they came out of the pan—usually with homemade jam, but sometimes with just a sprinkling of sugar or a little grated chocolate. I duplicate this taste treat for my daughter for breakfast from time to time. It is easily done in a few minutes and is always a winner.

⅔ cup/150 g all-purpose flour
2 large eggs
½ tsp sugar, plus more for filling
¾ cup/175 ml nonfat milk
1 tbsp/15 ml corn or canola oil, plus more for greasing the skillet
Best quality jam or preserves: strawberry, apricot, quince, raspberry, plum, or the like
Grated chocolate (optional)

Combine the flour, eggs, sugar, and ¼ cup/60 ml of the milk in a bowl and mix with a whisk until smooth; the mixture will be fairly thick. Add the remaining milk and the oil, and mix until smooth.

Lightly grease the bottom of an 8- to 9-in/20- to 23-cm nonstick skillet with a little oil, and heat the pan over medium to high heat. When it is hot, add about 3 tbsp/ 45 ml of the crêpe batter, and quickly tilt and move the skillet so the batter coats the entire bottom of the pan. Move quickly, or the batter will set before the bottom of the skillet is coated, and the crêpe will be thicker than desired.

Cook the crêpe for about 45 seconds on one side, and then turn it and cook for about 20 seconds on the other side. As you make the crêpes, stack them on a plate, first-browned side down, so that when they are filled and folded this nicer side will be visible. The crêpes are best made and filled just before eating.

To fill, spread each crêpe with about 2 tbsp/30 ml of jam or 1 tsp of sugar or 2 tsp/10 g of grated chocolate. Fold it in half, enclosing the filling, and then fold it in half again. Eat immediately.

Serves 4

5 tbsp/70 g palm sugar
2 tbsp/30 ml water
2 small dried chilies
½ cup/120ml plus 1 tbsp/15 ml vegetable oil
½ cup/120 ml Japanese organic soy sauce
½ cup/120 ml rice wine vinegar
½ tsp Japanese mustard powder
1 medium red onion, peeled and grated
½ tsp crushed black peppercorns
1 small bunch baby mâche (lamb's lettuce), trimmed
1 bunch baby shiso (Japanese mint), trimmed
1 small bunch baby watercress, trimmed
9 to 11 oz/250 to 300 g sashimi-grade tuna, cut into ⅛-in/3-cm thick slices
Pickled ginger (optional)
Prepared wasabi (optional)

To Prepare the Dressing:
Add the palm sugar to a heavy-based pan, place it over medium heat until the sugar is caramelized, then add the water and remove the pan from the heat. In a separate sauté pan, blacken the chilies in 1 tbsp/15 ml of vegetable oil, and then crush them. In a large mixing bowl, combine the soy sauce, rice wine vinegar, and the remaining ½ cup/120 ml of vegetable oil. Add the mustard powder and stir until it is completely dissolved. Next, stir in the palm sugar mixture, grated onion, and peppercorns.

To Serve:
Sprinkle the mâche, shiso, and watercress on a large serving plate. Arrange the sashimi tuna around the herbs, and pour the dressing over everything. It's excellent served with pickled ginger and wasabi.

— MARTIN PICARD —
FOIE GRAS AND BOUDIN TART

Serves 4

1 sheet puff pastry
8 tbsp/115 g butter
4 medium onions, thinly sliced
Salt and freshly ground pepper
1²⁄₃ cups/395 ml béchamel sauce
2 tsp Dijon mustard
1¾ lbs/790 g boudin
20 La Ratte or other fingerling potatoes, boiled
1 cup/235 ml venison stock
7 oz/200 g salted foie gras
2 tbsp chopped flat-leaf parsley

Roll out the pastry dough until it is ¹⁄₈ in/¹⁄₃ cm thick and cut out 4 rounds, each 6-in/15¹⁄₄-cm in diameter. Set aside in the refrigerator.

In a large sauté pan, heat 4 tbsp/55 g of the butter over low heat. Add the onions and cook until they are caramelized, approximately 45 minutes. Season to taste with salt and pepper.

Preheat the oven to 450°F/230°C. Spread approximately ¹⁄₃ to ¹⁄₂ cup/80 to 120 ml of béchamel sauce and about ¹⁄₂ tsp of mustard on each of the pastry rounds. Cover them with a layer of caramelized onions. Bake for 15 minutes.

While the tarts are cooking, cut the boudin into ¹⁄₂-in/1-cm slices. Cut the potatoes the same way.

Heat 2 tbsp/30 g of butter in a large skillet, over medium heat. Add the potato slices and sauté until golden brown. Add the slices of boudin and sear these a little as well. Season to taste with salt and pepper. Deglaze the skillet with the venison stock. Reduce by approximately one-fourth, then add the remaining 2 tbsp/30 g butter and stir until melted. Season to taste with salt and pepper.

When the pastry rounds have cooked, scatter the sausage and potato slices on top and spoon some béchamel over each. Add some dabs of Dijon mustard to taste. Complete the presentation by adding slices of salted foie gras to the top of each.

Crown with a few twists from the pepper grinder and a little chopped parsley. Serve immediately and be sure to eat with your fingers to get the most flavor.

Serves 4 to 6

According to photographer Jill's mum, you need "love and hot fat" to make perfect crisp Yorkshire puddings — I can't argue with that!

2¾ to 3⅓ lbs/1¼ to 1½ kg rib beef, on the bone
½ tsp sea salt plus more for seasoning beef
Freshly ground black pepper
2 tbsp/30 ml olive oil
1 cup/225 g plain flour
4 eggs, beaten
1¼ cups/300 ml milk
About 4 tbsp/60 ml vegetable oil (or beef drippings) for cooking
3 to 4 sprigs thyme
4 garlic cloves, unpeeled
2 red onions, peeled and sliced
4 plum tomatoes, halved
½ bottle red wine (about 1½ cups/350 ml)
5 cups/1¼ l beef stock

Heat the oven to 400°F/200°C. Season the beef with salt and pepper and sear in a hot roasting pan with the olive oil to brown on all sides, about 3 to 4 minutes on each side. Transfer to the oven and roast, allowing 15 minutes per 1 lb/450 g for rare or 20 minutes per 1 lb/450 g for medium.

For the Yorkshire pudding batter, sift the flour and ½ tsp of salt in a large bowl. Add the eggs and half the milk and beat until smooth. Mix in the remaining milk and let the batter rest.

When the beef is cooked, transfer it to a warmed plate and let it rest, lightly covered with foil, in a warm place while you cook the puddings and make the gravy. Increase the oven setting to 450°F/230°C. Put 1 tsp/5 ml of vegetable oil or, better still, hot fat from the beef roasting pan, into each section of a 12-hole Yorkshire pudding tray (or muffin tray) and put it in the oven on the top shelf until very hot, almost smoking.

Whisk the batter again in the meantime. As soon as you

take the tray from the oven, ladle in the batter so each tin section is three-quarters full (it should sizzle) and immediately put the tray back in the oven. Bake for 12 to 20 minutes until the Yorkshire puddings are well risen, golden brown, and crisp. Don't open the oven door until the end or they might collapse.

To make the gravy, pour off the excess fat from the roasting pan, place it on medium heat, and add the thyme, garlic, onions, and tomatoes. Cook for 4 to 5 minutes, then pour in the wine and bring to a simmer. Squash the tomatoes using a potato masher to help thicken the sauce. Pour in the stock and bubble until reduced by half, about 10 minutes. Pass the gravy through a sieve, pressing the vegetables to extract their flavor. Bring it back to a boil and reduce to a gravy consistency. Check the seasoning.

Carve the beef thinly. Serve with the gravy and Yorkshire puddings, along with sautéed cabbage, glazed carrots, and roast potatoes.

Serves 4

I enjoy this ratatouille hot, with a pasta or couscous, or cold right out of the fridge when I get home from a late night at the restaurant.

4 tbsp/60 ml olive oil, plus more as needed
1 medium to large eggplant, peeled and sliced into ½-in/1-cm cubes
Sea salt
2 medium to large zucchini, halved lengthwise and sliced into ½-in/1-cm thick slices
1 large yellow onion, sliced into ½-in/1-cm cubes
1 bell pepper, sliced into pieces 1-in/2½-cm long (any color is fine)
1 28-oz/830-ml can diced tomatoes, drained (drink the tomato juice; it's awesome)
1 to 3 cloves garlic, minced
Freshly ground pepper

In a large skillet, heat 4 tbsp/60 ml of olive oil over medium to high heat. When the oil is hot, add the eggplant and toss it in the oil. Season the eggplant liberally with salt, and cook until it roasts to a deep golden brown. Watch the eggplant carefully, tossing often, to ensure that it does not burn. Once it is brown all over, remove the eggplant with a slotted spoon and place it in a bowl to await the rest of the cooked vegetables. Keep the remaining oil in the pan to cook the zucchini.

Next, place the zucchini in the skillet and toss it in the oil. Once again, season with salt and watch carefully to ensure that the zucchini roasts thoroughly but does not burn. When the zucchini has browned, remove it from the oil and place it in the bowl with the eggplant. See if there is enough oil left in the bottom of the skillet to cook the onion; you may need to add 1 tbsp/15 ml or so. Put the onion in the skillet, season with salt, and roast until

golden brown. Remove the onion and add it to the bowl of cooked veggies. Add a little olive oil to your skillet for the bell pepper, if needed. Then add the pepper to the pan and season with salt. This is the most difficult vegetable to roast because it burns easily, so watch the pepper like a hawk! Keep the heat medium low; it may take a little longer but the results are better.

Finally, return all the roasted vegetables to the skillet. You may have to find a larger one if they don't fit. Add the tomatoes and the garlic. Season the ratatouille with several turns of freshly ground pepper and stir so all the ingredients blend well. Reduce the heat to low and let it simmer for 30 to 45 minutes, uncovered, stirring occasionally. The veggies in the bottom of the skillet should start to caramelize. This gives the ratatouille its amazing flavor. Serve warm and then enjoy the leftovers later.

Serves 2

The key to this recipe is good, fresh crab. Matsuba crab is similar to snow crab; the meat is sweet and tender.

2 large Matsuba crabs
Salt to taste
2 8-in/20-cm sheets of rice paper
1 cup/235 ml sake

Using a large knife or cleaver, cut the legs and pincers from each crab's body. Cut the legs at the joints to make them into smaller pieces. Open the body of the crab by prying off the top of the shell and remove the gills. Quarter the body and sprinkle the crab pieces liberally with salt.

Preheat a grill to medium heat. Soak the rice paper in the sake for 15 minutes. Throw the crab pieces onto the grill and cover them with the rice paper like a blanket. Grill until the crab is cooked through, about 12 to 15 minutes.

— NANCY SILVERTON —
EGGPLANT CAPONATA

Serves 4

1 large eggplant, stem removed, peeled
1 tbsp kosher salt
¼ cup/60 ml plus 2 tbsp/30 ml extra-virgin olive oil
¼ tsp freshly ground black pepper
½ yellow onion, cut into ½-in/1-cm dice
2 garlic cloves, thinly sliced
2 tbsp/30 g pine nuts
2 tbsp/30 g currants
½ cup/120 ml tomato sauce, preferably without cheese or meat
1 tsp fresh thyme leaves
1 tbsp/15 g capers
½ tsp/2 g red pepper flakes
¼ cup/55 g kalamata olives, seeded
2 tbsp/30 ml balsamic vinegar

To Prepare the Eggplant:
Preheat the oven to 450°F/230°C. Cut the eggplant lengthwise into four sections around the core and discard the seedy core. Cube the sections into 1-in/2½-cm pieces. In a large bowl, toss the eggplant with the salt, ¼ cup/60 ml of extra-virgin olive oil, and the black pepper. Place the prepared eggplant on a baking sheet and bake for 30 to 35 minutes, or until browned. Remove the eggplant from the oven and set aside.

To Prepare the Caponata:
In a large sauté pan, heat the remaining 2 tbsp/30 ml of extra-virgin olive oil over medium heat until almost smoking. Add the onion, garlic, pine nuts, and currants. Cook until the onions are tender and the pine nuts are toasted, stirring frequently, about 4 to 5 minutes. Stir in the tomato sauce, eggplant, thyme, capers, red pepper flakes, olives, and balsamic vinegar. Bring the mixture to a boil, and then simmer for 4 to 5 minutes until it thickens. Serve at room temperature.

— MASA TAKAYAMA —
GRILLED MATSUBA CRAB

Serves 2

The key to this recipe is good, fresh crab. Matsuba crab is similar to snow crab; the meat is sweet and tender.

2 large Matsuba crabs
Salt to taste
2 8-in/20-cm sheets of rice paper
1 cup/235 ml sake

> *Using a large knife or cleaver, cut the legs and pincers*
> *from each crab's body. Cut the legs at the joints to make*
> *them into smaller pieces. Open the body of the crab*
> *by prying off the top of the shell and remove the gills.*
> *Quarter the body and sprinkle the crab pieces liberally*
> *with salt.*
>
> *Preheat a grill to medium heat. Soak the rice paper in the*
> *sake for 15 minutes. Throw the crab pieces onto the grill*
> *and cover them with the rice paper like a blanket. Grill*
> *until the crab is cooked through, about 12 to 15 minutes.*

— LYDIA SHIRE —
STEAK AU POIVRE

❧

Serves 1

My last meal on earth would definitely include a thick 14 to 16-ounce super prime sirloin steak with fat on it...probably cooked au poivre with my recipe and sauce.

1 14 to 16-oz/400 to 450-g prime sirloin steak
Salt and pepper to taste
2 tbsp/30 ml olive oil for frying
3-4 tbsp/45-60 g room temperature butter
¼ cup/55 g shallots, finely diced
⅓ bottle of great red wine (such as a cabernet)
Lemon juice to taste, about ¼ tsp/1 ml

Season the steak with salt and pepper. Heat the olive oil in a sauté pan over very high heat. Sauté the steak until it's black and blue (well seared on the outside, but really rare), less than 1 minute on each side. Remove from the pan.

Melt the butter in the same pan you used to cook the steak, then add the shallots and sauté them until golden. Next, add the wine and reduce it by two-thirds. Remove pan from heat, and whisk in room temperature butter. Stir in the lemon juice and season to taste with salt and pepper. The sauce should be silky and coat the back of a spoon. Pour over the steak...then go to heaven.

— MARCUS SAMUELSSON —
GRAVLAX WITH MUSTARD SAUCE

Serves 10 to 12 as an appetizer, more as part of a buffet

1 cup/225 g plus 2 tsp granulated sugar
½ cup/110 g plus ¼ tsp kosher salt
2 tbsp cracked white peppercorns
1 2½ to 3-lb/1 to 1⅓-kg skin-on salmon fillet, in one piece, pin bones removed
3 large bunches fresh dill, coarsely chopped, stems included and ½ cup/110 g finely chopped dill fronds
2 tbsp prepared honey mustard
1 tsp Dijon mustard
1½ tbsp/20 ml white wine vinegar
1 tbsp/15 ml strong coffee, cold
¼ tsp freshly ground black pepper
¾ cup/175 ml grape seed oil or canola oil
1 loaf of potato mustard or whole-grain bread, thinly sliced

To Prepare the Gravlax:
Combine 1 cup/225 g of sugar, ½ cup/110 g of salt, and the peppercorns in a small bowl and mix well. Place the salmon in a shallow dish and rub a handful of the salt mixture into both sides of the fish. With the skin side down, sprinkle the salmon with the remaining salt mixture and cover with the chopped dill. Cover the dish and refrigerate for 3 days to cure.

To Prepare the Mustard Sauce:
Combine both mustards, the remaining 2 tsp of sugar and ¼ tsp of salt, the vinegar, coffee, and pepper in a blender.

With the machine running, add the oil in a slow, steady stream, blending until the sauce is thick and creamy. Transfer the sauce to a bowl and stir in the dill fronds. Cover and refrigerate for at least 4 hours, or overnight, to allow the flavors to marry.

To Serve:
Scrape the seasonings off the gravlax. Slice the gravlax on the bias into thin slices, or leave whole so your guests can slice it themselves. Serve with the mustard sauce and thin slices of potato mustard bread or whole-grain bread.

— MICHEL RICHARD —
LAURENCE'S RATATOUILLE

Serves 4

I enjoy this ratatouille hot, with a pasta or couscous, or cold right out of the fridge when I get home from a late night at the restaurant.

4 tbsp/60 ml olive oil, plus more as needed
1 medium to large eggplant, peeled and sliced into ½-in/1-cm cubes
Sea salt
2 medium to large zucchini, halved lengthwise and sliced into ½-in/1-cm thick slices
1 large yellow onion, sliced into ½-in/1-cm cubes
1 bell pepper, sliced into pieces 1-in/2½-cm long (any color is fine)
1 28-oz/830-ml can diced tomatoes, drained (drink the tomato juice; it's awesome)
1 to 3 cloves garlic, minced
Freshly ground pepper

In a large skillet, heat 4 tbsp/60 ml of olive oil over medium to high heat. When the oil is hot, add the eggplant and toss it in the oil. Season the eggplant liberally with salt, and cook until it roasts to a deep golden brown. Watch the eggplant carefully, tossing often, to ensure that it does not burn. Once it is brown all over, remove the eggplant with a slotted spoon and place it in a bowl to await the rest of the cooked vegetables. Keep the remaining oil in the pan to cook the zucchini.

Next, place the zucchini in the skillet and toss it in the oil. Once again, season with salt and watch carefully to ensure that the zucchini roasts thoroughly but does not burn. When the zucchini has browned, remove it from the oil and place it in the bowl with the eggplant. See if there is enough oil left in the bottom of the skillet to cook the onion; you may need to add 1 tbsp/15 ml or so. Put the onion in the skillet, season with salt, and roast until

golden brown. Remove the onion and add it to the bowl of cooked veggies. Add a little olive oil to your skillet for the bell pepper, if needed. Then add the pepper to the pan and season with salt. This is the most difficult vegetable to roast because it burns easily, so watch the pepper like a hawk! Keep the heat medium low; it may take a little longer but the results are better.

Finally, return all the roasted vegetables to the skillet. You may have to find a larger one if they don't fit. Add the tomatoes and the garlic. Season the ratatouille with several turns of freshly ground pepper and stir so all the ingredients blend well. Reduce the heat to low and let it simmer for 30 to 45 minutes, uncovered, stirring occasionally. The veggies in the bottom of the skillet should start to caramelize. This gives the ratatouille its amazing flavor. Serve warm and then enjoy the leftovers later.

— ERIC RIPERT —
TRUFFLED COUNTRY BREAD

Serves 1

1 loaf country bread
Fresh garlic
Unsalted butter
Black truffles
Rock salt
Black pepper in a mill, set to a larger grind
Extra-virgin olive oil

This is really a simple yet decadent treat. I like to use a beautiful, rustic country bread from my local baker — something that is round and has a crispy crust but is also chewy on the inside. It should be a medium-size loaf, so you can cut yourself a nice long piece of bread or two. Slice the bread so it's a good 1/2 in/1 1/4 cm thick. Throw it in the oven, directly on the rack, to get nice and toasted. Not putting it on a sheet tray allows it to get crispy all over, not just on the top. When it's crispy, take it out of the oven. Take a head of fresh garlic and pluck off a couple of cloves. Peel them and lightly rub them on the toasted bread. You'll smell a hint of garlic start to waft up toward you, but don't worry, the flavor won't be too strong. Next, take some unsalted butter and spread it generously on the bread. I like to use cold butter because more stays on and doesn't get soaked into the bread.

Now comes the really decadent part: the freshly cut truffles. The truffles should have a nice, dark marbling in the center — and of course be really aromatic. I like to shave them on a truffle mandolin, but you might find slicing them as thinly as you can with your sharpest knife will work as well. Slice enough truffles so you can layer 1/4 in/6 mm or so all over the slice of bread. Take some delicious sea salt — a nice larger-crystal rock salt like fleur de sel adds an extra crunch and of course flavor — and sprinkle it generously over the truffles. Grind some fresh black pepper over the truffles as well. To finish, you'll want an extra-virgin olive oil that's fruity but not too acidic. You shouldn't taste any bitterness when you try it straight; something with an acidity of 0.3 percent is really nice. Drizzle the olive oil on the bread and you're ready to eat!

— LAURENT TOURONDEL —
BLT GRILLED TUNA SANDWICH

Serves 6

1½ lb/680 g yellowfin tuna, cut into 12 slices, about ½ in/1 cm thick
½ cup/120 ml olive oil, plus more to rub tuna
Fine sea salt and freshly ground pepper to taste
4 tsp/20 ml fresh-squeezed lemon juice
½ tsp chopped garlic
1 large bunch arugula (rocket), tough stems removed
½ cup/120 ml mayonnaise
¼ cup/55 g black olive tapenade
1 loaf rustic Italian bread, cut into 12 diagonal slices, ½ in/1 cm thick, toasted
12 slices apple-wood smoked bacon, cooked until crisp
1 medium red onion, sliced
2 ripe tomatoes, sliced
3 hard-boiled eggs, peeled and sliced
6 oz/170 g parmigiano-reggiano, cut into thin slices with a vegetable peeler or mandolin slicer
1 ripe avocado, preferably Hass
1 bunch basil, tough stems removed

To Prepare the Tuna:
Preheat a grill pan or barbecue grill over medium heat. Rub each piece of tuna lightly with olive oil. Sprinkle the tuna on both sides with salt and pepper. Place the tuna on the pan or grill rack and cook 1 to 2 minutes per side or until rare to medium rare, depending on your preference.

To Prepare the Arugula:
In a medium bowl, whisk together ½ cup/120 ml of olive oil, the lemon juice and garlic, and salt and pepper to taste. Add the arugula and toss well.

To Assemble the Sandwiches:
Spread some of the mayonnaise and tapenade on each slice of bread. Divide the bacon, onion, tomatoes, eggs, parmesan, and avocado over half of the slices. Top with tuna, basil, and the arugula salad. Cover with the remaining bread, coated side down. Cut the sandwiches in half and serve immediately.

CHARLIE TROTTER
AHI TUNA POKE WITH SOY-YUZU-CILANTRO SAUCE

✹

Serves 2

½ lb/225 g ahi tuna (sashimi grade), cut into ½-in/1-cm dice
2 tsp/10 ml garlic-chili paste
1½ tbsp minced ginger
1½ tbsp/20 g minced shallot
2 tsp black sesame seeds
3 spring onion tops (green part only), cut finely on the bias
1½ tbsp/25 ml sesame oil
Salt
2 tbsp/30 ml yuzu lemon juice
1 tbsp/15 ml soy sauce
1 tbsp/15 g chopped cilantro
1 tbsp/15 ml olive oil

To Prepare the Tuna Poke:
Place the tuna, garlic-chili paste, ginger, shallot, sesame seeds, spring onion tops, and sesame oil in a mixing bowl. Toss together until thoroughly combined and season to taste with salt. Refrigerate until ready to serve.

To Prepare the Sauce:
Place the lemon juice, soy sauce, and cilantro in a small mixing bowl and slowly whisk in the olive oil.

To Serve:
Place some of the poke in the center of each plate and lightly spoon some of the sauce around it.

Note:
Yuzu lemon is an aromatic, Japanese citrus with a flavor that is distinctive from the lemons you find in the supermarket. Bottled yuzu lemon juice and, occasionally, fresh lemons can be found at gourmet food shops and specialty stores. If you cannot find yuzu lemon juice, you can substitute an equal amount of regular lemon juice for this recipe.

— JEAN-GEORGES VONGERICHTEN —
TUNA AND CHILI TAPIOCA WITH ASIAN PEAR

Serves 10

2 lbs/910 g trimmed, sashimi-grade tuna
¼ cup/60 ml grape seed oil
5 shallots, peeled and thinly sliced
9 chipotle peppers (smoked jalapeño peppers), toasted and chopped
2 ancho chilies, toasted and chopped
6 dried Thai chilies
4 tsp annatto seeds
1 tsp cloves, toasted
4 cinnamon sticks, toasted and smashed
1 tsp Szechuan peppercorns, crushed
7 cups/1⅔ l water
5 tbsp/70 g salt
¾ cup/170 g plus 3 tsp sugar
1 box large-pearl tapioca
4 tbsp/60 ml chili oil
3 cups/710 ml coconut juice
¾ cup/175 ml coconut milk
1 green finger chili, chopped
¾ cup/175 ml fresh lime juice, plus 3 oz/90 ml to finish
5 stalks lemongrass, crushed and finely chopped
40 Kaffir leaves, chopped
1 jicama, peeled and cut into ¼-in/½-cm diamonds
1 Asian pear, peeled and cut into ¼-in/½-cm diamonds
3 tbsp/40 g spring onions, chopped
1 red bell pepper, char-grilled, peeled, and cut into ¼-in/½-cm diamonds

To Prepare the Tuna:
Slice the tuna into pieces 1 in/2½ cm long, ½ in/1 cm wide, and ⅛ in/⅓ cm thick and fold each piece in half. Arrange the tuna in individual serving dishes, about 3 oz/85 g per dish. Keep it refrigerated until ready to serve.

To Prepare the Chili Tapioca:
Heat the grape seed oil in a medium saucepan over medium heat. Sweat the shallots, chipotle peppers, ancho chilies, Thai chilies, annatto seeds, cloves, cinnamon, and peppercorns until they are golden brown. Add the water, 4 tbsp/55 g of salt, and 3 tsp of sugar and bring to a boil. Next, add the tapioca and cook until clear, stirring occasionally. Strain the tapioca and place it in a sealable container. Pour the chili oil over the tapioca and refrigerate.

To Prepare the Lime-Coconut Broth:
In a large saucepan, combine the coconut juice, coconut milk, chili, ¾ cup/175 ml of lime juice, ¾ cup/170 g of sugar, and the remaining 1 tsp of salt and bring to a boil. Stir in the lemongrass and Kaffir and immediately remove the pan from the heat. Set the mixture aside and allow it to cool, uncovered. Once the mixture has cooled completely, strain it through a fine sieve and finish with the lime juice.

To Serve:
Sprinkle the tuna lightly with salt. Scatter the tapioca over the tuna, then the jicama, and finally the pear. Sprinkle with spring onions and then scatter with red pepper. Add lime-coconut broth to cover halfway.

— TETSUYA WAKUDA —
TARTARE OF TUNA WITH GOAT CHEESE

Serves 4

9 oz/250 g tuna, finely diced
1 pinch white pepper
1 tbsp/15 ml olive oil
1 tsp finely chopped anchovies
2 oz/60 g fresh goat cheese, finely chopped
¾ tbsp finely chopped chives
½ tbsp/7 ml soy sauce
½ tbsp/7 ml mirin
1 pinch sea salt
1 pinch cayenne pepper
1 pinch finely chopped garlic
½ tsp finely chopped ginger
1 small bunch baby shiso (Japanese mint) for garnish
1 small bunch mâche (lamb's lettuce) for garnish

*Mix all the ingredients together (except the garnishes) in
a large bowl. Divide between 4 serving plates, and
garnish with shiso and mâche leaves.*

— JONATHAN WAXMAN —
SHORTBREAD ICE CREAM SANDWICHES

Makes about 6 sandwiches

¾ lb/115 g butter
1 cup/225 g plus ½ cup/110 g sugar
1 tbsp/15 ml vanilla
3 cups/680 g organic pastry flour, plus more for sprinkling
¾ tsp plus a pinch salt
4 egg yolks
½ cup/120 ml milk
½ cup/120 ml heavy cream (double cream)
1 vanilla bean
½ cup/110 g milk chocolate, chopped into small pieces
1 pint/560 g wild strawberries

To Prepare the Shortbread Cookies:
Cream the butter and 1 cup/225 g of sugar together in a mixing bowl, then add the vanilla. Mix in the flour and ¾ tsp of salt until just incorporated; be careful not to overmix. Form the dough into 3-in/8-cm diameter cylinders, wrap them in plastic wrap, and chill them in the refrigerator for 30 minutes. Then slice the cylinders into disks ¼ in/½ cm thick and sprinkle liberally with sugar. Bake the cookies in a 350°F/175°C oven until golden, but not too dark, about 12 to 15 minutes.

To Prepare the Ice Cream:
Combine the remaining ½ cup/110 g of sugar, the egg yolks, and a pinch of salt in a small bowl. Whisk together until they are thoroughly mixed and the yolks are light in color. Set aside. Put the milk and cream into a small saucepan. Split the vanilla bean lengthwise and scrape the seeds into milk, then add the vanilla pod. Carefully heat the milk mixture, stirring often, until it starts to boil. Set it aside to steep for 5 minutes.

Slowly whisk the hot milk mixture into the egg mixture. When they are combined and smooth, return the milk-egg mixture to the saucepan. Add the chocolate and mix. Stirring continuously, heat the mixture over medium heat until it begins to thicken and easily coats the back of a wooden spoon. Remove the vanilla bean. Transfer the mixture into a bowl set in an ice bath. Stir the mixture until it is chilled, and then freeze it in an ice-cream machine.

To Prepare the Sandwiches:
Use ¼ cup/60 ml of ice cream per two cookies, form a sandwich, and chill. Serve with a bowl of perfect wild strawberries!

RESTAU

FERRAN ADRIÀ

El Bullí (Barcelona)

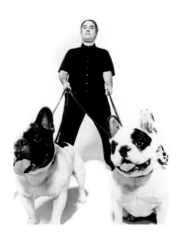

TOM AIKENS

Tom Aikens (London)

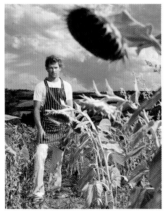

JOSÉ ANDRÉS

Jaleo, Café Atlántico, minibar by José Andrés, Oyamel, Zaytinya (Washington, D.C., area)

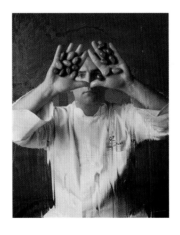

RANTS

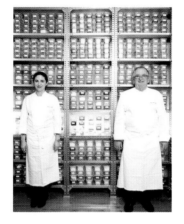

ELENA ARZAK AND
JUAN MARI ARZAK

Restaurante Arzak (San Sebastián, Spain)

DAN BARBER

Blue Hill (New York), Blue Hill at Stone Barns (Pocantico Hills, New York)

LIDIA BASTIANICH

Felidia, Becco, Esca, Del Posto (New York); Lidia's (Pittsburgh and Kansas City)

MARIO BATALI

Babbo, Lupa, Esca, Otto, Casa Mono/Bar Jamón, Del Posto (New York);
Pizzeria Mozza/Osteria Mozza (Los Angeles); B&B Ristorante, Enoteca San Marco (Las Vegas)

RICK BAYLESS

Frontera Grill, Topolobampo (Chicago)

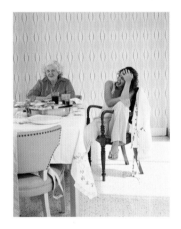

MICHELLE BERNSTEIN

Michy's, Social Sagamore (Miami); Social Hollywood (Los Angeles)

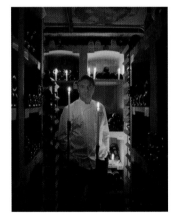

RAYMOND BLANC

Le Manoir aux Quat'Saisons (Oxford, England)

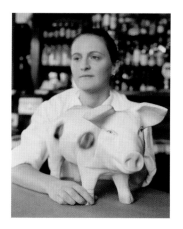

APRIL BLOOMFIELD

The Spotted Pig (New York)

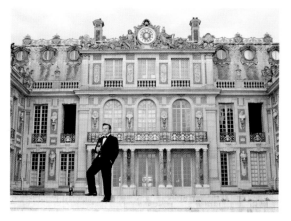

DANIEL BOULUD

Daniel (New York), Café Boulud (New York and Palm Beach), DB Bistro Moderne (New York),
Daniel Boulud Brasserie (Las Vegas), Feast and Fêtes Catering (New York)

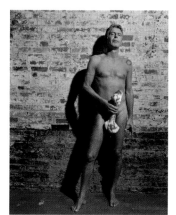

ANTHONY BOURDAIN

Brasserie Les Halles (New York)

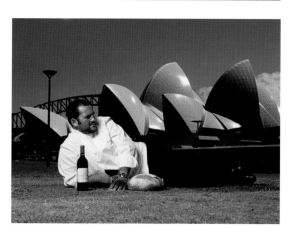

GUILLAUME BRAHIMI

Guillaume at Bennelong (Sydney, Australia)

AMIT CHOWDHURY

The Taj Mahal Hotel (New Delhi, India)

SCOTT CONANT

L'Impero, Alto (New York)

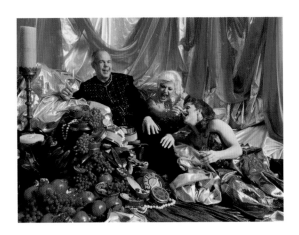

GARY DANKO

Gary Danko (San Francisco)

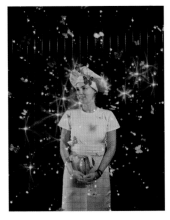

HÉLÈNE DARROZE

Hélène Darroze (Paris)

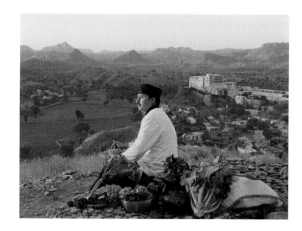

VIMAL DHAR

Devi Garh Hotel (Udaipur, India)

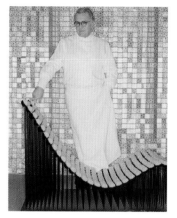

ALAIN DUCASSE

Le Louis XV — Alain Ducasse (Monaco), La Bastide de Moustiers (Provence),
Alain Ducasse au Plaza Athénée (Paris), Le Relais Plaza (Paris), La Cour Jardin (Paris),
SPOON food and wine (Paris), Bar & Boeuf (Monaco), Spoon des Îles by Alain Ducasse (Mauritius),
L'Hostellerie de l'Abbaye de la Celle (Provence), Spoon at Sanderson (London), Spoon Byblos (Saint-Tropez),
Auberge Iparla (French Basque Country), Aux Lyonnais (Paris), SPOON by Alain Ducasse (Hong Kong),
Tamaris (Beirut), BEIGE Alain Ducasse (Tokyo), MIX in Las Vegas, La Trattoria Toscana (Tuscany),
Ostapé (French Basque Country), Le Domaine des Andéols (Provence), Benoit (Paris and Tokyo),
Le Relais du Parc (Paris), be boulangépicier (Paris and Tokyo), Café be au Printemps de la Maison (Paris)

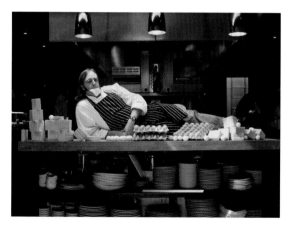

WYLIE DUFRESNE

WD-50 (New York)

TYLER FLORENCE

Chef, author, and television host (Tyler's Ultimate, Food 911, and How to Boil Water)

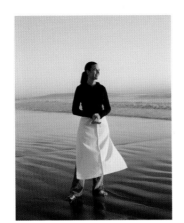

SUZANNE GOIN

Lucques, AOC, the hungry cat (Los Angeles)

GABRIELLE HAMILTON

Prune (New York)

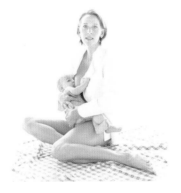

ANGELA HARTNETT

Angela Hartnett at The Connaught (London), Cielo by Angela Hartnett (Boca Raton, Florida)

FERGUS HENDERSON

St. John, St. John Bread & Wine (London)

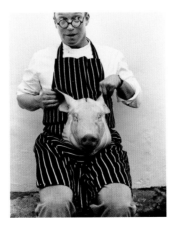

PAUL KAHAN

Blackbird, Avec (Chicago)

THOMAS KELLER

*The French Laundry (Yountville, California), Per Se (New York), Bouchon (Yountville, California),
Bouchon Las Vegas, Bouchon Bakery (New York), Ad Hoc (Yountville, California)*

ANITA LO

Annisa (New York)

GIORGIO LOCATELLI

Locanda Locatelli (London)

CHUI LEE LUK

Claude's Restaurant (Sydney, Australia)

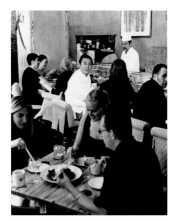

NOBU

Nobu and Matsuhisa restaurants worldwide

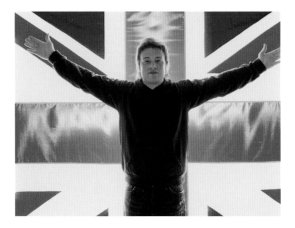

JAMIE OLIVER

Fifteen London, Fifteen Cornwall, Fifteen Amsterdam, Fifteen Melbourne

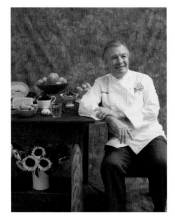

JACQUES PÉPIN

Chef, cookbook author, cooking teacher, and TV host

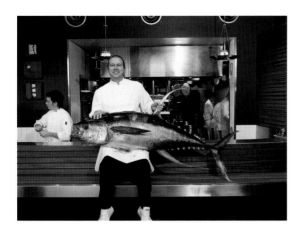

NEIL PERRY

Rockpool (Sydney, Australia), Rockpool Bar and Grill (Melbourne, Australia)

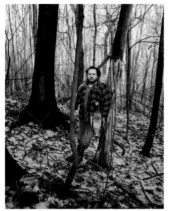

MARTIN PICARD

Au Pied de Cochon (Montreal)

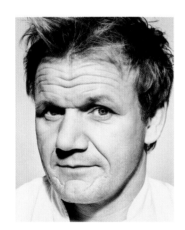

GORDON RAMSAY

Gordon Ramsay at the London West Hollywood, Gordon Ramsay at the London (New York),
Restaurant Gordon Ramsay, Pétrus (London), Gordon Ramsay at Claridge's (London),
Angela Hartnett at The Connaught (London), the Savoy Grill (London), Boxwood Café (London),
Maze (London), La Noisette (London), Banquette (London), Cielo by Angela Hartnett (Boca Raton, Florida),
Gordon Ramsay at Conrad Tokyo, Verre (Dubai)

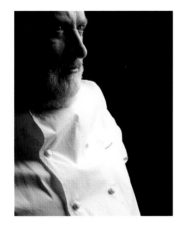

MICHEL RICHARD

Citronelle (Washington, D.C.)

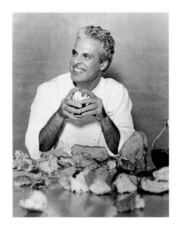

ERIC RIPERT

Le Bernardin (New York)

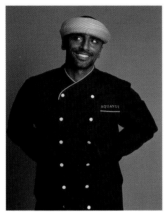

MARCUS SAMUELSSON

Aquavit (New York)

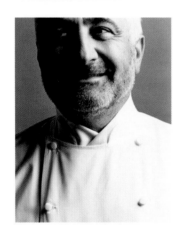

GUY SAVOY

Guy Savoy (Paris and Las Vegas)

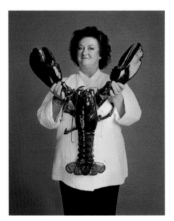

LYDIA SHIRE

Locke-Ober (Boston)

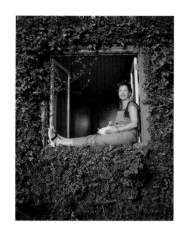

NANCY SILVERTON

Pizzeria Mozza, Osteria Mozza (Los Angeles); La Brea Bakery (USA)

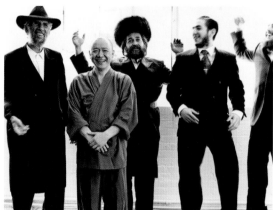

MASA TAKAYAMA

Masa (New York)

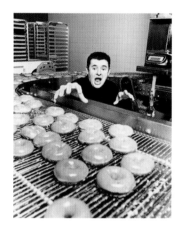

LAURENT TOURONDEL

BLT Steak, BLT Fish, BLT Prime, BLT Burger (New York)

CHARLIE TROTTER

Charlie Trotter's (Chicago)

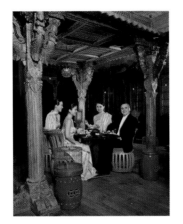

JEAN-GEORGES VONGERICHTEN

Jean Georges/Nougatine, JoJo, Mercer Kitchen, Vong, 66, Spice Market, Perry St. (New York); Vong's Thai Kitchen (Chicago); Prime Steakhouse (Las Vegas); Bank (Houston); Café Martinique, Dune (Paradise Island, the Bahamas); V, Rama (London); Market (Paris); Jean Georges Shanghai

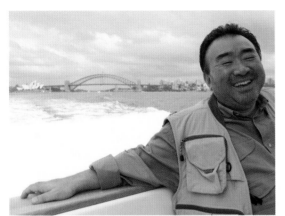

TETSUYA WAKUDA

Tetsuya's (Sydney, Australia)

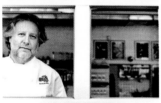

JONATHAN WAXMAN

Barbuto (New York)

THANKS

My number one thank you is to Nigel.
Thank you for being kind, helpful, and wonderful during my year of "cheffing."

I also want to say an extra special thank you to Farley Chase, Geoff Katz, Giovanni C. Russo,
Hugo Reyes, Jennifer Stanek, Karen Rinaldi, Koji Hokari, and Lindsay Sagnette
who I bugged day and night relentlessly.
Marc Haeringer thank you for testing all of the recipes.
Merci to Eric Ripert for allowing me to unceremoniously chop his head off on the cover!
Tony Bourdain, thanks for your wonderful introduction.

Adriana Gelves, Alexandre Chemla, Alexei Orescovic, Alina Lundry, Altour International,
American Airlines, Anne Madden, Arnaud Adida, Aude de Margerie, Beth Collier, Bloomsbury USA,
Brianne Moncrief, Carol Heron, Caroline DeJean, Chateau Versailles, Chris Glassman, Chris March,
Chris Protopapas, Christine Hahn, Creative Photographers Inc., Danny Greer, Daria Fabian,
Deborah Williams, Deborah Williamson, Denise Feltham, Donna Imbriani, Dorothy Hamilton,
Elisa Lipsky-Karasz, Emma Parry, Florence Sicard Russo, Fred Chatterton, Fuel Digital Labs,
George Dunea, Glen Dorman, Gregg Delman, Grill Bitch, Industria Superstudios, Jack Parry,
Jeanne Hollande, Jeff Dymowski, Jenna Menard, Jennifer Crawford, Jessica Branson,
Joanna McClure, John Kohler , Justus Oehler, Ken Friedman, Khaled Anwar, Kimberly Slayton,
Kristin Powers, Lisa Greer, Maggie Goudsmit, Margo Katz, Martine Sicard, Matt Furman,
Mike O'Connor, Nikki Wang, No11 Inc., Oscar Desouza, Pam Katz, Paul Judice, Paul Katz,
Paula Froelich, Paula Lizarraga, Peta O'Brien, Polly Napper, Ramon Palacios-Pelletier, Rick Kaplan,
Sarah Louise Tildesley, Scott Waxman, Sunshine Flint, Taylor Steel, Tim Bizzarro,
Uncle David, Uta Tjaden, Yves Sicard

I want to say a special thank you to all of the chefs' executive assistants and publicists.
Without them, there is no way I would have one chef in this book.
I appreciate all of their cajoling, bullying, and pestering to make the chefs turn up at the shoots!

Aisha Cooper, Alex Hasbany, Aline Oshima, Anna Hextall, Belinda Colley, Belquis Thompson,
Beth Atresky, Carine Guillemot-Polito, Carolyn Wang, Charlotte March, Courtney Bone, Cristina Cortes,
Daniel Del Vecchio, Dianne James, Diva Dan, Ellen Malloy, Gaëlle Cerf, Georgette Farkas,
Gregory Brainin, Heather Freeman, Helene Bagge, Irene Hamburger, Isabel Adria, Jen Fite,
Jennifer Compton, Jessica Aufiero, Jessica Kingsland, Jo Barnes, June Fujise, Ken Friedman, Kim Yorio,
Kirsty Tyrrell, Kristine Keefer, Laura Hiser, Laura Savoy, Laura Trevino, Lauren M. Kehnast, Lisa Klint,
Liz McMullan, Mandy Oser, Mel Davis, Michael Krikorian, Nesrine El Ayoubi, Norma Galehouse,
Pam Lewy, Rachael Carron, Rochelle Smith, Sarah Abell, Sarah Carter, Sonja Toulouse, Stefanie Cangiano,
Suzanna de Jong, Tiffany Hoffman, Tracey Clinton, Vicki Wild, Victoire Obindou

All recipes in My Last Supper appear courtesy of, and with copyright assigned to, each respective chef, except in the cases where recipes have previously appeared and are reprinted with gracious permission: "Shrimp in Crazy Water" from Mario Batali Holiday Food © 2000 by Mario Batali. Used by permission of Clarkson Potter/Publishers, a division of Random House, Inc. • "Roast Bone Marrow with Parsley Salad" from The Whole Beast: Nose to Tail Eating © 2004 by Fergus Henderson. • "Seared Foie Gras and Green Apple Risotto" and "Vinegar Reduction" from Scott Conant's New Italian Cooking with Joanne McAllister Smart © 2005 by Scott Conant. Used by permission of Broadway Books, a division of Random House, Inc. • "My Friend Suzy's Best French Fries in the World" adapted from the original, which first appeared as "Les Meilleures Frites du Monde de Ma Copine Suzy" in personne ne me volera ce que j'ai dansé © Hélène Darroze. Published by Le Cherche Midi, 2005. • "My Favorite Simple Roast Chicken" from Bouchon © 2004 by Thomas Keller. Used by permission of Artisan, a division of Workman Publishing Co., Inc., New York. All Rights Reserved. • "Crêpes à la Confiture" adapted from Jacques Pépin's Table. Published by KQED Books, 1995. • "Roast Beef with Yorkshire Pudding and Red Wine Gravy" from Gordon Ramsay's Sunday Lunch © Gordon Ramsay. Published by Quadrille Publishing, 2006. • "Gravlax with Mustard Sauce" from Aquavit: And the New Scandinavian Cuisine by Marcus Samuelsson © 2003 by Townhouse Restaurant Group. Reprinted by permission of Houghton Mifflin Co. All rights reserved.

Published by Bloomsbury USA, New York
Distributed to the trade by Holtzbrinck Publishers

All papers used by Bloomsbury USA are natural, recyclable products made from wood grown in well-managed forests. The manufacturing processes conform to the environmental regulations of the country of origin.

LIBRARY OF CONGRESS CATALOGING-IN-PUBLICATION DATA HAS BEEN APPLIED FOR.

ISBN-10: 1-59691-287-1
ISBN-13: 978-1-59691-287-8

First U.S. Edition 2007

3 5 7 9 10 8 6 4 2

Typeset by No11, Inc.
Printed in Italy by Artegrafica S.p.A., Verona

Index

A special nod to World Hunger Year (WHY) for all the fantastic work they are doing.